PICTURING US

Picturing Us

AFRICAN AMERICAN IDENTITY
IN PHOTOGRAPHY

Edited by
DEBORAH WILLIS

THE NEW PRESS · NEW YORK

PUBLISHED IN THE UNITED STATES BY THE NEW PRESS, NEW YORK
DISTRIBUTED BY W. W. NORTON & COMPANY, INC.,
500 FIFTH AVENUE, NEW YORK, NY 10110

LIBRARY OF CONGRESS CATALOGING-IN-PUBLICATION DATA
Picturing us: African American identity in photography / edited by Deborah Willis.
 P. CM.
 ISBN 1-56584-107-7
 1. Portrait photography. 2. Afro-Americans—Portraits.
 I. Willis-Thomas, Deborah, 1948–
 TR680.P53 1994
 770'.89'96073—dc20 94-3742

PRODUCTION MANAGEMENT BY KIM WAYMER

ESTABLISHED IN 1990 AS A MAJOR ALTERNATIVE TO THE LARGE, COMMERCIAL PUBLISHING HOUSES, THE NEW PRESS IS THE FIRST FULL-SCALE NONPROFIT AMERICAN BOOK PUBLISHER OUTSIDE OF THE UNIVERSITY PRESSES. THE PRESS IS OPERATED EDITORIALLY IN THE PUBLIC INTEREST, RATHER THAN FOR PRIVATE GAIN; IT IS COMMITTED TO PUBLISHING IN INNOVATIVE WAYS WORKS OF EDUCA-TIONAL, CULTURAL, AND COMMUNITY VALUE THAT, DESPITE THEIR INTELLECTUAL MERITS, MIGHT NOT NORMALLY BE "COMMERCIALLY" VIABLE. THE NEW PRESS'S EDITORIAL OFFICES ARE LOCATED AT THE CITY UNIVERSITY OF NEW YORK.

PRINTED IN THE UNITED STATES OF AMERICA
96 97 9 8 7 6 5 4 3

to bell hooks, Kellie Jones, Clarissa Sligh,
Hank Sloane Thomas, and to the memory of Ellis Haizlip,
all of whom inspired me
to look at images in a critical way

Contents

CONTENTS

Preface

ONE DAY IN JUNE 1992, I TALKED AT LENGTH WITH bell hooks about her recently published book *Black Looks: Race and Representation* and discovered that we were both transfixed by the same image, a portrait of Billie Holiday made by *Ebony* and *Jet* photographer Moneta Sleet, Jr. We both felt moved by the subtlety of the image in displaying the sensitive, sensual nature of the subject. We talked for a long time about why it was so important that we think and write critically about images and how they affect the African American community.

That same evening another friend, Kathe Sandler, called to tell me that she had finished editing her film *A Question of Color*. To promote the film, she told me, she was using a photograph of "newly freed slaves" that I had found in 1972 in the Philadelphia Public Library.

The following day, Clarissa Sligh invited me to come to her opening in Washington, D.C., at the Washington Project for the Arts. The exhibition was a political art installation entitled "Witness to Dissent: Remembrance and Struggle," with photographs, text, and video installation recounting her involvement in the civil rights movement. She had also invited over two hundred people to write about "how the civil rights movement affected their lives," and their statements were included in the installation. I talked with her about a scrapbook in the exhibition that included snapshots and newspaper photographs of her as a teenager when she had been a plaintiff in a suit to integrate the public schools of Arlington, Virginia. We talked specifically about the newspaper photograph and how her family preserved the image and what it meant to her today, over thirty years later.

These three conversations made me wonder why there has been no text offering a critical discussion of the photograph, or the maker of the photograph, in the African American community.

We have all looked at photographs of Africans and African Americans. In looking through picture books, photograph collections, and private albums, I have encountered many intriguing and disturbing images. The photographic medium has given me the opportunity to walk through history and imagine the lives of distinct peoples.

The photographing of African Americans for personal collections, scientific studies, advertising purposes, or for general public use dates back to 1839. Early black-and-white photographs taken by artistic photographers attracted the attention of a buying public. Some photographers created images, specifically made for private collections, that idealized family life and notable individuals. Other photographers found it more profitable to create a series of prejudicial and shocking photographs of their black subjects, provoking critical comments, favorable as well as adverse, from various communities. Many of these photographs were negative, insulting images of black Americans—such as young black boys used as "alligator bait," and old, grinning black men eating watermelon. Today, such nineteenth-century genre subjects, including various poses of African American men, women, and children, have enjoyed more popularity with collectors and the general public than many other images made during that century. Many of these images of blacks are rare and salable to dealers, auctioneers, collectors, and curators. Ironically, some of the most impressive and startling photographs of blacks were also produced in the nineteenth century.

In the last few years there has been a surge in interest in photography, specifically in the ways one looks at and interprets photographs and how identity and representation are constructed in photographs of African Americans.

David Sternbach of The New Press invited me to edit this book on African American identity in photography, shortly after *Partial Recall: Photographs of Native North Americans* (edited by Lucy Lippard) went to press. For the past fifteen years I had spent many, many hours thinking about photography, criticism, and how the photographic image has transformed my life. I hoped, therefore, that this collection of essays could offer a new and distinctive perspective in the field of photography, and that the reading of photographic images by African Americans could suggest a restructuring of our perceptions. The eighteen essays in this volume are filled with revealing and highly personal observations on photography. I am certain they will stimulate further discussion and advance critical writing on photography. They will also underscore the necessity for more critical writing about African American photographic images.

In selecting the contributors for this book I contacted friends and col-

leagues who often talked with me about various photographs or whose writings, I felt, were especially informed by the visual. I telephoned and met with bell hooks, Clarissa Sligh, Claudine Brown, Manning Marable, Robert Hill, Kathe Sandler, Luke Harris, Christian Walker, Ed Jones, Ethelbert Miller, Jacquie Jones, Philip Royster, Carla Williams, Paul Rogers, Kimberlee Crenshaw, Kellie Jones, Lisa Jones, Greg Tate, Pat Ward Williams, and Itabari Njeri. All were supportive and enthusiastic; but, because of prior commitments, a few were unable to contribute.

The essays included in this book are greatly varied. Some are auto-biographical, and many describe experiences that are shared by the African American community. Many of the writers chose a family snap-shot to take them back to the past and to contextualize their self-image within a larger social framework. Many of the discussions are self-refer-ential and open ended. But they are all inspiring, as each of the contrib-utors examines the impact of one or two images on their lives, as well as the larger questions of how photography and African American identity have shaped each other. Some of the photographs are from family albums, others from picture agencies, libraries, and archives. Our inter-est in this publication is to present a different voice, a privileged voice, one that can afford to direct the gaze outward and express the personal thoughts of a group of artists, cultural critics, novelists, scholars, histo-rians, and poets who write for the first time about their interpretations of African American photography. Their narratives are analytical and personal. They speak about the pleasures and pitfalls of photography. The essays are openly, unabashedly shaped by the writers' political and personal views. This collection is not meant to be corrective, exhaus-tive, or inclusive, but merely to illuminate.

Picturing Us addresses image making and interpretation, subjectivity and representation. It looks at how photographs have been used; the implications of stereotyping; what is self-conscious imagery; how gen-der is portrayed; what assumptions are made of images of girls in gen-der-specific roles; of black male imagery; of socially conscious, race-conscious imagery; of color consciousness in the black family structure. A unique collective portrait develops in this book, and I am reminded of the comment made by Zora Neale Hurston when she received a group of photographs of herself from Carl Van Vechten: "I love myself when I am laughing. And then again when I am looking mean and impressive."

With this remark Hurston reveals that she was aware of the value of the photograph as historical evidence, and, as the sitter, her acceptance of her own alternative modes of expression.

Despite the long history of critical writings on photography, there is a lack of books and articles on reading photographic images of and by African Americans. As bell hooks has written in her book *Black Looks*:

> Like that photographic portrait of Billy [Billie] Holiday by Moneta Sleet I love so much, the one where instead of a glamorized image of stardom, we are invited to see her in a posture of thoughtful reflection, her arms bruised by tracks, delicate scars on her face, and that sad faraway look in her eyes. When I face this image, this black look, something in me is shattered. I have to pick up the bits and pieces of myself and start all over again—transformed by the image.

The connections made by the writers in this book to the photographic image, and the location of that image within each writer's memory, have begun to make the experience of reading photographs definable. I myself have chosen several photographs and photo stories to reconstruct within this book. Hence, there is an extraordinary accumulation of photographic imagery, from the formal portrait photograph to the most casual snapshot. My hope is to present the variety of photographs that played a part in shaping my own and the contributors' interests in photography—that is, in history and identity.

Acknowledgments

IN PREPARING THIS BOOK I HAVE HAD TREMENDOUS SUPPORT AND cooperation from many friends, colleagues, and institutions. Without their help and their permission to reproduce photographs, this book would not have been able to take its distinctive place in the current swell of writings on African American life and culture. I would especially like to thank all the contributors and the individuals in their families who are the "keepers of the photographic album," private collectors such as Derrick Joshua Beard, Donna Mussenden-VanDerZee, and Emily Saunders, and repositories such as the *Washington Post*, the J. Paul Getty Museum (Photograph Division); the Schomburg Center for Research in Black Culture; Black Star Publishing, Inc.; the Montana Historical Society; and the Bettmann archive. A number of people gave me advice and encouragement. I would like to thank Yvonne Willis Brooks; Mark Wright; Leslie Willis; Hank S. Thomas; Jane Lusaka; Mecca, Kalia, and Medea Brooks; Shirley Solomon; Sharon Howard; Deirdre Cross; and my mother, Ruth Willis. I am particularly grateful to the staff of The New Press: Dawn Davis, Max Gordon, and David Sternbach.

PICTURING US

INTRODUCTION: PICTURING US

Deborah Willis

In 1955, WHEN I WAS SEVEN YEARS OLD, MY MOTHER DECIDED THAT she wanted to be a beautician and enrolled in the Apex Beauty School on South Broad Street in Philadelphia. My Mom had three daughters, four sisters, four aunts, nieces, a mother, and grandmother. All of them supported her interest in becoming a hairdresser. Still, a few were a little skeptical when Mom wanted to put a hot comb to their roots. Her daughters, however, had no choice; we had to experience that "rite of passage."

Nineteen fifty-five was also the year Langston Hughes and Roy DeCarava published *The Sweetflypaper of Life*. This book described life in Harlem through the eyes of a grandmother, Sister Mary Bradley. Every week my older sister and I went to the public library on Lehigh Avenue to select a book to read for the week. That was a ritual we had performed since we started elementary school. I can still remember browsing the shelves, looking for an easy-reading book that I could finish in time to go to the Saturday matinee. On one occasion I stumbled upon *The Sweetflypaper of Life* and proudly brought it home. DeCarava's photographs left an indelible mark on my mind. Hughes was already a household name because of the books my father had in his bedroom, and, of course, during Negro History Week we always read his poetry.

As I struggled through the book, I was excited to see the photographs: it was the first book I had ever seen with "colored" people in it—people that I recognized, people that reminded me of my own family. I remember sitting in the "kitchen," the upstairs room where my mom "did hair," waiting my turn to get my hair straightened. I dreaded it. The wait was always filled with listening to my sister or my cousin crying and watching them pull away in pain from the hot comb.

First, I read the book *visually*, "reading" the pictures and relating to the experiences that I thought Langston Hughes was writing about. Although I could read words with some difficulty, I was learning to read images with ease and imagination. Then, as I waited, I began to read and understand the text. I looked through the pages with great intensity, asking questions about the people. The lighting in the photographs

was dramatically dark and realistic. The story line was simple for me to understand, the photographs spoke to me in a manner that I will never forget, and they led me to ask questions about the photographs we had in our house.

The images on the wall, on the mantle, and on the piano were taken by my father's cousin, Alphonso Willis. He was the family photographer and had a commercial studio near our house. My father was a serious amateur photographer himself. He had a camera that always fascinated me. I was unable to use it because it was too difficult for me to hold, and I had trouble focusing on the ground glass, but I always looked forward to my father coming home with the past week's prints and negatives. I enjoyed placing the photographs in the photographic album and trying to structure the album the way Hughes and DeCarava had set the photographs in *Sweetflypaper*. *Sweetflypaper* spoke of pride in the African American family, good times and hard times, with an emphasis on work and unemployment. *Sweetflypaper* said to me that there was a place for black people's stories. Their ordinary stories were alive and important and to be cherished. There were photographs of black women in tight sweaters dancing sensually—just like the movies of Marilyn Monroe!—sassy women and women who sacrificed for the family; and then there was Rodney, photographed handsomely by DeCarava in lighting only he could capture. For me a veil was lifted. I made it a point from that day in 1955 on to continue to look for books that were about black people and to look at photographs that told or reflected our stories.

Untitled Snapshot of My Sister Yvonne and Me, 1955
PHOTOGRAPHER: THOMAS WILLIS (COURTESY DEBORAH WILLIS)

This photograph was taken the day after Christmas. My father and his cousin were always on hand to commemorate special family occasions such as graduations, weddings, family reunions, and funerals, as well as everyday events. I found this picture in an album while compiling family photographs to use in a photo-quilt. Here, my sister and I are two pretty little girls holding our brand-new Christmas presents. Our smiles are wide as we sit before the camera. I am on the left, holding the black, brown-eyed, black-haired doll, and my sister is cradling the white, blue-eyed, blond doll. Our facial features indicate that we are

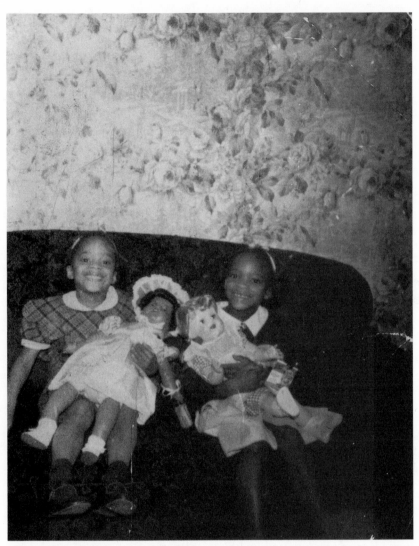

Untitled Snapshot of My Sister Yvonne and Me, 1955
PHOTOGRAPHER: THOMAS WILLIS (COURTESY DEBORAH WILLIS)

sisters, and the external clues about our choice of dolls create a curious narrative. When I look at this image today, I think of the Dolls Test, devised by psychologists Kenneth and Mamie Clark. In an attempt to investigate the development of racial identification and preference in African American children, the Clarks performed a test in which black children were asked to select a white or black doll to play with. Results of the test showed that the black children, ranging in age from five to seven, clearly rejected the brown-colored doll, preferring, by and large, the white one. The test asked the black children to select the doll that was most like them. Other directions included:

- Give me the doll that you like to play with or the doll you like best.
- Give me the doll that is the nice doll.
- Give me the doll that looks bad.
- Give me the doll that is a nice color.

The majority of the African American children who took the test indicated an overwhelming preference for the white doll and a rejection of the brown doll.

In looking at this snapshot, I find it a real-life, personal illustration of this test. I wonder now when I became aware of racial identification in toys. Learning about race and racial pride was consciously encouraged by the black teachers I had in elementary school. Many of my friends who were educated in the North did not have black teachers. I was fortunate because at home and at school racial pride was taught. I called my mother recently to ask why, in all the photographs in the album that included dolls, mine were black and Yvonne's were white. She told me about how she and my father would take us Christmas shopping and how I insisted on having black dolls. She said my sister rejected them until we were too old to buy dolls. This photograph offers insight into my early interest in understanding African American material culture.

Raccoon Couple in Car, 1932
PHOTOGRAPHER: JAMES VANDERZEE (COURTESY DONNA VANDERZEE)

In 1969, I visited the Metropolitan Museum of Art's exhibition, "Harlem on My Mind." It was the first experience I had in a major museum

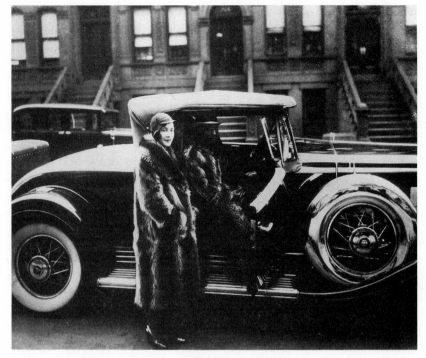

Raccoon Couple in Car, 1932
PHOTOGRAPHER: JAMES VANDERZEE (COURTESY DONNA VANDERZEE)

where photographs of African Americans were presented. I had recently moved to New York City from Philadelphia with my cousin Veanie to take photography classes and visited virtually every museum in the five boroughs of New York City. Walking through the grand galleries of the Met, I heard sound—jazz, blues, and speeches. I heard the anonymous voices of the community and the familiar words of Malcolm X. There were small photographs and photographic murals, photographs mounted on masonite and images blown up to fifty feet of black people: Reverend Adam Clayton Powell, Sr., the Sunday school classes at the Abyssinian Baptist Church, Paul Robeson, Marcus Garvey, Madame C. J. Walker.

I vividly recall walking through the exhibition wondering why protestors on the front steps were carrying placards saying "Whitey Has Harlem on His Mind—We Have Africa on Our Mind." At twenty one,

never having seen images of black people exhibited in a major museum, outside of a natural history museum, I felt great pride in that presentation. But I also felt conflicted. I wanted to discuss my personal pride in the exhibition openly with the people I met on the picket line but was afraid to do so because of their obvious discontentment. I later heard the issues voiced this way: Why were photography and social issues being examined in an art museum? Why were there no black artists on the curatorial advisory committee? And the title of the exhibition, "Harlem on My Mind," was taken from an Irving Berlin song! I wanted to honor the picket line, but I also wanted to experience the photographs. I understood the protestors' concerns but fundamentally disagreed with them, and I went back five times to view that groundbreaking show. I was most curious about the photographs of James VanDerZee and wondered who he was and why he was not mentioned in any of my books on the history of photography. One image in particular, *Raccoon Couple in Car*, raised a whirlwind of social and photographic questions. Just as *The Sweetflypaper of Life* had prompted my general interest in photography and African American images, confronting VanDerZee's photograph marked the beginning of my formal education in the field of photography. *Raccoon Couple* perfectly symbolized, in my mind, the celebration of black life and economic and cultural achievement.

The car is parked away from the curb, the woman is wearing a full-length raccoon coat, as is the man. He is partly seated in the car on the passenger's side and she is standing in the street. As I looked at the photograph, I romanticized this period in history through VanDerZee's portrayal of the couple. In the stories I heard about it while I was growing up, Harlem was a source of pride. The long oral narratives by my parents, aunts, uncles, and their friends could keep me spellbound for hours. The dances, the rent parties, the plays, the musicians, and the numbers. VanDerZee empowered his subjects for posterity. During that period Harlem was struggling and surviving during the Depression years. His photographs broke the stereotype of Harlem during the Depression, and seeing the exhibition in 1969 made me want to recover the personalities captured within his frame. The couple appears to be distant, yet charming. There is a sense of spontaneity. There is a wonderful play of reflected light and distorted image in the chrome of the

wide spare wheel. I imagined, as I saw this photograph on the walls of the Met, that life during the Harlem Renaissance must have been vibrant, supportive, and prideful, but where were the newly arrived migrants from the Deep South? Were they invisible to VanDerZee?

Saturday Afternoon, Brooklyn, New York, 1988
PHOTOGRAPHER: HILTON BRAITHWAITE (COURTESY HILTON BRAITHWAITE)

This photograph takes me back to the streets of North Philadelphia, the area called the Village, where I spent my formative years. It reminds me of my church and the women in my family. I often walked my grandmother and her friends to church on Saturday, after leaving a movie matinee. They were wearing similar clothing—white dresses and uniforms for their official church duties. I loved their devotion, their excitement about going to church. They were serious about their involvement, no matter what level of activity. It was a major part of their social life. Some held prayer vigils; a few were deaconesses; many of them cooked.

When I moved to Brooklyn at the age of twenty one, in 1969, my grandmother said to me and my cousin, "Find yourself a church home when you get settled in New York." I used to walk on the street where this photograph was taken, stand on the same corner and watch people like the subject of this photograph. I wanted to make photographs on that same corner. For some reason I did not, and I tried to justify my guilty feelings by thinking, "Some things just don't need to be photographed." Then, when I saw this photograph in an exhibition catalogue in 1992, I felt relieved that someone else had seen fit to make the image.

This striking portrait of a "church woman" dressed in white on Fulton Avenue serves as a metaphor and reflects the sentiments of traditional documentary photography. It is rooted in the street photography that became popular in the mid-1950s; it speaks to us about community, responsibility, and spirituality. In the background there is a Black Muslim enterprise, Steak 'n' Take Restaurant, a couple conversing on the corner under the traffic light, a stopped car; the middle ground is the subway entrance—a poster plastered on the side reads: "The Truth: Vote Against Reagan...." The street is remarkably clean of debris. The subject stands squarely in the foreground. Wearing a crocheted shawl,

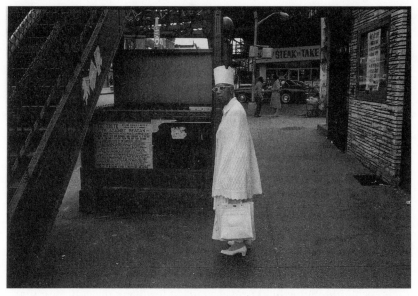

Saturday Afternoon, Brooklyn, New York, 1988
PHOTOGRAPHER: HILTON BRAITHWAITE (COURTESY HILTON BRAITHWAITE)

white-rimmed glasses, cylinder-shaped hat, ankle-length white dress, white stockings and shoes, and carrying a white tote bag, this African American woman is stopped in time. She is an archetype: evangelist, missionary, nurse, or usher. It is ambiguous just how willing she is to be photographed; she appears defiant, yet at the same time approachable. She would be a favored subject for any photographer because of the starkness of her dress against the overhead El platform. Her suggested forceful stride is broken, and her multidimensional character becomes apparent the moment the shutter is closed. She has a mission, and the ability of the photographer to document her self-possession is a central point of this photograph. To capture the attitude of black women on film, without categorizing their posture as sassy, docile, and/or threatening, is a transformative act. This image defies the objectified images of African Americans made by many photographers from outside the community. It allows us to look at and reclaim our neighborhoods and to identify the community as a place with a distinctive and productive personality.

Malcolm X with Wife Betty Shabazz and Daughters, c. 1959
PHOTOGRAPHER: RICHARD SAUNDERS (COURTESY EMILY SAUNDERS)

In 1990 I received a call from Malcolm X's daughter Attallah asking me for a copy of this photograph. The image had recently appeared in a book I edited, *An Illustrated Bio-Bibliography of Black Photographers, 1940–1988.* She said the family did not have many photographs of private moments. The image was composed of the typical elements found in family photographs: father, mother, and children. But the positioning of the family was in stark contrast to my own family photographs. Malcolm X stands to the right of the frame, while Betty Shabazz sits on the sofa with one of her daughters on her lap. The other daughter, Attallah, sits at her mother's side looking into the camera, her index finger in her mouth. The room is decorated simply and the plainness of the room heightens the drama of the image. A portrait photograph of the Honorable Elijah Muhammad is perched high on the wall, at the line of the molding, as if he is looking over and approving this domestic scene. It is an unusual height for a framed photograph. It was a conscious act to place the photograph in that manner. As I studied this photograph over the past six years, I began to feel as if I was an invited guest in their living room.

There is a sharp increase in the number of artists who are using family photographs in their work today. The family has become political in their work. As I read the photograph of Malcolm X and his family, the image becomes more than a family affair; it is also a political statement. Malcolm X is seen here as the husband and father. His wife, Betty Shabazz, is smiling quietly and looking admiringly at her husband as he appears to be reading a book. Is it the Koran or is it a prop for the photographer? The floors are shiny and there are plastic slipcovers on the sofa, of the sort commonly seen on furniture in the late fifties and early sixties in middle-class homes in this country. The family looks lost and out of place in the scantily furnished room. Stripped of familiar and familial materials, the "family" appears to have less of an identity. The portrait of the Honorable Elijah Muhammad appears to be the most treasured and essential artifact the family possesses. Looking at this image, one assumes that the family is obeying a religious stricture not to consume "worldly possessions." We often learn from photographs

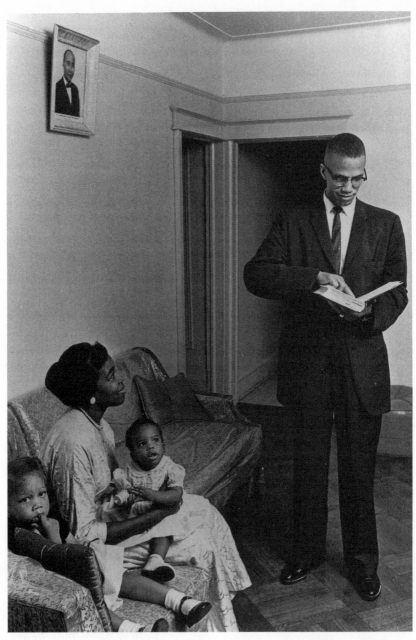

Malcolm X with Wife Betty Shabazz and Daughters, c. 1959
PHOTOGRAPHER: RICHARD SAUNDERS (COURTESY EMILY SAUNDERS)

how a family has lived. Malcolm X was a public figure, and most of his family photographs have not been published. What I find intriguing about this photograph is the fact that the conventional public image we have of him is still preserved here: he is dressed in a suit, his furniture looks uncomfortable, and it appears that he has no time off.

Photograph of Execution of William Biggerstaff, Hanged for the Murder of "Dick" Johnson, April, 1896, Helena, Montana, with Rev. Victor Day, J. Henry Jurgens, Sheriff, 1896
ALBUMEN PRINT, CABINET CARD. PHOTOGRAPHER: J. P. BALL
(COURTESY MONTANA HISTORICAL SOCIETY)

The first time I saw this picture was in 1972, when it fell out of a pile of photographs sent to me from the Montana Historical Society. I was researching a paper on black photographers while an undergraduate at the Philadelphia College of Art. My search for black photographers was an attempt to respond to the proliferation of negative, derogatory images of black people. White perceptions of black inferiority were often reinforced by the same images of black men that I had seen, and my intention was to challenge those images and the history books by identifying the breadth and depth of experiences of black people as recorded in photographs.

This image was one of a set of four. One was taken in the studio while William Biggerstaff was still alive; the others were taken during and after his death. I was surprised to learn that the photographer, J. P. Ball, was a black man. I studied the photograph for a long time and wondered, given the history of lynchings of black men in America, how he could have taken a photograph of another brother being hanged?

The photograph had an inscription on the verso: "William Biggerstaff, a former slave, was born in Lexington, Kentucky, in 1854. He was convicted of killing Dick Johnson after an argument that took place June 9, 1895. Biggerstaff pleaded self-defense. The records state that after postponement the hanging took place April 6, 1896; the 'weight fell at 10:08 A.M. in Helena courtyard.'" It was difficult to express my feelings. I could see a ring, possibly a wedding band, on Biggerstaff's limp left hand. I tried to imagine Biggerstaff's life: born into slavery, migrating to the West in the hope of contributing to its expansion, possibly marrying and having a family, dying at the age of forty two. After

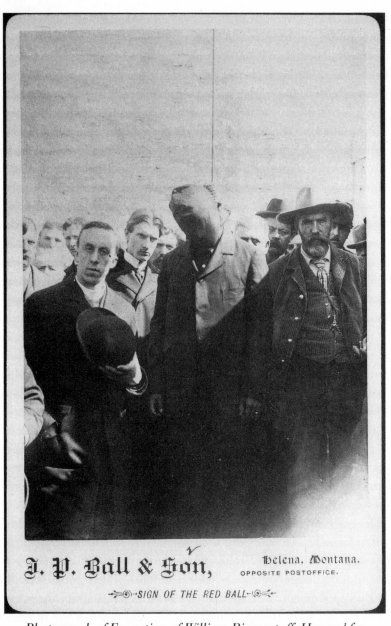

J. P. Ball & Son, Helena, Montana.
OPPOSITE POSTOFFICE.

SIGN OF THE RED BALL

Photograph of Execution of William Biggerstaff, Hanged for
the Murder of "Dick" Johnson, April, 1896, Helena, Montana, with
Rev. Victor Day, J. Henry Jurgens, Sheriff, 1896

ALBUMEN PRINT, CABINET CARD. PHOTOGRAPHER: J. P. BALL
(COURTESY MONTANA HISTORICAL SOCIETY)

surviving slavery, having spent the first eleven years of his life as human property, Biggerstaff's final portrait is that of a man silenced. He can no longer defend himself or express his anger. He must accept his violent death with dignity. He is dressed in a suit and tie. A tie pin is positioned neatly on his chest and the top button of his jacket is still fastened; yet, seeing his neck broken, even though the hangman's hood still covers his face, we know that his body is lifeless. The white men who have witnessed this hanging stand proud. One rests his bowler hat on his chest; others look directly into the camera, emotionless. What about the other black man in this picture, the one behind the camera? Is he only the recorder of this "legal lynching," or is he sending us another message? His photographic legacy has revealed a disturbing story, and one that has been suppressed. Recording this execution must have been an unsettling experience for Ball, who I later learned was a former abolitionist. He knew that black oppression was often violently manifested in the lynchings that Ida B. Wells and others protested against, but which continue to this day.

Trouble Ahead, Trouble Behind, c. 1880s
BLACK-AND-WHITE LANTERN SLIDES, 4" × 5"
PHOTOGRAPHER: KEYSTONE VIEW CO. (COURTESY DEBORAH WILLIS)

The photographer Christian Walker gave me a set of late-nineteenth-century lantern slides for my forty-second birthday. He knew of my interest in collecting black images from this period. These photographically beautiful and well-preserved glass slides are examples of a genre commonly known as "Black Americana," which includes a wide variety of popular artifacts depicting crude, degrading, racial caricatures of African Americans.

This sequential lantern-slide set depicts a weary-looking African American woman in a printed dress and white apron. There is a floured rolling pin on the table, and her gesture suggests that she is rolling dough and making bread, possibly as a means of self-employment. The image clearly establishes her class position. A small child lies beside her, asleep in a wooden cart. Behind her, an older male child, about eight years of age, is scribbling on the wallpaper. The drawing made by the child might be a drawing of the mother, because the word scrawled on the wall over it is "Mamy."

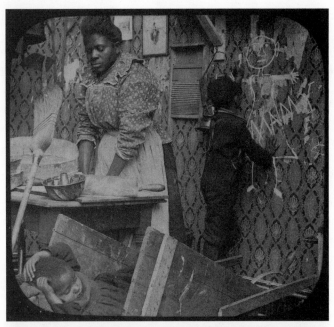

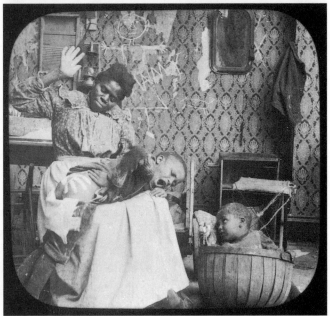

Trouble Ahead, Trouble Behind, c. 1880s
BLACK-AND-WHITE LANTERN SLIDES, 4″ × 5″
PHOTOGRAPHER: KEYSTONE VIEW CO. (COURTESY DEBORAH WILLIS)

In the second slide, she has placed the "unruly" older child across her knee and is spanking him. This slide, which glorifies the beating of a young African American male, was produced for the amusement of a white audience, as were others, such as the postcard images of young African American boys depicted as "alligator bait." While one may argue this point, it is undeniably a destructive image, one that plays on stereotypes and perpetuates racial myths. These images now exist as frozen racial metaphors from a time when images of African Americans were rarely produced by or for African Americans.

Photograph of Woman, South African, c. 1880s
ALBUMEN PRINT. PHOTOGRAPHER: BARNETT
(COURTESY ANONYMOUS DONOR)

In an article titled "A Tribute to the Negro" (published April 7, 1849, in the journal *The North Star*), Frederick Douglass cogently explains the problem inherent in attempts by white artists in the nineteenth century to depict likenesses of black people:

> Negroes can never have impartial portraits at the hands of white artists. It seems to us next to impossible for white men to take likenesses of black men, without most grossly exaggerating their distinctive features. And the reason is obvious. Artists like all other white persons, have adopted a theory dissecting the distinctive features of Negro physiognomy.

Upon reflection, this quote seems to adequately summarize the depiction of black people worldwide, and it remains true for this century also. Black women, in particular, have been subjugated and misinterpreted in photography since the early days of the medium. This is true both in domestic treatments, such as *Trouble Ahead, Trouble Behind*, and in representations of "exotic" others. The "civilized" photographer-traveler often found the nude image of an African woman irresistible. This nineteenth-century photograph of an African woman typifies what bell hooks calls the "miscegenated gaze." European photographers and tourists were keen voyeurs of African people, and women in particular. As a curator and "keeper of images," I have found countless nude photographs of African women. From 1839 to well into the twentieth century, photographers roamed the continent making

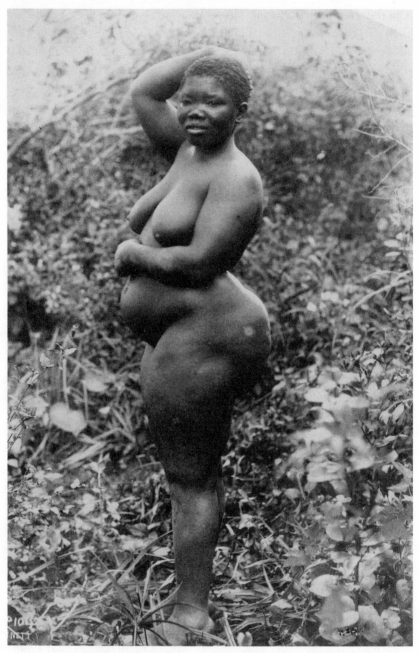

Photograph of Woman, South African, c. 1880s
ALBUMEN PRINT. PHOTOGRAPHER: BARNETT
(COURTESY ANONYMOUS DONOR)

such images. In looking at these images, one sees that the face of the woman often was unimportant as an element of the picture. Her buttocks and breasts are the primary focus. Nicolas Monti, an Italian photographic archivist, traced the history of these images. He states:

> One might almost say that the black woman was imagined without a head: The body is all that counts, a body offered to man's pleasure, an extremely simplified idea in which beauty is exclusively seen as underlining the erogenous zones of breasts and buttocks. The curves are abundant, the back is sumptuous, and the hips are magnificently shaped, while adolescent breasts blossom out on a superb, enticing bust.[1]

One of the early accounts referencing this type of image is the story of Saartjie (Sarah) Baartman, also known as the "Hottentot Venus." Saartjie Baartman was brought to Europe and placed on exhibit by scientists who found the size of her buttocks "grotesque and different." Beginning in 1810 she was exhibited, naked, in cages in Paris and London for over five years. Occasionally, she and other African women, like the one photographed here, were the object of amusement at parties in Paris, where they were required to wear very skimpy garments. The "Hottentot Venus" was "admired" by her protagonists who depicted and described her as animal-like, exotic, different, deviant. Scholar Sander Gilman describes the impact of Baartman on European society:

> It is important to note that Sarah Baartman was exhibited not to show her genitalia but rather to present another anomaly which the European audience…found riveting. This was the steatopygia, or protruding buttocks, the other physical characteristic of the Hottentot female which captured the eye of early European travelers…. The figure of Sarah Baartman was reduced to her sexual parts. The audience which had paid to see her buttocks and had fantasized about the uniqueness of her genitalia when she was alive could, after her death and dissection, examine both.[2]

Seeing this photograph and other nineteenth-century images of African women suggests the need for us to clarify and reexamine the discourse of sexuality that still prevails in twentieth-century images.

These "anthropological" studies from the nineteenth century can easily be linked, for example, to the advertising images produced by Benetton, the Italian clothing maker. Black subjects are used to sell an image—or, more generally, to attract attention. There are a number of disconcerting images produced by Benetton. One in particular, which appeared on billboards in Europe and elsewhere but was deemed too controversial for American consumers, shows a white baby sucking at the breast of a black woman. The black British photographer and writer David A. Bailey observes:

> Benetton's photographs have legacies with particular genres within photographic history. If we look at early anthropological photography we can see the process of categorisation and construction of racial difference in which cultures were either photographed voyeuristically within their homelands (emphasizing physical features) or photographed and measured in studies. This is reproduced in the Benetton campaign by the categorisation of differences and the emphasis on physical features such as eyes, hair and skin color. This emphasis on physical features is also similar to the early medical and police photographs of mental, physical and social deviants. Likewise the framing and cropping of the United Contrasts of Benetton advertisements is very similar to these earlier photographs. [3]

Bailey's analysis of the "selling" of a race as a product offers a way to reexamine this type of imagery and to understand the effects it has had on racial discourse in the nineteenth century—as well as the impact that discourse has had on us in the latter part of the twentieth century.

Whipped at Post, c. 1880s
PHOTOGRAPHER: UNKNOWN (COURTESY OF DERRICK JOSHUA BEARD)

Initially this photograph annoyed me. I was struck by the stiff poses the men in the photograph assumed in order to demonstrate the techniques of torture. Then the photo disturbed me. Three black men, "models" for the photographer, are held in constraining devices; two white men stand on either side of the post, ready for action—one holds a whip. This photograph acts as evidence of the brutality endured by our ances-

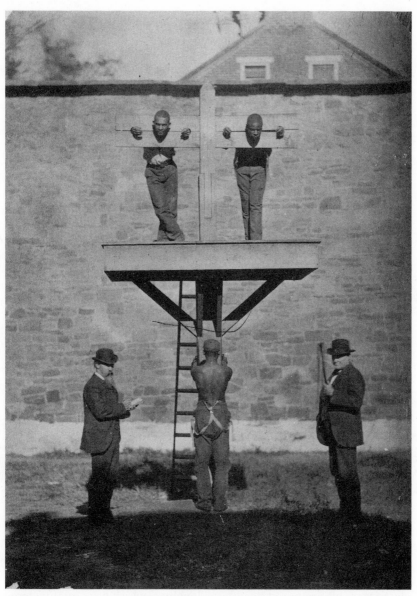

Whipped at Post, c. 1880s

tors. Why was this photograph taken? Was it meant to show the brutal-ity of enslavement?

I have read, during my entire adult life, about the brutal beatings that black men, women, and children endured during slavery at the whipping post. It was not until I visited the Maryland Historical Society in 1991 that I began to comprehend fully the craft and industry of punishment. I saw a whipping post in an installation curated by Fred Wilson titled "Mining the Museum." The cherry-wood whipping post was displayed in the same room with three or four chairs carved out of the same beautiful wood. The juxtaposition of these several items was the ironic comment by the artist that the same meticulous care and craftsmanship went into both the chairs and the whipping post. The chairs had long been displayed by the Maryland Historical Society as examples of historical craftsmanship. Fred Wilson found the whipping post in the basement.

The questions raised by Wilson came to mind while I was looking at this photograph. Trying to reconstruct the lived experiences of slave culture, I wondered: Who made this whipping post? Why did he place a crucifix-type structure on the platform that was to be used to restrain and torture a black man or woman? What was the purpose of this pho-tograph? And who were the "models"? Were they paid? The question-ing of this image is primary when trying to reconstruct the lived experi-ences of slave culture and it's legacy. Imaginatively retitling this photograph *But Some of Us Are Brave* (the subtitle of a book by Gloria Hull, Patricia Bell Scott, and Barbara Smith) allows me to consider how the black men and women themselves responded to this type of punish-ment and the challenges they endured. It also helps me to imagine the psyche of an individual who could design a torture device in order to control another human being. Since the whipping post in this photo-graph is in what appears to be a courtyard, I also react to this torture as public spectacle, performed in full view of the townspeople. Other slaves were also required to witness floggings, which were administered by whites as well as by African Americans who were often forced to also participate as a means of terrorizing them into obedience.

Perplexed after seeing the photograph and the whipping post in Fred Wilson's exhibition, I began to document in my daybooks various refer-ences to flogging:

On the 28th of May 1866, Henry Seward made affidavit that in December 1861 while in conversation with Mr. Samuel Cox living five miles South of Port Tobacco [Maryland], he (Cox) confessed that in August 1861 he had murdered one of his Slaves, Jack Scroggins by whipping him to death.... This statement is corroborated by affidavits made by John Sims and William Jackson—(at a different time) who testify that Scroggins was flogged to death for having escaped to the Federal lines, when he was recaptured and on the 12th of May 1866—Wm Hill, col[ore]d an employee at the Senate Post Office reports this case and states that in whipping Scroggins to death Cox was assisted by Frank Roly his overseer and two other men. All these parties are living now at the same place and have never been arrested....

Another man reports his wife's and mother's beatings:

...they were both taken to the barn and severely whipped. Their clothes were raised and tied over their heads to keep their screams from disturbing the neighborhood and they were tied up and whipped very severely and then taken to Upper Marlborough to jail....

There is deviant behavior here that has not been adequately investigated. In order to begin to develop a theoretical framework in which to analyze the slave culture, we need to re-examine the situations of all participants involved in this photograph: the "models," the artisan, the photographer, as well as the person who commissioned this photograph.

Daguerreotype Portrait of Young Black Girl
Holding a White Baby, c. 1850s
PHOTOGRAPHER: UNKNOWN (COURTESY J. PAUL GETTY MUSEUM)

This daguerreotype is one of the earliest photographic images to refute the stereotype of the black women who became known as "mammies." Many young black women assumed the role of nanny, or "mammy," for white children.

The young African woman in this portrait looks pensively into the camera while holding tightly to the child. The woman's head is

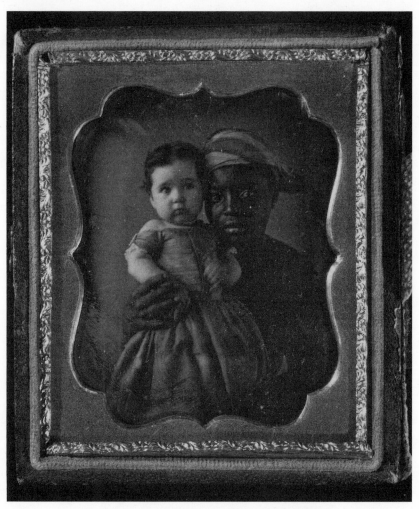

*Daguerreotype Portrait of Young Black Girl
Holding a White Baby,* c. 1850s

PHOTOGRAPHER: UNKNOWN (COURTESY J. PAUL GETTY MUSEUM)

wrapped in a scarf and tied in the manner of West African women's headdresses. Other than the color of her skin, the headdress is the only signifier of her African heritage. Her mood is solemn, her mouth is closed tightly, creating a sad or resigned look on her face. It is clear that she is a teenager, possibly between the ages of thirteen and fifteen. The young child appears unaware of the photographer as she looks off to the right. Why was this photograph commissioned? Since this photograph was taken during the period of slavery, we may assume that the young black woman is human property. Then again, what was the purpose of this photograph? Are these the "master's" possessions? Or is the black woman the subject or object of the photograph? Because of the complacent expression on the young African woman's face, it is unlikely that this photograph was used for propaganda purposes in the antislavery movement. In asking myself these questions, I began to answer them with more conjecture. Will her family ever see this image? If so, what will they make of her situation? Does she live with or near her biological family? The loneliness expressed in her eyes speaks to me 150 years later. It evokes for me the title of James Baldwin's book *Nobody Knows My Name.* Moreover, this image becomes a marker for me, for the women who wrote of their own experiences in slave narratives but who were never photographed. There is a self-consciousness depicted in the photograph. As the woman holds tightly to the baby's hand, her eyes speak of a sense of loss—loss of self and identity. It is curious that this image became commonly known in the mid-1980s when it was reproduced as a postcard. Perhaps the image speaks to African American women even today who feel that they, too, could lose their individuality at an early age. Fifty years after this photograph was taken, the poet Paul Laurence Dunbar wrote these words in his poem "We Wear the Mask":

> We wear the mask that grins and lies,
> It hides our cheeks and shades our eyes,
> This debt we pay to human guile;
> With torn and bleeding hearts we smile,
> And mouth with myriad subtleties.

NOTES

1. Monti Nicolas, *Africa Then: Photographs 1840–1918* (New York: Alfred A. Knopf, 1987), p. 73.

2. Sander L. Gilman, "Black Bodies, White Bodies: Toward an Iconography of Female Sexuality in Late Nineteenth-Century Art, Medicine, and Literature" in Henry Louis Gates, Jr., ed., *"Race," Writing, and Difference* (Chicago: University of Chicago Press, 1985), pp. 223–261.

3. David A. Bailey, "Product Branding the World" in *The Globe: Representing the World*, ed. Paul Wombell (York, Eng.: Impressions Gallery, 1989), p. 65.

PART I

VISUAL MEMORIES

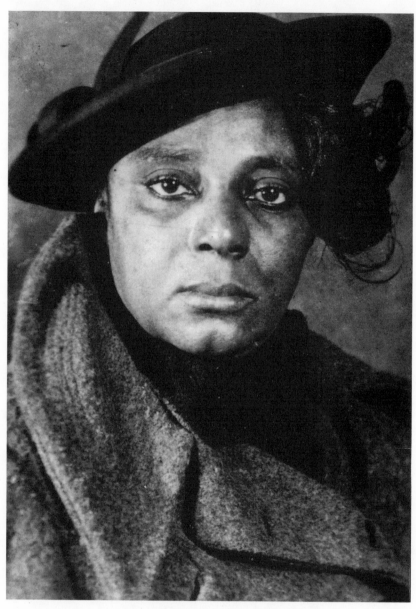

Estella Smart, N.D.
PHOTOGRAPHER: UNKNOWN
(COURTESY VERTAMAE SMART-GROSVENOR)

WHEN YOU MEET
ESTELLA SMART, YOU BEEN MET!

Vertamae Smart-Grosvenor

IF FAMILY STORIES WERE PHOTOGRAPHS, I'D NEED A SMALL MUSEUM to house them, but a shoe box could hold all the photos I have of my family. Devastation by fire was a common occurrence in the wooden-frame houses where my family lived in rural South Carolina—besides which, photo opportunities were few and far between. Few photos survived.

Memories are our photos. The family history is told in stories; and I mean those Geechee people tell some stories!

I would do the hucklebuck in Macy's window for a photo of my great-grandfather Mott. They say he was a seven-feet-tall African man who could jump so high that his heels clicked three times before he came down. And they say his voice was so powerful that when he called "quitting time" you could hear him on plantations in the next county.

Not too long ago a bank was running TV spots called "First Americans." The idea was to talk about a person in your family who was or did something unusual and succeeded. I submitted Granddaddy Mott's name. He was a first American, and succeeded in spite of bitter southern oppression to live to be ninety-five years old.

I never heard from the bank. I'm convinced it's because I didn't have a photo.

On the other hand, I do have a picture of my grandmother, and it is one of my most treasured possessions.

Estella Smart was my grandmother on my father's side. I could say she was my paternal grandmother, but I like the way they say it back home.

For sure the picture was taken in Philadelphia where my grandmother, like many other southern blacks, migrated in the forties in search of a better life.

And I believe it was taken in the 1100 block of Girard Avenue. On visits to my grandmother I remember seeing a studio there, where on the weekend a steady stream of southern migrants came, eager to have the

camera catch their likeness, to send home so everybody could see how well they were doing in the promised land.

Like most of the southern arrivals, my grandmother worked as a domestic when she first came to Philadelphia.

She hated it.

"I can't stand cleaning my own house, so you know I didn't want to clean nobody else's!"

So she worked as a domestic by day, and at night went to school to learn factory sewing, eventually getting the factory job she held until she retired in the sixties.

They say that children don't know that their lives or family circumstances are weird or different. To them that's what it is. I'm not sure that's always true. I knew straightaway my grandmother was different.

She just didn't or wouldn't do things the way everybody did, and it didn't seem to bother her. But it bothered almost everybody else. They had moved north to better themselves, and one of the first ways to do that was to get rid of those country ways, and Geechees were the *country-est* of all country people, the butt of numerous jokes. It was painful to be called "a bad-talking rice eater."

But Estella Smart wasn't about to get rid of nothing that was worth keeping. She continued to eat her rice every day, say "goober" for peanut, "kiver" for cover, "britches" for pants, and any other Geechee thing she wanted.

"They can ki-ki* this and ki-ki that about me as much as they please, I'll talk about them on my knees," she said.

"Hit'a sin and a shame."

"Going to the market with a homemade basket, instead of shopping bag like everybody else, up here."

"Ain't hit the truth!"

"Did you see what she was wearing?"

"Lord knows hit's a shame."

"She make 'em!"

"Think she is something! She ain't no better than nobody else."

* A Gullah word meaning "to gossip."

"There's was a way to act and that's all there is to it!"

It wasn't only the way she acted, it was her presence.

Langston Hughes must have had her in mind when he wrote, "There are people (you've probably noted it also) who have the unconscious faculty of making the world spin around themselves, throb and expand, contract and go dizzy...."

But magic is threatening and, for many, a little Estella Smart went a long way. Those who knew her when would always allow with a certain edge in their voice, "She always been like that."

Estella, or Telly, as she was called, was the youngest of eight children born to Sam and Rina Myers, in the Atlantic coastal city of Port Royal, South Carolina. Her parents were former slaves. She used to tell me, "Many days us shed tears of sorrow" when we talked about slavery time.

According to family legend, young Telly was "oomanish"—meaning she was sassy.

She married twenty-four-year-old Cleveland Smart, a wheelright, when she was fourteen. And as family legend has it, Mr. Smart had his hands full.

His independent and strong-willed bride didn't "act right." For one thing, she balked at working by the sun in the fields with her husband as most wives were expected to do, and did. Cleveland Smart went to see his father-in-law and asked him to do something with this peculiar-acting bride. But Sam Myers couldn't help him.

"Us never could do nuthin wid Telly, she just don't take no tea for the fever. Takes after her grandmama who she named for, and they couldn't do nuthin wid her either. Now if you don't want Telly bring her home. And anyhow we didn't name her to be no mule."

Cleveland Smart kept his bride and they had five children. Now, according to some more legend, Estella birthed all five by herself without a midwife. I don't know if it's true, but if you ever met Estella Smart you would believe it could be true.

There is a lot of mystery surrounding Cleveland Smart's life. They say he was a big black man. "A saltwater African" who was adopted. By whom, and from whom? They say the Smarts lived in the swamp in a house surrounded by a moat and that they had a safe in the house. Why?

Still I would love to see a photograph of Cleveland Smart. Legend is
he was a dreamer…. When Cleveland Smart dreamt something and
told you this and that was going to happen, it did!

When my mother was "that way" he had a dream and told her she
would have a girl and to name her Verta.

Well to make a very long story short, Mama did have a girl and a boy,
so it looked like Cleveland Smart's dream didn't come true. But the
baby boy died, and of course they named me Verta. Still I could never
understand why they did, because Gullah people pronounce v's like w's
and everybody called me "Werta."

I couldn't call Estella Smart "Grandmama," like I called my other
grandmother. I was to call her "Mother Dear," which came out sound-
ing like "Mudear." This was alright around other Geechees, but as I got
older and integrated with blacks from other places, I was, as they say,
"too shame to say it." But Estella Smart didn't have no shame around
"siddy" blacks or white folks. She was confident and self-assured
around everybody.

In 1970, when my first book came out, she came to the book party in
New York. A slightly drunk and very condescending white man came
up to her and said, "Haven't I met you before?"

"If you had met me you would have know it, cause when you meet
Estella Smart, you've been met!"

I think that is the quality I admire most about my grandmother, her
sense of self. Where did she get it? It certainly wasn't easy for an eccentric
Geechee woman with a second-grade education…. I asked her about it,
but she didn't think "sense of self" was something people could give you.

"Yes," I would say, "but it's not easy in these hard times." She would
look at me with her eyes the color of iced tea and say, "If colored people
didn't have hard times, they wouldn't have no times, so keep your eyes
on the prize and git on up and keep yourself to yourself."

I also admire the way Estella Smart took on the challenge of living in
Philadelphia, a woman apart from Carolina. She and the others who
came to the city from the country were real urban pioneers.

*

I have no idea how old my grandmother was at the time the photo-graph was taken. She always said, "A woman who will tell her age will tell anything."

I didn't discover her age until she died in 1985, a week before her hundredth birthday.

Now that I know her age, I think of what it must have been to go from cooking in a fireplace to a gas stove, from kerosene lamps to electric lights, and from driving a horse and buggy to driving a car. Unbe-knownst to the family, Estella Smart took driving lessons. I was in high school the day she asked us to come with her outside the house. We did and she stepped into the car and drove off.

Estella Smart was not an easy grandmother to have. She had little patience, and not the greatest sense of humor. Saturdays, when other children were going to the movies, I was at her house helping her clean and sew. I had to bring my own lunch because she didn't cook.

She never remembered birthdays and didn't give Christmas presents. But I was enchanted by her.

My favorite memories of Mudear are of the good times we had in Atlantic City.

She would take me to Atlantic City to "catch the sea breeze and bathe in the salt water, cause we come from saltwater people."

We didn't have money to rent a room, so we undressed on the beach.

Estella Smart looked normal until she peeled off her clothes down to the two-piece bathing suit made of cretonne-print upholstery fabric that she had made. Then she was a mermaid.

She would swim way out on her back. The lifeguards would blow their whistles. She kept on swimming.

The lifeguards would look scared, afraid they might have to swim out that far to get her. But they never did.

When they would blow the whistle, folks would crowd around as folks will and ask, "What happened?"

Once someone asked me, "Who is that woman out there?"

"That's no woman," I said, "That's Mudear riding the waves."

For a picture of that I would do the hucklebuck naked in Macy's window.

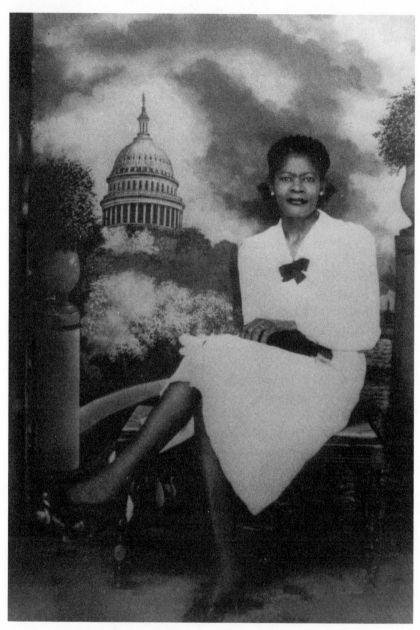

Edward P. Jones's Mother, Jeanette Satana Majors, N.D.
PHOTOGRAPHER: UNKNOWN (COURTESY EDWARD P. JONES)

A SUNDAY PORTRAIT

Edward P. Jones

THERE IS A SHORT STORY BY DELMORE SCHWARTZ CALLED "IN
Dreams Begin Responsibilities," wherein the unnamed narrator sits in a
1909 movie theater with other patrons, watching what starts out as a
pleasant Sunday of courtship by his mother and father, long before the
narrator even comes into being. The jerky black-and-white silent movie,
the Biograph Theater, the intrigued patrons—all of it is a mere dream,
the dream of the narrator, some twenty-one years hence; but the movie—
down to knowing what his father-to-be is thinking as he jingles the coins
in his pocket—is informed by a narrator who has lived those twenty-one
years with that man and that woman and knows all too well what will
happen in the years after the sun sets on that Brooklyn day of courtship.
At one point, just a second after the narrator's future father has asked the
narrator's future mother to marry him and she sobs that that is all she
ever wanted from "the first moment I saw you," the narrator stands in
the theater and shouts: "Don't do it! It's not too late to change your
minds, both of you. Nothing good will come of it, only remorse, hatred,
scandal, and two children whose characters are monstrous."

I have had no such cinematic dream, only a photograph of a grandly
beautiful dark woman sitting in a long-sleeved white dress with a black
bow just below the neck. She is wearing pearl-like earrings. There might
well be a ring on the third finger of her left hand, but then, too, it might
be the way the light is playing with the fingers of that hand. She holds
white gloves and a black purse in her lap and wears a knitted hat that I
believe my sister and I played with when we were children. My then-
unmarried mother, who would have been Jeanette Satana Majors in
that photograph, smiles complacently, as if only good and wonderful
things will come her way. And to see her sitting there, that precious face
on the verge of a smile, I am reminded all over again how that, in so
many ways, did not happen. My mother believed in dressing as well as
her money would allow, and so although I am as certain as I can ever be
that the photograph was taken on a Sunday, a day off, it would not have
been unusual for her to dress so well. The picture shows a cardboard

35

background of the Capitol Building in Washington, which is typical of photographs of poor blacks taken in the Washington photo shops of that era. But that Capitol background is the one thing that distinguishes it from the millions of pictures taken in other shops in other cities. For my mother was no different from thousands upon thousands of other poor blacks who, in the first decades of the twentieth century, left peasant parents and grandparents and a southern history that was born in chains to come to northern cities—to Detroit, to Chicago, to New York, to Baltimore, to Boston, to Washington—to those places where they hoped to claim as their own a bit more of the sun, where a person could work and walk with a more straightened back; places where white people would have less say about how the sun was doled out and about how far a person should bend her back when she picked tobacco or walked down a one-street, two-dog town.

In so many cases, they did not find in the North as much as God had promised them in their dreams. But what they did find, they wanted to document, since it was often so much more than what they had had "back home" in the South. And one way of documenting it was in photos. Black men and women, workers in the Detroit car plants, in the Chicago stockyards, in the mansions of Washington politicians, had pictures taken of themselves sitting on the hoods or in the driver's seats of cars they were still paying for, dressed in exquisite clothes they would not have minded being buried in. Some had their own cameras, but others, like my mother, visited photography shops. They all sent pictures "back home," back to relatives who stuck them in the frames of cracked mirrors or put them away in dresser drawers lest the strong light of the South fade the pictures and take away the magic; back to relatives who marveled over the changes in sons and daughters and cousins who only last year went about barefoot and in clothes three degrees from being rags.

My mother always wore a dark red shade of lipstick and that is surely the case in the photograph with the Capitol background, and that lipstick and those lips enhance a face that touches and haunts me like no other photograph I own. My mother's legs are crossed in the picture and people have told me that she must have been a tall woman. I cannot say; at seventeen I was as tall as she was, and that's all I know. If she was tall in the way the world means it, it was something I was not conscious of.

36

The first time I ever saw the photograph I was twenty-four years old and my mother had been dead and buried about a month. It was sent to me by my cousin, who had inherited it from her mother, neither of whom had ever lived outside North Carolina. Until seeing that picture, I had no idea that my mother had ever looked so majestic, and so young and innocent. It had never occurred to me that once upon a time she may have been a member of some group of well-dressed, well-coiffed young people walking down Sunday streets with their happy companions, sharing private jokes and strolling as if the rest of their lives would be nothing but Sunday afternoons in the spring. I suppose I always saw my mother as an okay-looking woman, even plain at times. A son, a man-child, is not always the best judge of the beauty or plainness of a woman who has no life for him beyond that of being his mother, perhaps sometimes an unfair mother who could answer no when he wanted a yes. I had never seen anything more than a hard-working mother, and that woman had no caring man in her life I could see take her hand and kiss the palm and then say to her face, a million times, that she is the only reason the sun rises for him each day. I suppose if forced to as a small child, I might well have said that there was a kind of attractiveness about her, an attractiveness that began to fade after years of slaving for herself and her children as a dishwasher and floor-scrubber, after being forced to place her beloved retarded son, her youngest, in an institution, after years in a relationship with a boy-friend who gave her no sustenance, after three strokes that froze the right side of her body, after lung cancer took final hold of her face and body and twisted her into the same lump of clay God must have seen the moment before he shaped and first breathed life into her.

Had I the power, had I power greater than that of the narrator in Schwartz's story, who merely dreams of his parents stepping off into a disastrous life, had I the power to go all the way back, I would have walked up that street and met that woman who was to become my mother. Touched her hand the second before she reached for the knob of the door of that photography shop, taken her hand and asked her to believe what I was about to say. My mother was always a gentle woman, kind beyond anything even God would ask of his creatures, and so I think, after some initial hesitation, she would have stepped away from the door and listened. This would have been in the late 1930s, perhaps,

or the early 1940s, a time old people now say they never had to lock their doors, a time before thugs with guns and knives roamed the street. And perhaps, too, she would have seen her own genes in my face, in my bearing, and that would have given her comfort.

Save yourself, I would have told her. Save us all. Do not marry him, I would have said of my father, dooming myself, my brother, my sister to some universe of never-to-be-born beings. And dooming, as well, my niece and nephews, who never kissed the hands of a grandmother who died before their births and who, as a mother, always shrank away from affection. Save yourself.... I would have wanted to tell her to go off and see as much of the world as she could, come back, and then go off and see it all over again. See so much of the world that you come to learn the hearts of men-people and what kind of heart will best be a companion for yours, for my father's heart would not be, my heart will not be, and the hearts of the men who come after him will not be either. I am haunted by the photograph of this lovely woman who could have done things, who, in a truly godly world, could have been a thousand different women; and more than all of that, I am haunted because I was not the best of sons and because, in the end, I fear that too much of what she saw of the world was the bottom of a soap-filled dirty pot.

Perhaps this woman in her white dress and black pumps, on her way to becoming my mother, might have allowed me to take her a few feet away from the door of the photography shop, for people would be going in and out, and she was not one to impede anyone's way. And maybe, after lighting up a Pall Mall to calm her nerves, she would have listened to more talk of the turmoil and unhappiness that awaited her when she stepped out of that Seventh Street photo shop with a receipt and a notice to pick up her photograph a week or so hence. But soon enough she would have asked me to stop. I know what that religious soul of hers would have begun to whisper: that I was the Devil, or a servant of the Devil, come dressed in the finest of clothes, as the Devil will do, the better to tempt her from that fateful path on which God had promised her that the light will always shine.

It could well be that the blame for the tragedy of my mother and father's marriage rests primarily with my mother. I cannot know. I never asked her. And my father—with whom I exchanged less than two thousand words in his lifetime—is dead as well, lying in a grave that

has no marker, symbolic of his failure to provide me and my sister with even simple and basic things, like a loaf of bread or a pair of shoes. I have seen his grave but once and do not think I will ever see it again. Nor do I have one single picture of my father. Whether any pictures of him exist or ever existed, I do not know. I never once asked my mother if she ever had any photos of him. There exist only a few of me, my sister, and brother as children. And there are even less of my mother; and most of those were taken after I was eighteen, so it is not so surprising that we had none of my father. The few times I visited the last place my father lived in before he died, the walls, the tables, the whole place was without pictures. I can count on both hands the number of times I have seen his face. I would know if I saw it someplace, but I cannot describe it. I sometimes think that as the coming years make judgments about what I should and should not remember, his face will be lost to me altogether. It matters, but not very much.

No, among the treasures I might give my life for are the photographs of my mother, including the last one taken of her, at George Washington University Hospital in 1974, taken on a day when, again, she was having radiation therapy. She is fifty-seven years old, thin, afraid, her gray hair in plaits, not done up in the grand way it is in the photograph with the cardboard Capitol in the background. Some careless hospital technician took the picture, perhaps the thousandth of the day. Although they cannot be seen in that picture, there are blue lines about her skeletal chest, drawn as a target for the technician shooting the radiation gun.

My mother comes out of the Seventh Street photo shop. I know that I cannot stop her from going off and marrying my father, and so I offer a feeble blessing and tell her to have a good life, though I have no power to guarantee it.

She died as she had lived, without very much peace, I think. Her grandchildren play in Brooklyn, where thugs roam the streets; I want them to have good lives, but I cannot guarantee that either. Before she goes on her way with her photo shop receipt, the woman who will become my mother wishes me a good life as well. She might have been surprised that I was still waiting there, and she hurries away, her shoes making confident sounds along the sidewalk. I call after her, knowing she can't hear me anymore: "If I do, I will do it in your name."

Perhaps she went off to a movie with the man who was to become my

father, to some wickedly syrupy movie that told them lies about their future together. Because I write—the consequence of some gene she, or he, passed down to me—I wish with all my being that she, on that Sunday— she who never learned to read or write a single word—had gone home from that Seventh Street photo shop to a room to sit out the afternoon writing in a dime-store notebook, or typing on a typewriter she'd bought dirt-cheap in a pawn shop. Writing as if her life depended upon it.

At the end of Delmore Schwartz's short story, the narrator, horrified by what he knows awaits his parents and their children, makes such a scene that the usher has to escort him out of the theater. The usher tells the narrator, "You will be sorry if you do not do what you should do. You can't carry on like this, it is not right, you will find that out soon enough, everything you do matters too much." Then the twenty-one-year-old narrator awakes to a morning that has already begun. My youngest nephew, too, talks to everyone as if he expects only good things to come from them; even now, at seven, he has a brave and kind soul; once upon a time, he would have saved his kingdom and been a dragon slayer. His brother is worldly in a way his grandmother and his uncle were too afraid to be. And so, too, is my niece; almost everything must be her way. The word *no*—with a dismissive gesture of her hand— comes as easily to her mouth as her own name.

I do not know if any of my mother's grandchildren will become writers. And I do not know how many more words I have in me—whether one or one million. If there are one million, I will do them all in her name. Write them as if the rest of her long, long life after that Sunday portrait depended upon it.... But almost twenty years after my mother died, the picture of that young woman full of promise haunts me. In some ways, I will be forever stuck there, on Seventh Street, at the door of that photo studio, forever trying to change for the good what did not happen to her after she took that train north and later went in to the shop. I will forever have to watch her go in and come out.... Sometimes, in a fanciful moment, after I have watched her walk out of my sight, I open the door of the shop. I sit on the same stool my mother-to-be has just sat on. Take my picture, I tell the photographer. Take my picture the same way you took that of the woman who came before me.

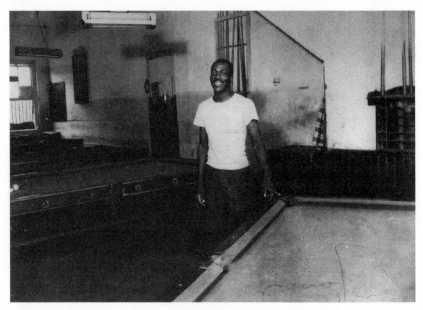

Veodis Watkins, 1949
PHOTOGRAPHER: UNKNOWN (COURTESY bell hooks)

IN OUR GLORY:

PHOTOGRAPHY AND BLACK LIFE

bell hooks

ALWAYS A DADDY'S GIRL. I WAS NOT SURPRISED THAT MY SISTER V. became a lesbian, or that her lovers were always white women. Her worship of daddy and her passion for whiteness appeared to affirm a movement away from black womanhood, and of course, that image of the woman we did not want to become—our mother. The only family photograph V. displays in her house is a picture of our dad, looking young with a mustache. His dark skin mingling with the shadows in the photograph. All of which is highlighted by the white T-shirt he wears.

In this snapshot he is standing by a pool table. The look on his face confident, seductive, cool—a look we rarely saw growing up. I have no idea who took the picture, only that it pleases me to imagine that he cared for them—deeply. There is such boldness, such fierce openness in the way he faces the camera. This snapshot was taken before marriage, before us, his seven children, before our presence in his life forced him to leave behind the carefree masculine identity this pose conveys.

The fact that my sister V. possesses this image of our dad, one that I had never seen before, merely affirms their romance, the bond between the two of them. They had the dreamed-about closeness between father and daughter, or so it seemed. Her possession of the snapshot confirms this, is an acknowledgment that she is allowed to know—yes, even to possess—that private life he had always kept to himself. When we were children, he refused to answer our questions about who he was, how did he act, what did he do and feel before us? It was as though he did not want to remember or share that part of himself, that remembering hurt. Standing before this snapshot, I come closer to the cold, distant, dark man who is my father, closer than I can ever come in real life. Not always able to love him there, I am sure I can love this version of him, the snapshot. I give it a title: *in his glory*.

Before leaving my sister's place, I plead with her to make a copy of this picture for my birthday. It does not come, even though she says she will. For Christmas, then. It's on the way. I surmise that my passion for

43

it surprises her, makes her hesitate. Always rivals in childhood—she winning, the possessor of Dad's affection—she wonders whether to give that up, whether she is ready to share. She hesitates to give me the man in the snapshot. After all, had he wanted me to see him this way, "in his glory," he would have given me a picture.

My younger sister G. calls. For Christmas, V. has sent her a "horrible photograph" of Dad. There is outrage in her voice as she says, "It's disgusting. He's not even wearing a shirt, just an old white undershirt." G. keeps repeating, "I don't know why she has sent this picture to me." She has no difficulty promising to give me her copy if mine does not arrive. Her lack of interest in the photograph saddens me. When she was the age our dad is in the picture she looked just like him. She had his beauty then—that same shine of glory and pride. Is this the face of herself that she has forgotten, does not want to be reminded of, because time has taken such glory away? Unable to fathom how she can not be drawn to this picture, I ponder what this image suggests to her that she cannot tolerate: a grown black man having a good time, playing a game, having a drink maybe, enjoying himself without the company of women.

Although my sisters and I look at this snapshot and see the same man, we do not see him in the same way. Our "reading" and experience of this image is shaped by our relationship to him, to the world of childhood and the images that make our life what it is now. I want to rescue and preserve this image of our father, not let it be forgotten. It allows me to understand him, provides a way for me to know him that makes it possible to love him again and against past all the other images, the ones that stand in the way of love.

Such is the power of the photograph, of the image, that it can give back and take away, that it can bind. This snapshot of Veodis Watkins, our father, sometimes called Ned or Leakey in his younger days, gives me a space for intimacy between the image and myself, between me and Dad. I am captivated, seduced by it, the way other images have caught and held me, embraced me like arms that would not let go.

Struggling in childhood with the image of myself as unworthy of love, I could not see myself beyond all the received images, which simply reinforced my sense of unworthiness. Those ways of seeing myself came from voices of authority. The place where I could see myself, beyond the

imposed image, was in the realm of the snapshot. I am most real to myself in snapshots—there I see an image I can love.

My favorite childhood snapshot then and now shows me in costume, masquerading. And long after it had disappeared I continued to long for it and to grieve. I loved this snapshot of myself because it was the only image available to me that gave me a sense of presence, of girlhood beauty and capacity for pleasure. It was an image of myself I could genuinely like. At that stage of my life I was crazy about Westerns, about cowboys and Indians. The camera captures me in my cowgirl outfit, white ruffled blouse, vest, fringed skirt, my one gun and my boots. In this image, I became all that I wanted to be in my imagination.

For a moment suspended in this image: I am a cowgirl. There is a look of heavenly joy on my face. I grew up needing this image, cherishing it—my one reminder that there was a precious little girl inside me able to know and express joy. I took this photograph with me on a visit to the house of my father's cousin, Schuyler.

His was a home where art and the image mattered. No wonder, then, that I wanted to share my "best" image. Making my first big journey away from home, from a small town to my first big city, I needed the security of this image. I packed it carefully. I wanted Lovie, cousin Schuyler's wife, to see me "in my glory." I remember giving her the snapshot for safekeeping; only, when it was time for me to return home it could not be found. This was for me a terrible loss, an irreconcilable grief. Gone was the image of myself I could love. Losing that snapshot, I lost the proof of my worthiness—that I had ever been a bright-eyed child capable of wonder, the proof that there was a "me of me."

The image in this snapshot has lingered in my mind's eye for years. It has lingered there to remind of the power of snapshots, of the image. As I slowly work on a book of essays titled *Art on My Mind*, I think about the place of art in black life, connections between the social construction of black identity, the impact of race and class, and the presence in black life of an inarticulate but ever-present visual aesthetic governing our relationship to images, to the process of image making. I return to the snapshot as a starting point to consider the place of the visual in black life—the importance of photography.

Cameras gave to black folks, irrespective of our class, a means by

which we could participate fully in the production of images. Hence it is essential that any theoretical discussion of the relationship of black life to the visual, to art making, make photography central. Access and mass appeal have historically made photography a powerful location for the construction of an oppositional black aesthetic. In the world before racial integration, there was a constant struggle on the part of black folks to create a counter-hegemonic world of images that would stand as visual resistance, challenging racist images. All colonized and subjugated people who, by way of resistance, create an oppositional subculture within the framework of domination, recognize that the field of representation (how we see ourselves, how others see us) is a site of ongoing struggle.

The history of black liberation movements in the United States could be characterized as a struggle over images as much as it has also been a struggle for rights, for equal access. To many reformist black civil rights activists, who believed that desegregation would offer the humanizing context that would challenge and change white supremacy, the issue of representation—control over images—was never as important as equal access. As time has progressed, and the face of white supremacy has not changed, reformist and radical blacks alike are more likely to agree that the field of representation remains a crucial realm of struggle, as important as the question of equal access, if not more so. Significantly, Roger Wilkins emphasizes this point in his recent essay "White Out" (published in the November 1992 issue of *Mother Jones*). Wilkins comments:

> In those innocent days, before desegregation had really been tried, before the New Frontier and the Great Society, many of us blacks had lovely, naïve hopes for integration.... In our naïveté, we believed that the power to segregate was the greatest power that had been wielded against us. It turned out that our expectations were wrong. The greatest power turned out to be what it had always been: the power to define reality where blacks are concerned and to manage perceptions and therefore arrange politics and culture to reinforce those definitions.

Though our politics differ, Wilkins' observations mirror my insistence, in the opening essay of *Black Looks: Race and Representation*, that black people have made few, if any, revolutionary interventions in the arena of representations.

In part, racial desegregation, equal access, offered a vision of racial progress that, however limited, led many black people to be less vigilant about the question of representation. Concurrently, contemporary commodification of blackness creates a market context wherein conventional, even stereotypical, modes of representing blackness may receive the greatest reward. This leads to a cultural context in which images that would subvert the status quo are harder to produce. There is no "perceived market" for them. Nor should it surprise us that the erosion of oppositional black subcultures (many of which have been destroyed in the desegregation process) has deprived us of those sites of radical resistance where we have had primary control over representation. Significantly, nationalist black freedom movements were often only concerned with questions of "good" and "bad" imagery and did not promote a more expansive cultural understanding of the *politics* of representation. Instead they promoted notions of essence and identity that ultimately restricted and confined black image production.

No wonder, then, that racial integration has created a crisis in black life, signaled by the utter loss of critical vigilance in the arena of image making—by our being stuck in endless debate over good and bad imagery. The aftermath of this crisis has been devastating in that it has led to a relinquishment of collective black interest in the production of images. Photography began to have less significance in black life as a means—private or public—by which an oppositional standpoint could be asserted, a mode of seeing different from that of the dominant culture. Everyday black folks began to see themselves as not having a major role to play in the production of images.

To reverse this trend we must begin to talk about the significance of black image production in daily life prior to racial integration. When we concentrate on photography, then, we make it possible to see the walls of photographs in black homes as a critical intervention, a disruption of white control of black images.

Most southern black folks grew up in a context where snapshots and the more stylized photographs taken by professional photographers were the easiest images to produce. Significantly, displaying those images in everyday life was as central as making them. The walls and walls of images in southern black homes were sites of resistance. They constituted private, black-owned and -operated, gallery space where

images could be displayed, shown to friends and strangers. These walls were a space where, in the midst of segregation, the hardship of apartheid, dehumanization could be countered. Images could be critically considered, subjects positioned according to individual desire.

Growing up inside these walls, many of us did not, at the time, regard them as important or valuable. Increasingly, as black folks live in a world so technologically advanced that it is possible for images to be produced and reproduced instantly, it is even harder for some of us to emotionally contextualize the significance of the camera in black life during the years of racial apartheid. The sites of contestation were not *out there*, in the world of white power, they were *within* segregated black life. Since no "white" galleries displayed images of black people created by black folks, spaces had to be made within diverse black communities. Across class, black folks struggled with the issue of representation. Significantly, issues of representation were linked with the issue of documentation, hence the importance of photography. The camera was the central instrument by which blacks could disprove representations of us created by white folks. The degrading images of blackness that emerged from racist white imaginations and circulated widely in the dominant culture (on salt shakers, cookie jars, pancake boxes) could be countered by "true-to-life" images. When the psychohistory of a people is marked by ongoing loss, when entire histories are denied, hidden, erased, documentation may become an obsession. The camera must have seemed a magical instrument to many of the displaced and marginalized groups trying to create new destinies in the Americas. More than any other image-making tool, it offered African Americans disempowered in white culture a way to empower ourselves through representation. For black folks, the camera provided a means to document a reality that could, if necessary, be packed, stored, moved from place to place. It was documentation that could be shared, passed around. And ultimately, these images, the worlds they recorded, could be hidden, to be discovered at another time. Had the camera been there when slavery ended, it could have provided images that would have helped folks searching for lost kin and loved ones. It would have been a powerful tool of cultural recovery. Half a century later, the generations of black folks emerging from such a history of loss became passionately obsessed with cameras. Elderly black people developed a cultural passion for the camera, for the images it

produced, because it offered a way to contain memories, to overcome loss, to keep history.

Though rarely articulated as such, the camera became in black life a political instrument, a way to resist misrepresentation as well as a means by which alternative images could be produced. Photography was more fascinating to masses of black folks than other forms of image making because it offered the possibility of immediate intervention, useful in the production of counter-hegemonic representations even as it was also an instrument of pleasure. Producing images with the camera allowed black folks to combine image making in resistance struggle with a pleasurable experience. Taking pictures was fun!

Growing up in the fifties, I was somewhat awed and frightened at times by our extended family's emphasis on picture taking. Whether it was the images of the dead as they lay serene, beautiful, and still in open caskets, or the endless portraits of newborns, every wall and corner of my grandparents' (and most everybody else's) home was lined with photographs. When I was younger I never linked this obsession with images of self-representation to our history as a domestically colonized and subjugated people.

My perspective on picture taking was more informed by the way the process was tied to patriarchy in our household. Our father was definitely the "picture takin' man." For a long time cameras were both mysterious and off-limits for the rest of us. As the only one in the family who had access to the equipment, who could learn how to make the process work, he exerted control over our image. In charge of capturing our family history with the camera, he called and took the shots. We constantly were lined up for picture taking, and it was years before our household could experience this as an enjoyable activity, before anyone else could be behind the camera. Before then, picture taking was serious business. I hated it. I hated posing. I hated cameras. I hated the images they produced. When I stopped living at home, I refused to be captured by anyone's camera. I did not long to document my life, the changes, the presence of different places, people, and so on. I wanted to leave no trace. I wanted there to be no walls in my life that would, like gigantic maps, chart my journey. I wanted to stand outside history.

That was twenty years ago. Now that I am passionately involved with thinking critically about black people and representation, I can confess

that those walls of photographs empowered me, and that I feel their absence in my life. Right now, I long for those walls, those curatorial spaces in the home that express our will to make and display images.

Sarah Oldham, my mother's mother, was a keeper of walls. Throughout our childhood, visits to her house were like trips to a gallery or museum—experiences we did not have because of racial segregation. We would stand before the walls of images and learn the importance of the arrangement, why a certain photo was placed here and not there. The walls were fundamentally different from photo albums. Rather than shutting images away, where they could be seen only by request, the walls were a public announcement of the primacy of the image, the joy of image making. To enter black homes in my childhood was to enter a world that valued the visual, that asserted our collective will to participate in a noninstitutionalized curatorial process.

For black folks constructing our identities within the culture of apartheid, these walls were essential to the process of decolonization. Contrary to colonizing socialization, internalized racism, they announced our visual complexity. We saw ourselves represented in these images not as caricatures, cartoon-like figures; we were there in full diversity of body, being, and expression, multidimensional. Reflecting the way black folks looked at themselves in those private spaces, where those ways of looking were not being overseen by a white colonizing eye, a white supremacist gaze, these images created ruptures in our experience of the visual. They challenged both white perceptions of blackness and that realm of black-produced image making that reflected internalized racism. Many of these images demanded that we look at ourselves with new eyes, that we create oppositional standards of evaluation. As we looked at black skin in snapshots, the techniques for lightening skin which professional photographers often used when shooting black images were suddenly exposed as a colonizing aesthetic. Photographs taken in everyday life, snapshots in particular, rebelled against all of those photographic practices that reinscribed colonial ways of looking and capturing the images of the black "other." Shot spontaneously, without any notion of remaking black bodies in the image of whiteness, snapshots posed a challenge to black viewers. Unlike photographs constructed so that black images would appear as the embodiment of colonizing fantasies, these snapshots gave us a way

to see ourselves, a sense of how we looked when we were not "wearing the mask," when we were not attempting to perfect the image for a white supremacist gaze.

Although most black folks did not articulate a desire to look at images of themselves that did not resemble or please white folks' ideas about us, or that did not frame us within an image of racial hierarchies, that need was expressed through our passionate engagement with informal photographic practices. Creating pictorial genealogies was the means by which one could ensure against the losses of the past. They were a way to sustain ties. As children, we learned who our ancestors were by endless narratives told to us as we stood in front of pictures.

In many black homes, photographs—particularly snapshots—were also central to the creation of "altars." These commemorative places paid homage to absent loved ones. Snapshots or professional portraits were placed in specific settings so that a relationship with the dead could be continued. Poignantly describing this use of the image in her most recent novel, *Jazz*, Toni Morrison writes:

> …a dead girl's face has become a necessary thing for their nights. They each take turns to throw off the bedcovers, rise up from the sagging mattress and tiptoe over cold linoleum into the parlor to gaze at what seems like the only living presence in the house: the photograph of a bold, unsmiling girl staring from the mantelpiece. If the tiptoer is Joe Trace, driven by loneliness from his wife's side, then the face stares at him without hope or regret and it is the absence of accusation that wakes him from his sleep hungry for her company. No finger points. Her lips don't turn down in judgement. Her face is calm, generous and sweet. But if the tiptoer is Violet the photograph is not that at all. The girl's face looks greedy, haughty and very lazy. The cream-at-the-top-of-the-milkpail face of someone who will never work for anything, someone who picks up things lying on other people's dressers and is not embarrassed when found out. It is the face of a sneak who glides over to your sink to rinse the fork you have laid by your place. An inward face—whatever it sees is its own self. You are there, it says, because I am looking at you.

I quote this passage at length because it describes the kind of relationship to photographic images that has not been acknowledged in critical discussions of black folks' relationship to the visual. When I first read these sentences I was reminded of the passionate way we related to photographs when I was a child. Fictively dramatizing the way a photograph can have a "living presence," Morrison offers a description that mirrors the way many black folks rooted in southern traditions used, and use, pictures. They were and remain a mediation between the living and the dead.

To create a palimpsest of black folks' relation to the visual in segregated black life, we need to follow each trace, not fall into the trap of thinking that if something was not openly discussed, or if talked about and not recorded, that it lacks significance and meaning. Those pictorial genealogies that Sarah Oldham, my mother's mother, constructed on her walls were essential to our sense of self and identity as a family. They provided a necessary narrative, a way for us to enter history without words. When words entered, they did so in order to make the images live. Many older black folks who cherished pictures were not literate. The images were crucial documentation, there to sustain and affirm oral memory. This was especially true for my grandmother, who did not read or write. I focus especially on her walls because I know that, as an artist (she was an excellent quiltmaker), she positioned the photos with the same care that she laid out her quilts.

The walls of pictures were indeed maps guiding us through diverse journeys. Seeking to recover strands of oppositional worldviews that were a part of black folks' historical relationship to the visual, to the process of image making, many black folks are once again looking to photography to make the connection. Contemporary African American artist Emma Amos also maps our journeys when she mixes photographs with painting to make connections between past and present. Amos uses snapshots inherited from an elder uncle who took pictures for a living. In one piece, Amos paints a map of the United States and identifies diasporic African presences as well as particular Native American communities with black kin, using a family image to mark each spot.

Drawing from the past, from those walls of images I grew up with, I gather snapshots and lay them out, to see what narratives the images tell, what they say without words. I search these images to see if there

are imprints waiting to be seen, recognized, and read. Together, a black male friend and I lay out the snapshots of his boyhood, to see when he began to lose a certain openness, to discern at what age he began to shut down, to close himself away. Through these images, he hopes to find a way back to the self he once was. We are awed by what our snapshots reveal, what they enable us to remember.

The word *remember* (*re-member*) evokes the coming together of severed parts, fragments becoming a whole. Photography has been, and is, central to that aspect of decolonization that calls us back to the past and offers a way to reclaim and renew life-affirming bonds. Using these images, we connect ourselves to a recuperative, redemptive memory that enables us to construct radical identities, images of ourselves that transcend the limits of the colonizing eye.

E. Ethelbert Miller, c. 1950s

IN MY FATHER'S HOUSE
THERE WERE NO IMAGES

E. Ethelbert Miller

It is very quiet. I think about this monastery that I am in. I think about the monks, my brothers, my fathers.

— THOMAS MERTON

MY FATHER, EGBERTO MILLER, SAVED PENNIES. IN HIS CLOSET there was a large jar filled to the top. He would keep it hidden, covering it with hats, sometimes with a towel. One day the jar disappeared. When my father died he was cremated, much to the surprise of his relatives and friends. How many black people are cremated every year? I remember the soft mumbling of shock at his funeral when everyone was waiting to go to the cemetery and a man said my father was going to be taken somewhere to be cremated and the next morning he would be taken to the cemetery to be buried. I remember, too, standing on a small hill outside New York, maybe somewhere near Yonkers, a place where I had come once before, only a few years earlier, and stood there weeping as my brother Richard was laid to rest. He was the same age I am today, and I think of how they placed this small box next to his grave. A box that contained all that was left of my father. A small box not much bigger than the jar of pennies he kept in his closet. The same jar that one day disappeared.

In my father's house there were no images. All the walls were painted white. My mother took pride in these white walls. On Saturdays she would find places to scrub, places where hands left marks, not fingerprints but marks. Smudges, maybe a place where you rested your head over the couch. A grease spot on a white wall.

My mother's father, Edgerton Marshall, was born in Barbados. He was the first old man that I knew. When I was young, he was old. He never aged. He was simply old and very strict. Even my mother was afraid of him, and I often wondered if he was not the one who made the rules about the walls. Perhaps it was linked to West Indian success in America. You came to this place, this country, and you worked hard and you saved your

money and you got an apartment, and you saved some more and finally you had a house, a brownstone in Brooklyn, and the walls were white, very white. Maybe my father was saving his pennies to buy a house.

It was my mother who reminded me that my father was once a photographer. I was too young to remember that moment in his life. I do recall seeing numerous pictures of me taken when I was a child. There I am crawling across a rug naked, a big smile on my face, maybe laughing at my father. Why were there so many pictures taken at the Bronx zoo? Was the rest of the world segregated? When you are the baby of the family, seldom do you know what is going on around you. No one answers your questions. And if they do, they talk in riddles and you don't unlock the clues until you're in therapy or reaching middle age.

They say he had a darkroom in the bathroom when we lived at 938 Longwood Avenue in the Bronx. He would develop his pictures in the dark, mixing chemicals, the way my mother prepared meals. My sister told me that my father would take pictures around the house and neighborhood. No one seems to know who taught him photography, or why he suddenly stopped. It's still a mystery even to those members of the family who are older than I am.

A black man with a camera in the 1940s, was that a threat? Did my father ever get stopped for carrying a camera or taking a picture? Why did he mainly take pictures of his family? Never a friend or neighbor. And, according to my sister and mother, he never liked to display his work in the house. There were no images in our house.

It was not always that way. There was one photograph that once hung in the living room. It was a large, handsome picture of my father taken when he was in his twenties. My father was dressed like a man who could break a woman's heart. It is difficult to imagine this person married, a father, raising children. "Prettyboy" or "fine nigger" is how one might describe my father in this photograph. I never saw the picture on the wall. When I was growing up it was kept in the back of a closet, covered with an old sheet.

My father took a picture of his children sitting on the sofa in front of his photograph. I have seen many pictures of this kind. They are taken in countries that have revolutions and political prisoners. The featured photograph is often one of the missing or deceased. Or maybe it is of the grandfather, the senior patriarch who lived in the Old Country. My

father was born in Panama and came to America when he was a small boy. His own father did not make the trip, so my roots in this country start with my father.

Photographs remind us of who we are, our ties to people and places. It is my understanding today that my father was looking for something in the dark. A way of creating a past, or maybe even a family. There in front of his own eyes he would give birth to images.

The Picture of Dorian Gray was one of my brother's favorite movies. He also kept a copy of the book, by Oscar Wilde, in his personal library. I think of this movie and the one picture of my father hanging in the house. This one image—suddenly the picture is removed and hidden in a closet. Why? Did my father dislike the fact that he was growing old? Did his own image haunt him, reminding him of the time he was single and could turn and walk out the door? In the aftermath of family arguments, my father would retire to his bedroom, cursing, talking to himself. At times he would talk about how he could have left, like so many others, gone, disappeared.

It is about five o'clock in the morning. I must be thirteen or fourteen. The place is 665 Westchester Avenue, the St. Mary's Projects in the South Bronx. This is my second home after moving from Longwood Avenue. It is as close to the middle class as my family will ever get. We live on the seventeenth floor and can see La Guardia Airport. I share one of the bedrooms with my older brother, Richard. He is praying as I lie in my bed. My brother has constructed a small altar in the room. A large wooden cross with Jesus hangs on one of the white walls. Two candles are burning, the light serving as an escort to the sunlight that will soon come through the window. I can hear Richard speaking softly in Latin, the other language he speaks fluently. Richard is Catholic and I am Protestant. Several years later I will call him from Washington, while working on a research paper in college, and ask him if becoming Catholic created any problems or tension in our family. I wanted to know because I was planning to become a Muslim. In our telephone conversation, my brother informed me that our father was Catholic. This surprised me as much as if I had learned that I was adopted. My father was a quiet man. He was also a very funny guy. When he was happy and

in a joyful mood, I felt our home was the best place in the world. Yet what he was thinking, and how he saw the world remains a mystery.

Everyone thinks he can be a photographer; all you need is a camera. What is often overlooked is that photography is a way of looking at the world. Why does a person stop and take a picture? Why do we pose when someone points a camera? How often do we look at a picture we have taken and see something we did not see at the time? When does a photograph become memory? What does it mean to look at a picture and not recall who it is standing with their arm around your shoulders? Why do we throw pictures away? Cut or tear them in a fit of rage? Why do we always want a photograph of our beloved? Why place a photo in a wallet, or hang one on a wall?

My father is looking in a mirror, staring at his face. He cannot explain the strange spots that are beginning to appear. My mother has an opinion on everything. I remember once arguing in the kitchen that the sun did not revolve around the earth. Explaining this concept went against what she saw when she went outside. How do you tell a black woman who works hard in the garment industry, sewing until her eyes can no longer see, that the earth is spinning? My mother was the first person I ever saw collapse. She was standing in the living room and fell into a heap. There was no handsome man around to catch her. I started running around the house, excited; my mother had fainted like a movie star. My father and brother rushed into the room and came to her assistance. I was told to hush, to be quiet, to get out of the way. The look on my father's face was one I had never seen. Years later I would sit in the back of a black limousine, the car slowly departing from the cemetery where my brother was laid to rest. On my father's face a quiet grief, fear, loss, a sadness catching a second wind. There is no need to take a picture of this, I will take this moment, this memory, to my own grave.

They say the Bronx was once beautiful. A place where one could go to escape from Manhattan. I love the names, Morris, Tremont, Fordham, Boston Road, White Plains, Van Courtland, Hunts Point, Jerome Avenue, Beck and Kelly streets. These are the neighborhoods I remember. Everyone who was related to me seemed to lived somewhere else. Brooklyn. I hated the long car rides, or, worse, the subway trips on Saturday for piano lessons.

We always had a piano in the house. Everyone knew how to play,

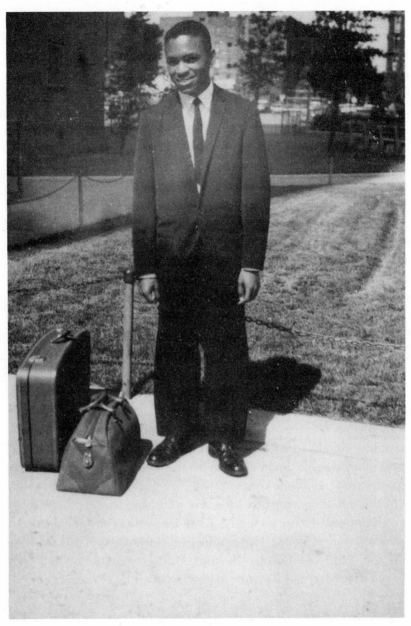

Richard Miller, c. 1960s

although my brother was the only one who really excelled and filled the apartment with Bach, Chopin, Brahms, Beethoven, Handel, and Mozart. My father could not read music but could play jazz. That was the sound he grew up with, the sound that led him to the Savoy, where he would ask my mother to dance. What was the name of the song that my mother and father first danced to? What did she think of this man who dressed so well, who was so handsome he could take your breath away? Did she faint?

In 1980, my mother and father moved into 40 Harrison Street, in Manhattan, near Chambers Street; in the distance, Wall Street, and there, in the Hudson River, the Statue of Liberty. I was thirty when I walked down the corridor of the seventeenth floor to their one-bedroom apartment. This was now my parent's home, a place where no kids would grow up; this was where my parents would grow old together. Leaving the Bronx was a major move for them. They had to give away furniture and other items that could not fit into the new space. Their living room remained much the same. The sofa and couches, which must have been wedding gifts or the first acquisitions of newlyweds, were fixed and given new upholstery. On the piano, and also on their bedroom dresser, they placed photographs of their children, Richard and Marie. There was no picture of me.

My brother told me once that I had escaped. By leaving the city and attending college in Washington, I had moved beyond the reach and grasp of my parents. I now came to see them on holidays or when I had a poetry reading in New York.

In this small apartment with white walls, my parents' hair slowly turned gray. My father grew a beard and was always asking me for an opinion on how it looked. He resembled an elder, maybe a jazz musician who could still tour Europe. He moved like Dexter Gordon in his last years. I wanted to take a picture of him but never had the opportunity.

My father's funeral was at the Benta Funeral Home in Harlem. The same place where people had come to pay their respect to Langston Hughes. My sister and I went to check on the arrangements. My father looked so young in his coffin that someone at the funeral home extended consolation to my sister for losing her husband.

After the funeral, my mother, while cleaning the house, came across the picture my father had taken of his three children sitting on a sofa in front of his photograph. My mother cropped the photograph so that it would fit in her wallet. She was not aware that she left an empty space above the heads of her children—a blues space, or a place for one's heart or memory.

In many African American households there is a dark, empty space where a man or father once was. Black holes sucking us in and out. Where do we go? What do we leave behind? There are too many homes with no images. As I struggle with my own marriage, I begin to understand what my father was doing in the dark, on Longwood Avenue in the Bronx. The idea of family is both real and abstract. At times it is a small head falling asleep on your chest, a grin or smile with chocolate candy dripping from the sides. It is also the desire to be held, to find someone in a crowd after searching everywhere. The family is an image we seek so desperately. My father was looking for it in the dark, finding it in photographs but afraid to frame it. There are so many stories I could tell about my family if only I knew them. In the dark, so many secrets can be kept, so many things can disappear.

I like to think of my brother and me as two candles burning, giving light and warmth to each other. It was my brother who confessed over the phone one night that he felt so alone in the world. In so many ways he sounded like my father, a man reduced to saving pennies.

PART II:

REFLECTING COLOR

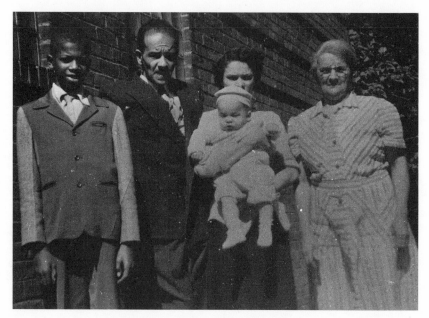

Mildred Paige and Children, N.D.

GAZING COLORED: A FAMILY ALBUM

Christian Walker

The blacker the berry the sweeter the juice,
but when they get that black they ain't no use

—CHILDHOOD RHYME

There seems to be some tension as a result of the lighter com-
plexioned women I dated and the woman I choose to be my
chief executive, my preferring individuals of the lighter com-
plexion.

—CLARENCE THOMAS

LINED UP, AS IF BY RANK, AN ILLUSIONARY VALUE OF WORTH, the darkest to the lightest, the youngest closest to the old. The light-skinned, near-white baby appeared, at least in 1954, to be a promise ful-filled. At least for the old lady in the photograph, my great-grandmother, Mildred Paige. The baby was the prized result of my family's assimilation by the process of miscegenation. Baby Jimmy reappears a year later, in a photograph taken at my first birthday party, looking conspicuous and disconnected, like a newly met neighborhood kid making his first cautious visit to the home of the colored family on the block.

It was he, along with his sister, who became the only relatives of my generation to totally and completely "integrate" themselves outside the boundaries of race, and that fact seemed to keep my family mired in endless battles over "racial heritage." In the late 1960s, these two cousins of mine crossed what Du Bois called "the most important line of the twentieth century"—the color line—to become, in their minds and in the minds and hearts of scornful and envious relatives, white people.

As a child, I cherished looking through the family album. Older relatives would act as guides, identifying the estranged cousin or renegade uncle who had moved to another place to become another person. Uncles and aunts, as if on cue, would comment on nuances of color and the quality of hair texture of Mildred Paige and five of her six children (ignoring Ralph), comparing their features, their racial physicality, to those of the relatives now passing for white. We kept our family

65

discussions on the merits of race (as opposed to our discussions on the injustices of race) focused on light-colored eyes and thin lips.

Their recollections, coupled with the photographs, appeared as firm evidence to support intricate rumors spanning four generations. There were whisperings about my great-grandmother's two common-law husbands, one black, one white. There were photographs of my Uncle Joe, his white wife, and their son Butch, who had gone to jail for "hanging around too many white people," half sentences about my mother's first marriage to a white jazz musician and hidden debates about the exact paternity of her fair-skinned brother and sister. It was in looking at family photographs that I first developed a "critical eye" for the nuances of race and especially color, for distinguishing certain racial characteristics as "more black" or "more white."

Yet for me, a brown-skinned child, the most resonant photographs were of Ralph. He was the youngest, and the one child of Mildred Paige who had the most visible African ancestry. In most pictures, made at family gatherings, he stands farthest from his mother. It was he who held, in my imagination, the power to explode the real or imagined myths of my family's couplings with the Irish, the Italians, the Cherokees, the Jews, the Cubans. Ralph, in his blackness, was the pivotal element in our collective family consciousness.

Unlike the near-white cousins, who defined our aesthetic sense of the desirable and the ideal for a person of color, Ralph's presence was at the core of our schism over our sense of marginalization and our estrangement from the newly "white" members of the family. Our identity, like theirs, was not informed by ethnicity or affectional ties, but by an elaborate system of representation based on white subjectivity and racial stereotypes. In essence, we were a family that thought the offspring with the bluest, grayest, or greenest eyes were not only the best looking but also the most likely to succeed.

In every African American family album there is an image that points to what James Baldwin has identified as the "Negro's past of rope, fire, humiliation, castration, and death." It is in those aging and fading pictures of relatives, living and dead, that one finds the underlying nature of self-actualization and its antecedent, the internalization of oppression. In my family album the most joyous photographs were of those relatives who seemed to have survived the subjugations of race, color, and class. Yet

for me, the images that held the most dramatic power were those of relatives who had chosen to live and love primarily in a white social context and who were subsequently plagued by breakdowns and dysfunctions.

In my family's ever-changing interpretation of the photographs, these pictures became infused by a value system that could not be contained within the narrative we assigned each individual image. We embellished each compliment on how pretty the light-skinned cousin was with how crazy or promiscuous she was, until our family pictures became identical to those mass-marketed images produced for general entertainment, and which ultimately function as the official history. We saw in the cousins the same qualities contained in the personality of Peola, the light-skinned girl in *Imitation of Life,* who rejects her mother to become white. For us, *Pinky* and *Sapphire* and *Kings Go Forth,* films where the central character struggles with racial identity, functioned as an authoritative chronicle. We valued these works, as one would value, say, a visual archive that is disputed but never challenged in its assumptions and conclusions about racial madness and interracial sexuality. Our gaze was always external. Some of us considered the family flawed, weak. We were unable to conceive why sane and careful individuals would willingly subject themselves to a cultural test that would define their degrees of blackness, and we wondered how an intelligent relative could have a fondness, an attraction, for white people.

bell hooks has called for the "necessity for black people to decolonize our minds." A rudimentary form of this process began for me in early adolescence, when I attempted a critical (as opposed to emotional) response to the family photographs—images of abandonment—that terrorized me. I seemed to lose my understanding of victimization and began to view acts of racial hysteria, both by African Americans and by whites, as logical choices. Murders, lynchings, the violent reactionary tactics of racism, defined my concepts of racial interaction; if you "hung around too many white people," you'd get hurt, jailed, or killed.

In my imagings of black/white sexuality, my family pictures seemed almost interchangeable with the erotic images of black men with white women and black women with white men that adorned the covers of the popular racial fiction of the day. The texts and images of white writers and illustrators provided the subtext for my family's fragmented sexual history. I suspected that the central reason for the rejection by my light-

skinned relatives of the constructs of racial identity could be found in the pages of novels like *Mandingo* and *Drum*. On the covers, and in their pages, white people appeared vicious but passionate, and black people were their rational, half-willing victims. I felt little rage or anger for the circumstances of their powerlessness. Instead, I developed a profound fascination and a dangerous fear of white people—all in keeping with family tradition.

Much has been written on the nature of photographs, their ability to function as both "mirrors" and "windows" in which the viewer projects his or her own sense of reality or truth. In the early 1960s, at the dawn of the principal battles for desegregation, documentary photographs (rather than family pictures, Hollywood movies, or paperback novels) became central to my formation of identity and suggested, for me, the boundaries that denied African Americans full participation in this democratic culture. It was not to images of racial solidarity that I was drawn—the march on Washington, the linked black and white arms. It was the photographs depicting confusion, chaos, and, ultimately, death that fascinated me. The first images from outside the family album that I thought to be accurate representations of myself were in the newspaper and magazine photographs of four black girls in their lacy Sunday dresses, killed in the bombing of an Alabama church; images of growling dogs and lethal jets of water directed at the bodies of children my age and younger codified my relationship to the dominant culture. I understood perfectly when a friend told me that after seeing the photographs of Emmett Till's battered and bloated body, he refused to visit his cousins living in the South.

It has been suggested that the horrific photographs of the direct-action era of the civil rights struggles in the United States "altered the consciousness of the nation" and helped direct the metamorphosis from a civil rights agenda to a human rights agenda that could, conceivably, embrace diversity. Yet these photographs also signified something quite different: that the outdated category of "Negro" was, as Michael Rustin said of race, "both an empty category and one of the most destructive and powerful forms of social categorization." A racial identity forged against the dangers of the "color line" seems a fragile and tenuous foundation for self-reliance and self-respect, the two most prominent defining principles of African American subjectivity.

It was in viewing the photographs of the political and cultural upheavals of the late 1960s—the stirring of contemporary Afrocentrism—that I first grappled with the notion that the essential nature of African American resistance is to reclaim a collective historical identity: the first line of defense against a legacy of cultural annihilation. In seeing the photographs of the raised arm and clenched fist of black Olympic gold medal winners in Mexico City in 1968, I first glimpsed the expansiveness of ethnicity. My racial identity became politicized. I saw myself as Huey Newton in his black leather jacket holding a rifle. I began to view race in a manner that Manning Marable has suggested "is essentially passive, a reality of being within a social formation stratified by the oppressive concept of race." I began to understand that beneath the portraits of the relatives who had abandoned the family was a strategy. Instead of dealing with their rupture between being "colored" or "white" or "negro" or "ethnic," they had chosen to flee. In their simple, elegant, and erroneous flight, they had elected, because of light skin, to disregard the joys and ravages of "decolonizing the mind."

Before the onslaught of images of the atrocities against blacks during the civil rights struggle, African Americans most often functioned as an invisible, carefully hidden obsession in the twentieth-century cultural consciousness, the separate-but-not-quite-equal other. The occasional public photograph of the "coloreds" (a term we used in my family to distinguish the lighter-skinned relatives) was deemed appropriate enough to contain all the distinctions of color, class, and gender that formed the foundations for the community's diverse nature.

Ironically it is the dichotomy between African American family photographs and the media's image of 1960s activist struggle that has provided the basis for the contemporary discourse on racial identity, the politics of visual representation, and the dismantling of the myth of a monolithic African American community in which all members share the same aspirations, the same political agenda, and the same sexuality.

Yet lately, anyone concerned with racial or sexual representation is tempted to flee the dominant culture's current fascination with the African American body. As Toni Morrison has pointed out, "a reference to a black person's body is de rigueur in white discourse." Two broad categories of visual representation of black identity seem to dominate in the contemporary news and entertainment media, the art galleries and

the museums: images of the elite group of African American achievers who have seemingly escaped marginalization, and, more importantly, images of racial isolation, disintegration, and genocide—the daily feast of photographs of crack dealers, crack mothers, and crack babies.

At a time when the African American visual image has never been more prominent, more commodified, it is crucial to question the ways that racial identity is informed through both public and private photographs: the transformation of a pop star from black child into a kind of Creole Frankenstein; the charting of the weight loss and gains of a talk-show host; the nationally televised "trial" of a conservative African American man's alleged sexual abuse of an equally conservative African American woman; the sexually radical photographs of a Miss America; a coffee-table book of images of naked, sexualized African American men; the image of a sports hero infected with HIV; the video-taped beating of an African American man by the white police; photographs of entire neighborhoods held hostage by drug-dealing teenagers; the internationally televised burning of a city by its minority citizens.

When African Americans glimpse into the "mirror" or "window" of photography, into public or private images, it is vital to acknowledge that what we are may not be the same as what we see. The reconciliation of the dual nature of contemporary racial identity, the acceptance of a racial consciousness that may view the exterior world from a position of both victimization and power, becoming what Deborah Willis calls "contemporary race men and women," might begin when one rejects a visual representation of self that has been germinated in the gaze of the other.

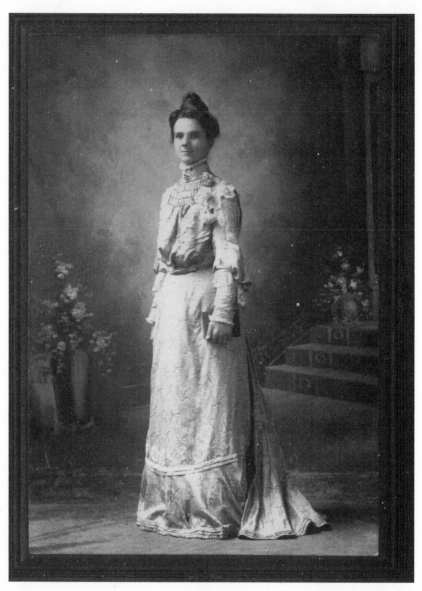

Adella, 1888

PHOTOGRAPHER: UNKNOWN (COURTESY ADELE LOGAN ALEXANDER)

GRANDMOTHER'S FACE
AND THE LEGACY OF POMEGRANATE HALL

Adele Logan Alexander

CAN ONE PHOTOGRAPH OR EVEN SEVERAL OF THEM REALLY ALTER THE course of one's life? I know that my life was changed in many ways by some photographs, and the very first image that precipitated those changes was, probably, that of Adella Hunt Logan's face. Adella was my never-known paternal grandmother, and I, her only granddaughter, had been named for her.

She had died ("tragically," older family members and friends whispered with some embarrassment and obvious pain, meaning that she had committed suicide) when my father, Arthur, was only six years old. She had been forty-seven when he, the last of nine children, was born, following a very difficult pregnancy. During the autumn of 1915, when she jumped to her death from a fourth-floor window of a classroom building at the famous Tuskegee Institute, her health had been failing; she was experiencing an exceptionally debilitating menopause; her many children sometimes seemed an unbearable load; woman's suffrage—her great passion—had suffered yet another political defeat; Booker T. Washington, probably black America's greatest hero and Adella's next-door neighbor and long-time friend, had just died; and then, on top of all that, local gossip maliciously hinted that her husband had been out philandering with a much younger woman. No wonder she had become so desperately depressed.

I was, I expect, no older than six myself when I first saw her picture, not in a family album, but rather, in a scholarly study concerning— of all things—physical anthropology. I could barely read or understand the text at the time, but I could make out both the name (the same as my own) beneath the picture and the arcane designation: "$1/8$ N $1/8$ I $6/8$ W." These mysterious ciphers, I later learned, were not cryptic musical notations indicating, perhaps, some bizarre mazurka; rather, they signified—with weighty, pseudo-scientific authority— Adella's purported racial makeup: "one-eighth Negro, one-eighth Indian, six-eighths White."

The photograph itself—perhaps a school picture—showed a very young Adella, her face serious, smooth, and still blessedly untroubled. Because I was her namesake, I cared for her and felt strong bonds of kinship with her right from the start. Many years later I found another image of Adella, which then supplanted the earlier one and became my favorite. It is her wedding picture, taken at an Atlanta studio in 1888. She stands, her expression a serene half-smile, regal and erect in her draped, flower-sprigged ivory silk dress with its short train. Like some late-Victorian Aphrodite, her long dark hair is mounded voluptuously atop her head. That day she clutched a Bible in her newly ringed left hand.

On the same page where I first found Adella, another photograph appears directly above hers. That image was identified as her mother, Mariah Hunt, but the name was spelled without the final "h"—which I only learned about years later when I also discovered that she and others always pronounced it "Mar-*eye*-ah." From information that I have since gathered about my great-grandmother Mariah, I would guess that her picture was taken about 1880. Mariah Hunt looks like one tough cookie in that photograph. She was, nonetheless, a rather handsome woman who wore her straight black hair severely pulled back from her face. Her skin seems very pale, her nose is narrow, lips thin, and her cheekbones quite pronounced. Her ears protrude just a bit too far. Although it may evoke uncalled-for echoes of *The Last of the Mohicans*, her eyes may best be described as "piercing." "One-quarter Indian," the book suggests just below Mariah's picture. I could certainly buy that. She had dressed herself for the photographer that day in an unrelieved black shirtwaist dress, buttoned up almost to her chin. Could she have been in mourning at the time? No jewelry adorned her dress, no hint of rouge brightened her cheeks, no warm smile, no soft edges on my Mariah.

Adella and Mariah's photographs appear on the upper-right-hand side of F10-Plate 38—a page reference that I still cannot fathom—in the (ponderously titled) book *A Study of Some Negro-White Families in the United States*. "Copyright 1932," states the fly sheet, "by the President and Fellows of Harvard College.... Reprinted from VARIA AFRICANA V, HARVARD AFRICAN STUDIES. VOLUME X, PART II." The study had been published by Harvard University Press in conjunction with the school's Peabody Museum of Anthropology. My mother's much older

half-sister, Caroline Bond Day, had researched and written that weighty tome, which evolved from her master's thesis (1932) in the department of anthropology at Radcliffe College, where she had worked under the tutelage of Harvard's renowned scholar Dr. Earnest A. Hooton. I have heard that she was the first African American to receive an advanced degree in anthropology anywhere in the country. When I was older and reread Hooton's ponderous and rather condescending foreword to my Aunt Carrie's book, I remember laughing because I found it such a thoroughgoing verification of the (Self-) Importance of Being Earnest. "Caroline Bond, Radcliffe 1919," wrote Hooton, "is an approximate mulatto, having about half Negro and half White blood"—coursing indiscriminately, one might therefore be led to think, beneath her tan skin and through her miscegenetic veins. But enough of my "approximate mulatto" aunt, who is important to this story only insofar as she introduced me—through those images captured by two unknown photographers—to both Adella and her mother, Mariah.

I first came across the photographs of my female antecedents during my childhood. At that time, my mother had passed on to me one of the few original editions of her sister's book. I looked back at this book only occasionally during my early years, but then delved into it (in Earnest?) once again about 1980, when I discovered that my grandmother, Adella Hunt Logan, who had lived, taught school, and raised her children at Alabama's Tuskegee Institute, had been prominent in the woman's suffrage movement. Aunt Carrie's book contained at least a few clues about the Logan family, and I needed all the help I could get.

I started to do some of my own research about Adella, wondering what in the world could have given her the idea (this was even before 1900, and American women did not obtain the right to vote until 1920) that she and other women like her should be able to exercise the franchise. She held those beliefs dear, and advocated them vigorously in a place and time when both African Americans and women in general were routinely considered unworthy of such a basic right of American democracy. Faced with those puzzling yet tantalizing incongruities, I knew that I had to delve more deeply into Adella Hunt Logan's background to learn exactly what family and societal forces may have molded her unconventionality.

I soon learned that she had been born during the Civil War in the

Cotton Belt community of Sparta, Georgia, the major town in a rural county that was dominated by large plantations, and where slaves outnumbered white people almost two-to-one. Then I found out, to my surprise, that she and her family belonged to a small, little known, and anomalous subcaste of southerners known as "free persons of color." "I was not born a slave," my grandmother, Adella Hunt Logan, wrote definitively in 1902 about her Georgia roots, "nor in a log cabin."

My preliminary investigation of Adella led me to write a couple of articles about her pro-suffrage activities and about her life at Tuskegee as well. Those articles, in turn, led to some requests for lectures, and I found myself increasingly immersed in American history, a subject about which I knew nothing. But history—African American and women's history especially—really had me hooked. More than twenty-six years after finishing college, I found myself (filled with almost paralyzing fear and trepidation) a new graduate student in the history department at Howard University. The subject of my three-hundred-plus-page master's thesis would be my grandmother's family, and it soon acquired the title, "Ambiguous Lives: Free Women of Color in Rural Georgia."

The photographic progression that ultimately changed my life led me first from Adella's picture to that of Mariah, and then across the page to a man identified only as "Judge Sayre." Aunt Carrie quite clearly and specifically designated him "4/4 w." Had he really been a judge? I knew that if the description of his profession was accurate (and, indeed it was), there could be no question that he must be "4/4 w," since in the antebellum South nonwhites had no political rights whatsoever. Where had Sayre come from? And where did he live in Sparta? And, of course, I wanted desperately to find out precisely what the familial relationship had been between him and Mariah ("1/4 N, 1/4 I, 1/2 w").

After many months of research, I learned that the judge's full name was Nathan Sayre and that he had moved to Georgia from New Jersey. In Georgia, some time during the 1820s, he had met and soon came to love a free woman of color—her father was a mulatto and her mother a Cherokee Indian. Her name was Susan Hunt. Mariah, in turn, was one of Nathan and Susan's daughters. With her piercing dark eyes and prominent cheekbones, she so closely resembled her mother's people that the locals even called her "Cherokee Mariah."

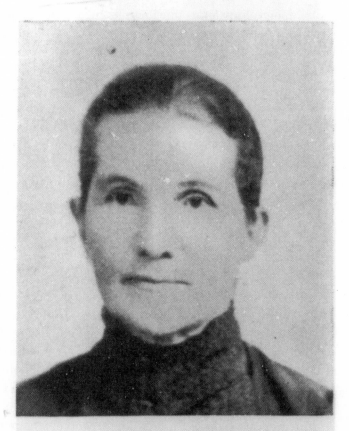

Maria Hunt, N.D.
PHOTOGRAPHER: UNKNOWN (COURTESY ADELE LOGAN ALEXANDER)

I later discovered a yellowed and crumbling copy of an old newspaper interview with one of my aunts in which she related the family's oral history, which preserved stories about the "sensitive white judge… who had only one family and this was his Negro family." Georgia's anti-miscegenation laws, of course, had denied couples of different races the right to marry, but the rather unconventional Judge Sayre—always listed as a bachelor in census reports—seems to have remained ever true to his black-eyed Susan. "Opponents would try to use this fact against him, but he was a devoted father," my aunt continued. He "would proudly parade his family before his constituents, and despite the opposition tactics he managed to be re-elected time and again," she concluded.

My attempts to unsnarl the tangled threads of my family's history led me south to Sparta, where my grandmother had been born, and where like a moth to a flame, I found myself irresistibly drawn to a classic, white-columned, Greek Revival antebellum house dramatically sited at the end of an arched tunnel of towering elm trees. Inquiring of a clerk at the county courthouse, I learned that the remarkably preserved mansion that had so attracted my attention was called Pomegranate Hall. It was, she informed me, "the old Nathan Sayre house." What a stunner that information was for a novice researcher like myself! Photographs and descriptions of that house further illuminate the lives of its residents—Nathan Sayre and his "wife," Susan Hunt. And there, Susan gave birth to and raised three children, the second of whom was my great-grandmother Mariah.

The windows really tell the story in photographs showing the exterior of Pomegranate Hall. In one corner of the house only, three floors—evidenced by three windows—are crammed into the elevation reserved for two throughout the rest of the house. Around 1830, Nathan Sayre had designed and personally supervised the construction of this large new mansion in Sparta—the house that he built for his "wife," Susan Hunt. The local white people certainly knew about the "illegal and illicit" activities that took place in the elegant mansion, but spoke about them only circuitously and by indirection. "From the back room on the third floor, a short stair leads down into a split-level room," one woman wrote about Pomegranate Hall. "This is small and its ceiling much lower than that of the principal apartments," she continued. "There are

three of these small rooms—one under the other and [they] had no connection with the outside world except by way of that third floor room. They are said to have been built that way," she archly asserted, "so that an eye could be kept on the children." Just precisely who were these children of one of Sparta's leading citizens—officially a bachelor—she does not specify. "[A] passage...opens into this room which," the author concluded, "must have been that of the 'Master.'" Photographs of Pomegranate Hall's interior taken in 1990 clearly reveal the secret passageway and the half-flight of steps leading from Nathan's bedroom directly down to Susan's, and up, as well, to the children's nursery.

Much to my surprise, when I finished my master's thesis, it was much in demand for publication. I contracted with the University of Arkansas Press to expand it into a book and, after another year of research and revisions, completed the manuscript, which was published in late 1991. My life had irrevocably changed course. Well into my middle years, by some mysterious and convoluted process, I seem to have become a historian—and not such a shabby one at that.

Before making my very first visit to Sparta, Georgia, I wrote letters to all of the many people in that small town who bore the surname Hunt, and soon they began to respond. Some were even kind enough to show me around, to take me to see old cabins, churches, and cemeteries, and to share with me the stories that their grandparents had told about life in nineteenth-century Georgia, as well as their own reminiscences. They graciously, even enthusiastically, included me—the "new cousin"— in their mammoth family reunions.

I think that my book *Ambiguous Lives* has managed to shed at least some small beams of light on a little known, often shunned, always discriminated against, nonenslaved subcaste of antebellum African American society. As important for me personally is the fact that I (who had grown up an only child, lacking even any previously acknowledged cousins on my father's—my grandma Adella's—side), suddenly found myself warmly embraced by members of this wonderful, boisterous, loud-talking but always welcoming, family whom I had never even known before.

Lisé with Her Mother, c. 1960s
PHOTOGRAPHER: ED HAMILTON (COURTESY LISÉ HAMILTON)

MY GRANDMOTHER DIED LAST NIGHT

Lisé Hamilton

MY GRANDMOTHER DIED LAST NIGHT. MY WHITE GRANDMOTHER. She was eighty years old. She had been sick for a long time. I knew this. It did not come as a shock to me. And yet, the way my mother—my white mother—told me did come as a shock. She did not tell me that my grandmother died. She told me that her mother died.

My mother does not know the extent to which her words hurt me. She called me again this morning, apologized for waking me up, and proceeded to ask me what my schedule was like for the next two weeks. I told her I had classes. She told me that she just wanted to make sure I didn't have any tests, because she wants me at the memorial service. As I read what I have just written, my mother's words seem rather benign, and so I know that I need to explain why "my mother just died" and "I want you at the memorial service" have hurt me so very deeply. To do this requires me to think about things I have not thought about in a long time, things that concern my basic identity.

My first experience of being black was a conversation I had with my father. I could not have been more than three, because my father left when I was four and I remember that we had this conversation long before he went away. He told me that my mother was white and that he was black. He told me that the world saw the children of such marriages as black. He told me that I was black. He told me that not all the world liked black people. He must have tried to explain a little bit about prejudice. I do not remember how much of his explanation I understood. What I do remember is that he told me that in spite of people's prejudices, I could be or do anything on the face of this earth that I chose to do. He also told me that I would have to work twice as hard and be twice as good as any white person to be accepted by them, but that I could do it. My father has a much dimmer recollection of the conversation. What he remembers is thinking that he should tell me that I was black, because I had begun to identify so strongly with my mother

This essay was previously published in *Reconstruction* 2, no. 2 (1993).

that he did not want me to be hurt later when I found out that the world would not identify me in the same way.

My father also explained to me that what he and my mother had done was not something that was ordinarily done in society. Some people were very uncomfortable with it; it had angered both his parents and my mother's mother very much. Again, there was this thing called prejudice, which made people very angry. But I would grow up and understand about prejudice soon enough.

I remember the first time I met my white grandmother. It was not very long after this conversation with my father. I remember that my mother took me to her sister's house and that there were other children there. They were my cousins. They were my grandmother's grandchildren too. When she met me, she gave me a big fancy pin. And then she played with the other children. She let them sit on her lap, she talked and laughed with them. I remember being fascinated with the pin for a short while and then looking up and seeing her playing with my cousins. I knew then that I would have given anything just to sit on her lap and have her laugh and play with me. I remember what that big fancy pin came to mean for me. I asked my mother about it later when we got home. I asked her why my grandmother had stayed away from me when she had not stayed away from the others. I tried to explain to her how I felt about the pin. I asked my mother what I had done wrong.

This was the first time that my mother tried to tell me about her mother. Essentially, her story never changed. She told me that she had hurt and angered her mother very much. She told me that her mother had not wanted her to marry my father, but that she had anyway. She told me that her mother was still angry. She explained that it was not really that my grandmother did not love me; and she was definitely not angry at me. It wasn't anything I had done. My mother told me that no matter what, I must never blame myself.

It took me a very long time to believe my mother. I chose, instead, to believe that if I was good enough and smart enough and polite enough and sweet enough and respectful enough and...and...and...my grandmother would eventually come to love me. I think I must have been about thirteen or fourteen before I realized that that just wasn't going to happen. I also realized a little later, with full clarity, that this woman's anger over her daughter's defiance did not adequately explain her atti-

tude toward me. She was a bigot. Plain and simple. My grandmother was a bigot; and my mother had, in some sense, tried to explain it away by making excuses for her.

When I was eight years old, I met my father's parents. I went to Georgia to spend the summer with them. I was already well practiced in the art of being polite and respectful. But that did not work with them either. Their inability to relate to me, however, seemed different from what I had experienced on the rare occasions when I saw my maternal grandmother. I could not quite put my finger on it, but my sense was that they thought I thought I was better than they were. I was hesitant to tell my father what was going on, in part because I did not fully understand what was happening myself. But what I did understand made me uneasy. I knew these people did not like me; and, again, I did not know what I had done wrong. He must have understood far more than I, because he got on a plane and came right down to see me.

He spent about two days there, asking his parents questions, asking me some more questions, and finally putting the whole thing together. He was furious. He got roaring drunk and had a huge argument with them in front of me. He said he didn't know why he had thought they would treat me any better than they had treated him. But he thought that maybe because I was their granddaughter they would have been able to love me. They shouted back that he had always thought he was better than everybody, that he had threatened to marry a white woman when he was just a teenager, and that he had done it just to hurt them. And so I saw the whole story begin to unfold.

In the end, my father told them that no matter what he had done, if they could not love me and treat me with respect, they did not deserve to have me as a granddaughter. And he took me away from Georgia for good. I have never been back.

My maternal grandmother's rejection has bothered me more than the rejection I suffered at the hands of my paternal grandparents. My father's parents rejected me because I was different. My mother's mother rejected me not only because I was different, but because she thought I was inferior. The rejection because of the assumed inferiority always hurt me more, and it was always something I thought I could prove was untrue.

Last night, however, I discovered another reason why one hurt more than the other. I realized what it had meant to me that my father called his parents out. He told them they were ignorant fools if they were going to let their own insecurities and prejudices stop them from loving me. He took away their power to reject me. He told them that there was no way he was going to let them hurt me. He did everything in his power to protect me from their prejudice. I never saw my grandfather again. But that was not because he did not want to see me. It was because my father would not let him hurt me again.

My mother never did that. She never confronted her mother in front of me, and she never tried to protect me from her mother's prejudice. I grew up knowing that I would have to see this woman every now and then. And I still wanted desperately to gain her acceptance—to prove that I was not inferior because I was black—and in some way to make up for this thing that my mother and I, by association, had done to her. I wanted my grandmother to forgive us both.

From what my mother tells me, she and my grandmother did eventually come to forgive each other. But my grandmother never came to forgive me, because there was nothing to forgive. She was never able to accept me fully, not because of her anger toward her daughter, but because of her bigotry. And my mother never said to her in front of me: If you cannot treat your own granddaughter with the love and respect she deserves, you will not see her. You may have hurt me, but I will not let you hurt her, too.

I asked my mother several months ago when my grandmother first became ill if I could go visit her. But even close to death, my grandmother was still worried about what the neighbors would think. She never told them about me. My mother said they both cried about it, but that her mother's answer was still no.

Even though the adult in me knows that it is not my fault—that I did everything possible to connect with this woman—the little girl in me has never given up patiently seeking that level of goodness that will break down the walls, still hopeful that the walls could be broken down. I have told my mother this. I have confessed how I thought I had resolved my feelings about my grandmother's lack of feeling for me; and yet, upon contemplating her death, I realized that a small part of me has never stopped trying. I have told my mother that my grand-

mother's death would mean that I can no longer try. That I have failed. I have told her how this saddens me. It does not come as a relief. And I have told my mother how important it is to me that she does as much as she can to repair her own relationship with her mother. I have told her not to worry that she was unable to bring her mother and daughter together. She did what she could. We all did what we could.

I am searching for the way to bear this in mind as I try to work through my anger at the way my mother told me about my grand-mother's death. She called and told me in a very cold and controlled manner that *her* mother had died. I was devastated not by the news, but by the significance of her choice of words—by the silence that followed, by the fact that she could not find a sympathetic way of telling me my own grandmother had died. I feel as if my mother could have, in some way, given my grandmother back to me at that moment, because there was no one left to oppose it. We could have grieved together, albeit each in our own separate way, for our different losses. I am angry at her for not finding a way that would have allowed us to do that, because I don't think she even tried.

I ask myself whether I am being unreasonable. Am I reading more into that moment than there is? My mother was upset. She was not thinking clearly. She could not have known that the mere utterance of a few words would so profoundly affect the way I received the news. But I got off the phone with her and felt so alone. I felt as if my mother has failed to understand my life, even though I have tried so hard to explain it in ways that cast no blame on her.

And I began to think back. I realized that I am angry not only for the way she told me about her mother but also for the way she continually failed to protect me from her mother when I was a child. If she had told me, "This woman is not your grandmother because she does not deserve to be your grandmother"—then perhaps the news of my mother's mother's death would not have been so devastating. But my mother never said that. When I would tell her how important my grandmother was to me, she would apologize, telling me how sorry she was that she could not convince my grandmother to accept our rela-tionship. And she would tell me that I must somehow find a way to accept this.

I guess I never really did accept it. I see that I am angry at my mother

for telling me of my grandmother's death in a way that completely denied my relationship to her. But the truth is that we never really had a relationship. I was the only one who still believed in the possibility of it. I was the only one who had kept the dream alive. My mother only spoke the truth. Her mother died.

My father took this photograph of my mother and me in the beginning—when dreams of possibilities were still strong and vibrant, when they were palpable.

Many experiences have challenged the bond of love that existed between us. Yet, if I have ever doubted that love, this photograph brings me back. I have found that the love is simply too powerful to be destroyed and have reclaimed it as part of my natural birthright. It is the source that has healed me. It is what has allowed me to survive.

REINTERPRETING VISUAL MEMORIES

CLARISSA THOMPSON
. . . asks for equality

Barbara S. Marx of Arlington and her daughter, Ann, principals in the Arlington school integration suit, examine a file of papers filed in the litigation.

THEY WANT INTEGRATION — Clarissa Thompson, 16, 1831 N. Columbus, Halls Hill, Va. and Ann Marx, 12, 6897 N. Washington Blvd., Falls Church, Va., are among the 23 plaintiffs who have filed suit against the Arlington County School Board asking for immediate integration according to the Supreme Court decision.

Suit Charges Bias Against White Pupils

By Tony Mason
Staff Reporter

A unique feature of Arlington school integration suit, now awaiting action by the United

tem. People are just people to him now, but if he is exposed to only one kind of people, he will have odd feelings about the other kind.

Orndorff, office manager of an Arlington engineering firm, is a native of Winchester, Va. He attended Strayer Business College and American University. His wife is from Wisconsin. They have lived in Arlington about 12 years.

The case will be known as Clarissa Thompson et al. vs. the Arlington County School Board et al. because the name of the 11th grade Negro girl leads the list of plaintiffs. Clarissa, 16, of 1831 N. Columbus st., says, simply, "I want to be considered an equal if anything I want to do." Clarissa would like to attend Washington and Lee High School instead of Hoffman-Boston.

school board to end racial segregation in the county's schools.

The white parents involved

Newspaper Clipping, 1956
(COURTESY CLARISSA SLIGH AND THE WASHINGTON POST)

THE PLAINTIFF SPEAKS

Clarissa T. Sligh

I WAS A TEENAGER WHEN I FIRST SAW THIS GROUP OF PHOTOGRAPHS and the article that they appeared with, on June 1, 1956, in the *Washington Post and Times Herald*, the major daily newspaper in the Washington, D.C., area. Since I was one of the people in the pictures, I knew that they were to be published and had been looking forward to seeing them with great anticipation for several months. Now, as I recall the time when I first saw the photographs and read the words, I remember how I felt very disappointed and let down. I felt that I had been used, although back then, I had no one to whom I could try to articulate why I felt that I had been "wronged."

The difference between right and wrong had been etched in my mind, in large measure at the neighborhood baptist church that we attended. At the Mt. Salvation Baptist Church, you were either on one side of the line or the other; there was never any "maybe" about it. The article appeared during the development of my second great period of cynicism. The first began at the early age of four years old, when it dawned on me that my oldest brother, Clarence Junior, controlled our household. No amount of telling my momma the mean things he did to me could protect me from his wrath.

I did not trust anyone except my brother Stephen, who was three years younger than me. But now that I had begun menstruating, more and more things in my life seemed too complicated and shameful to talk with him about.

I did not know anyone else who would understand me, who would not respond with blank looks or harsh disapproving words. The thoughts that ran through my mind were something like, "Be grateful! What do you expect? You are lucky to get any photograph in the *Washington Post* at all!" It was a newspaper for which we blacks were usually invisible, except as criminals or welfare recipients.

The mingled voices in my head were of my grandma, momma, daddy, the black preacher, and teachers all trying to teach me how to live in the world with a broken heart. As a young black female growing

up in the American South of the 1940s and '50s, I was taught, in words and by example, how to stand on my own two feet and not expect too much from anybody, no matter how sincere they appeared.

They were trying to teach me how to survive. My grandmother's father and my mother's grandmother had been slaves in this country. They were afraid that if I didn't "get it," I would end up in a madhouse or get myself killed. My father, however, didn't want me to become *too* independent. He would say that nobody would want to marry me.

I loved the out-of-doors, and I learned to do everything my brothers could do and relished the look on their faces when they saw me do it better. But my father's attitude was that doing women's work made a man a "sissy," and he would have no part of it. So I wondered, "Then why should *I* want to do it?" When he sent my brothers out to do chores in the yard, he would look at me and say, "Go help your mother." These words never failed to bring anger and disappointment to my heart. But I thought he would slap me down if I dared to talk back to him. Yet he never put a hand on me, except at my mother's urging, when she felt I was more than she could handle.

My father's only goal for me was to get a husband. He made it pretty clear to me that if I did not remain a virgin, or, worse, if I got pregnant, no man would ever want to touch me. He made it sound like I would spend the rest of my life wandering through hell. Yet I was aware at the same time that he felt that my failing to remain a virgin would be more a matter of another male getting over on him than it being a weakness on my part.

I knew my mother resented the isolated, tedious drudgery of raising babies and doing housework all the time. As the oldest girl, I was the only one who heard her complaints. Neither of us liked her life, and I knew she wanted more for me. So Momma and I were pretty excited when we found out that my picture was to be taken as part of a story about efforts to desegregate schools in Arlington. But Daddy did not want any part of it.

Two years earlier, in 1954, when the Supreme Court ruled that racially segregated schools were unconstitutional, it was like an invisible bomb dropping on our neighborhood. We lived in one of four black communities in the county that was totally surrounded by whites. Since the time when I was about eight my mother had been taking me to state and national NAACP meetings where people gave reports on civil rights

work that was going on throughout the South and discussed future strategies and ways to raise money for the legal work.

I did not believe that things would ever change. Momma, however, would quietly sit and listen. She was not one of those people who asked questions or spoke out in public, but I could tell she was intensely interested, because when she wasn't, she would be sound asleep, even while sitting upright in her chair.

Many times, she could not go because no one was available to stay with my three baby sisters, Gloria, Lillian, and Jean. My father refused to do any baby-related tasks. So, on those occasions, she would send me to the meetings with a neighbor or someone from our church. I was supposed to listen and come back and tell her everything that was said, a job I took very seriously.

Prior to the Supreme Court decision, I was "bussed" to the black high school on the south side of the county when I entered the seventh grade. One night while lying awake in bed, I heard my parents talk about how I was not getting much of an education. My bed was against the wall. I could also hear that they were not considering any plans to send me someplace else. I figured that it must have been because I was a girl. My two older brothers, Clarence Junior and Carroll, had been enrolled in the "better" schools of Washington, D.C.

Both of my parents had completed high school. At that time, it was considered the minimum requirement for getting a "decent" job. My mother had come to the D.C. area from Hickory, North Carolina, in order to find work. She had had a dream of going to Howard University, but she had no money to do it. My father grew up in D.C.. He had studied Latin and had read all the classics, but it did not seem to help him get any further than his job as a shipping-room clerk at the Bureau of Engraving. He griped about the stupid white men who were the bosses over his all-black group of workers. He was very bitter about it.

My mother had become a full-time domestic worker, shuttling to different white women's houses every day. She worked for the minimum wage until she was too old to do it anymore. Whenever she wanted to pull me up short, she would scream that if I didn't do well in school I would "end up working in some white woman's kitchen." To her that was as low as you could go. They struggled to make ends meet, and they knew that life would be very hard for us kids if we did not have at least

a high school education. Without that diploma, the most widely available job opportunities for blacks, where we lived, were domestic work for women and ditch digging for men. I saw that my parents were shut out of jobs available to whites with far fewer qualifications. Of course, employment want ads in the *Washington Post* generally began "Whites Only," and that was one qualification they would never have, no matter how much education they got.

My high school was being remodeled, but when I started there two years earlier, the school barely met the state of Virginia's minimum requirements for black students. There had been no gymnasium, cafeteria, science lab, or rooms to take home economics and shop classes in. When it rained, we put buckets around the room in our physical education class to catch the water that poured in. We did not have a library and all our textbooks were used books sent over to us from the local white schools. I remember opening up the books and seeing the names of the white kids who had used them before they were handed down to us. When we complained about it Mrs. Mackley, our math teacher, would say, "Count your blessings. You are lucky to get anything at all."

My mother had thought that the Supreme Court decision would mean that I would begin tenth grade at the white high school that was located near us. I had been pushed by my teachers and I got good grades. However, I felt a little nervous about going, and, I wondered how I would fare. After all, everybody knew that our black school was "not as good." Also, I did not think I was very smart. There were a lot of kids in my neighborhood who I felt were smarter than me but who got lower grades. School was boring; there was no doubt about that. They essentially refused to read or discuss the totally racist materials we were given. It made us feel bad about who we were. They did not believe that it was going to make their lives any different or better. I did not believe it would either, but I was hoping that it might. And I knew, that in going to the white school, we would be expected to prove that we were just as good, which meant doing more work for the same or a lower grade.

Some schools in nearby D.C. and Maryland were desegregated the following fall. In Arlington, however, we were sent back to our segregated schools. In one southern Virginia county, all the schools were shut down in response to the Court's order. I was completely stunned that something like that could happen.

This, however, did not deter my momma, who wanted more for her children than she had had for herself. I still recall the determination with which she went to meetings with people from the local NAACP and other black parents from our neighborhood to see what they could do about it. This was after being on her feet all day as a domestic worker. All of us kids had to help make dinner, but she saw that we sat down to eat. The following spring, when I was completing tenth grade, she asked me if I was willing to be part of a school integration court case with other kids from the neighborhood, and I agreed to do it. I figured it wouldn't be too bad if we all went together.

This, however, was the summer of 1955, when Emmett Till, a fourteen-year-old black boy, was lynched in Mississippi for "speaking to a white woman." It was in all the papers, but the local black newspaper, and *Ebony* and *Jet* magazines, which we followed carefully for the latest developments on school desegregation, wrote about it in great detail.

Two white men took him from his folk's house in the middle of the night, beat him and lynched him, tied weights to his body, and dropped him in the river. The black publications were the only ones we saw that showed photographs of Emmett Till's body after it came out of the river. Even after the undertaker "fixed up his body," it did not look like the face of a person who had ever been on the earth. I had grown up hearing about whites lynching black men, but because he was so near me in age, the horror of this truly seeped into my bones.

To whom could I turn to express my rage and indignation at the injustices being done? How could the adults around me accept that the white men who killed him would never be punished? Why didn't the major newspapers treat it like the horrible crime it was? I did not know what to do. I felt like a caged animal in a burning house. What was going to happen to me in a white school? How was I going to be able to sit in a classroom without showing how I felt? Whenever I blurted out what was on my mind, my mother would punish me for not behaving myself. At that time I had no idea the price I was paying.

During the fall of 1955, as I returned for eleventh grade to my old school on the south side, the Virginia Legislature passed something called the "massive resistance laws," which gave the governor the power to close down any school system that attempted to desegregate. I tried to talk with my momma about it, but she would say nothing to me

about it. Still, she continued going to the NAACP meetings with the other parents from the neighborhood.

Meanwhile, miles away in Montgomery, Alabama, Rosa Parks was being arrested for not moving to the back of a city bus. The bus boycott that followed was exciting news to us. Everybody talked about it. Blacks were fighting back. We saw news photographs of elderly black people walking many miles to work. It inspired us to see that our people, who were further south than us, and in a more hostile environment, were determined not to take it anymore.

At first there was a lot in our local newspapers about it. I read every word of every article I saw. And when the local newspapers stopped reporting what was going on, I went with my mother to some of the meetings where people who had just come from Montgomery told about what was going on, and asked for donations to help out. I would hold my breath as I listened to the accounts of how the city council and the courts were trying to break up the bus boycott by harassing people in so many ways. I could not imagine that they would be able to keep going with the people in power using all their resources against them. After these meetings, I would go home and pray very hard that God would help them hold out. Finally, we heard Dr. Martin Luther King speak on television. Daddy was really impressed. And Daddy was a man who rarely gave anybody any credit at all.

The month after the bus boycott began in Montgomery, whites rioted on the campus of the University of Alabama for three days after Autherine Lucy, a black woman, enrolled there. Because I too was going to be a desegregation plaintiff, I wanted to know everything that was going on. After all, I might find myself in her shoes.

I read every word of every article about it that I saw. She was barred from attending classes. After the rioting ended, she was eventually suspended. I was looking for clues about what I could expect when my time came to enter our local white high school.

A few months later, my mother asked me if I would be willing to be the lead plaintiff in the Arlington school desegregation case. She explained to me that some of the students who had been selected previously were about to graduate and that another student withdrew because her father was going to be fired from his job if she stayed in. I never expected that the court case would take over a year to be put

together. And I had definitely never expected to be singled out from what was originally a group of over twenty-five black students. I could only imagine that my life would be in a shambles.

I remember thinking, "Here I am already finishing the eleventh grade. Why would I want to go to a white school for my senior year?"

Although Momma said I didn't have to do it if I didn't want to, I could tell she wanted me to agree. Terrible images flashed through my adolescent mind: of Emmett Till being killed for saying something to a white woman; of Rosa Parks going to jail rather than give up her seat to a white man; of all those elderly black folks walking miles to their jobs in Montgomery; of Autherine Lucy at the University of Alabama. I swallowed hard and told her that I would. Since the age of eight, I had been "in it"; I knew that I was expected to do my part.

On May 17, 1956, the NAACP attorneys filed our lawsuit: *Clarissa Thompson et al. v. the Arlington County School Board et al.* I had no idea what sort of changes it would make in my life. What was happening did not really sink in until the newspaper let us know that they wanted to come out to take our pictures for an article about the case.

The photographs were taken by a newspaper photographer who accompanied the reporter to the home of Mrs. Barbara Marx, a white woman who was vice-president of the local NAACP chapter. Momma could not drive, and Daddy refused to be involved in what was going on. I rode with her in someone else's car to the neighborhood where Mrs. Marx lived. The group had asked my mother beforehand to have me prepare a statement.

During the interview, I was very nervous. I tried to act cool, but the underarms of my blouse were soaking wet. Cold sweat ran down the inside of my clothes. I sat and listened as the newspaper reporter interviewed the adults who were present; they included Edwin Brown, an attorney for the NAACP, and James Browne, the local NAACP chapter president. They talked about the history and background of the court action and about what they wanted to accomplish. When the reporter asked me why I wanted to go to a white school, I remember saying something about wanting equality and an end to being a second-class citizen.

Afterward, the reporter directed the staff photographer to take pictures of us. Then, the reporter, looking at eight-year-old Ann, said,

"Isn't she included in the case too? Let's include her in the photographs!"

The photographer began by taking pictures of Mrs. Marx and her daughter, Ann. He asked her to hold up a piece of paper as though she was reading something. I remember her fumbling around in a drawer until she found an envelope, took out a letter and held it up. It is only now, in looking back, that I realize how nervous she too must have been.

Next, the photographer decided to take photographs of Ann and me outdoors. I felt very stiff; I recall that I was very surprised that Ann and I would be photographed together. As I listened to the adults talk, it was the first time that I heard that her mother had included her and her sister, Claire, who was about to graduate from high school, in the suit. She was one of three white students in the class-action suit of twenty-two students. I was one of nineteen black students. It hardly seemed equal to me.

The photographer shot a number of pictures of Ann and me together. By now she seemed to be enjoying the attention and was very relaxed. I, on the other hand, was freaking out. Here I was, a sixteen-year-old, very self-conscious black female, with these white folks up in this white neighborhood, and I'm supposed to be relaxed? They killed Emmet Till. In addition to trying to keep myself together, I felt very awkward towering above this little girl, in height, as the photographer took shots of us standing together. I was sixteen years old and she was eight, not twelve as stated in the newspaper photo caption. Somehow, it seemed insulting to me to be photographed with an eight-year-old. At the same time, I felt bad that the other black students in the suit were not there. Despite the feelings I had, I tried hard to look agreeable and pleasant. I was hoping that the photographs would come out well, so that people would think I was an "all right" person. After taking several shots, he asked us to walk toward him. Then he asked us to carry a book in our hands as we walked toward him. Finally, he said "Okay, that's it." I was glad when it was over.

When the photographs were published, a picture of Barbara and Ann Marx appeared at the top of the page, just above the headline, which read: Suit Charges Bias Against White Pupils. The photograph, which was taken at fairly close range, was shot at just about eye level. Ann is standing next to her mother, who is seated at what appears to be

a desk or a table. This makes Ann's head a little higher than her mother's. The edges around both of their heads appear to have been painted in order to make them stand out against the background. The shape of the shadows cast by their heads suggest circular forms, giving the effect of halos behind their heads similar to those in the Christian religious art of the Middle Ages.

The mother and daughter are holding a piece of paper, supposedly a page from the papers filed in the suit; they are both smiling, as if they are happy and satisfied with what they have done. If I am a viewer who is at all sympathetic toward them, I look at this image without thinking how wonderfully honorable and courageous they must be. If I am a viewer who is angered by what they have done, I will be aware that any action I take against them is going to make me look like a "bad guy," so I am not going to express my feelings very publicly.

The second photograph, a closely cropped head shot of me, was placed to the upper right of the picture described above. It was shot from below my eye level, so that I appear to be looking down at the camera. You can tell by the shadow areas under my eyes, nose, and face, that the light source comes from the upper left hand side. This cropped head shot reminds me of the way photographs of "monsters" are lighted and shot. The angle of the lens, pointing up into my nostrils, also suggests to me certain European paintings of horses being ridden into battle. Moreover, the placement of the picture seems to suggest that the mother and daughter are placing themselves at risk by taking the moral action and putting themselves into this position, and that I am their "white man's burden." The caption read: "Clarissa Thompson…asks for equality." The small amount of white background does not give the viewer any clues as to where the picture was taken.

My head was printed larger than that of Barbara or Ann Marx, and the placement of the top of the photograph just above the top of their picture makes it pop off the page more than the other image. Even though the photograph of me is about one third the size of the photograph of Barbara and Ann Marx, the angle of the shot of my dark-skinned face puts my blackness in opposition to their whiteness. The relative placement of the photographs seems to suggest that people who are white are human and nice and that people who are black are threatening to those nice white people.

This meant that whites would only be able to see that generic black face they carried in their minds. They would not have to wonder about the life, the aspirations, the universal humanity hidden behind my dark skin. They would not be forced to examine, in a personal way, the injustice of the life I was forced to live.

The third photograph was printed on a different page. It is a picture of me and Ann walking toward the photographer, and he was crouching down when he shot it. It is close to evening. The photographer has his back to the sun. In the picture, I am on the left, Ann is on the right. We are both smiling and we each carry a book. The image is cropped to show our full bodies, but my right arm is nevertheless cut off. It looks as though I am walking out of the frame. It may even suggest that I am less than a whole person. Portions of the areas around our heads and shoulders have been painted to make us stand out from the background.

This photograph of me and Ann reminds me of similar images of young whites pictured with older, usually adult, blacks. Three references that immediately come to mind are Huckleberry Finn with the slave Jim, various movies of Shirley Temple in which she shows benevolence to an older, black, white-haired male servant/slave, and, of course, images from *Uncle Tom's Cabin*.

The article itself was written about the few whites who worked with us on the school desegregation case. None of the adults from my neighborhood, who had worked on the case for over a year, and who were the parents of the twenty-five black students, were even mentioned. In photographs and words, Barbara Marx and her daughter, a white mother and child, were thus highlighted and elevated to a position of significance over all the black people involved in the case.

If I had not been there on the two occasions when the reporter interviewed us, I would never have known that black adults participated in those meetings. I remember how seriously and carefully they made sure that what they said to the reporter was accurate and correct; how they helped each other find the words to describe exactly what they meant; how they sometimes told jokes to break the tension. Why was none of what they said included?

Except for me, none of the other black students was named in the article. The next to the last sentence in the article states, "The case will be known as Clarissa Thompson et al. vs. the Arlington County School

Board et al. because the 11th grade Negro girl leads the list of plaintiffs." It was made clear that my photograph was there only because my name was at the top of a list. Simply by looking at the photographs, both whites and blacks would think that the suit was initiated and organized by whites.

Today, I can still remember the safety I felt being surrounded by the black adults from my community during the interview. I remember all their faces but only a few of their names. By leaving them out of the article and photographs, the newspaper made them invisible. If one reads the article today, it looks like they never existed. Their being left out also made me feel unprotected and more vulnerable than ever as time went by. Their courage had been devalued. Their lack of power, of control over the situation, was magnified before my eyes. Even then, it was clear to me that readers of the newspaper would get the message that it was whites, not blacks, who were leading the interracial group to fight racial segregation in Virginia. It reinforced the stereotype that we had to be led by whites.

Today, I ask myself how those meetings with the reporter and photographer might have been different. Why were the interviews held at Barbara Marx's rather than the NAACP president James Browne's house? Both their homes were equally convenient from the highway. If the group had not made the decision beforehand to include Barbara Marx's daughter in the photo session, why didn't they object when the reporter suggested it? Were the black adults afraid to give the appearance of "slighting" a little white girl? Had they in some way gone along with their exclusion from the decision-making process? Had we blacks been excluded from participating in the so-called democratic decision-making process for so long and in so many ways, that any ordinary white person took our exclusion for granted—and so, perhaps, did we?

Today, I also ask myself about the motivations of the reporter. I remember her as being a white woman; yet the reporter's name, as published, appears to be masculine. Was it a pseudonym? As a southern white, would she have been capable of writing a news article that included a black person's point of view? Was she able or willing to hear any of the things we blacks were saying? Did she come there intending to write a story about white people? Certainly a story about the civil rights movement that included whites got more attention than one

about blacks alone. It later became a tactic which the black leaders in the movement themselves took advantage of. They saw that photographs of whites being beaten up while exercising their civil rights got much more attention; here was something unbelieving American whites could identify with, much more so than with photographs of black protestors being beaten by whites.

When the article was printed I felt betrayed. I had thought that it was really going to be a piece of investigative reporting about our work to win our civil rights under the Supreme Court ruling in *Brown v. Board of Education*. I wanted terribly to believe that I could have rights under the Fourteenth Amendment to the Constitution, which guarantees equal protection under the law. I wanted to believe in the Pledge of Allegiance, the National Anthem, the Bible, and all that other shit I had to regurgitate in school, even though I knew it clearly did not apply to me. I wanted the article to show that black people from my neighborhood were part of the struggle against legalized racial segregation too.

My mother did not say much to me about the article after it appeared. She did mention in passing, that some of the people from the community who had met with the reporter were not happy with the way the article turned out. Still, she seemed happy and satisfied that her daughter's picture was in the *Washington Post*. It was a big thing that would elevate her status in the neighborhood and beyond. She did not seem to fear that she would lose any of her domestic work; on the contrary, she seemed to be looking forward to the reaction of her employers.

The publication of those photographs, however, placed me in a new relationship to both the white and the black worlds. It wrenched me from what I considered to be the safety and security of my anonymous family into the spotlight of the hostile public's scrutiny. People began to notice me. I could no longer be just another black girl, or just myself. I had to mind my *p*'s and *q*'s. My behavior, my grades and test scores, my interests and accomplishments became public information.

I began to be expected to address groups of liberal white people, whose support was being solicited for our case. As a young black person, my personal contact with whites had been minimal before this. In fact, I had heard mostly bad things about them, so I was always scared to be with them. In Arlington, we were barred from the movies, restaurants, white churches, and most other public places. I could check out a

book from the public library, but I could not sit down to read it. On my way home from the District of Columbia I often sat alone on the bus, even when it was crowded, because none of the whites would sit beside me. I used to get upset about it, but then tried to act like I didn't see them.

Before I had been invisible. Now I was being scrutinized, not only by whites, but also by the black adults who took me into these new situations. I went along with it, but I tried really hard to hide what I really thought and who I really was.

I felt lucky to have met my boyfriend, Albert, before the photographs were published, because afterward I could not just hang out with my classmates or even slip into some of the places that were considered off-limits for "good girls." Nicknamed "Professor" by some of my classmates, I was never among the more popular girls at a party anyway. Now I could tell I was being seen in an even more distant light.

My teachers did not like my boyfriend, Albert. Considered a street guy, he was not heavy into the books. "Before the photographs," I regularly got good grades and that seemed to be enough; but now they expected me to be outstanding in every way. And even though my teachers were anxious about the future of their jobs if school desegregation were to occur, now I was a representative of their work and they wanted me to look good. They wanted me to succeed. Only one of them came out and said it, but the message from all of them came down to this: Don't you mess up everything by getting pregnant or getting into some other kind of trouble.

To people outside my neighborhood, I was considered a representative not only for black girls but for all young black people. I began to get some understanding of what it must be like to be a Joe Louis or a Jackie Robinson. When they knocked out a white man or hit a home run, it was not just for themselves but for all black people. For whites who did not believe we could do it or who were against us, taking a jab at me was like striking a blow at all blacks. Who I really was and how I really felt was not important. The group was more important. I was a good choice for the role. Because I was a good girl, I tried really hard to be better in every way I could.

This state of tension was the beginning of my learning to live a divided and alienated life. Even as a young person, I knew I had made the decision to allow myself to be used in a way that was unpleasant

and uncomfortable to me. It is true that I had been trained for it, but I could have opted out. I was hoping that it would lead to opportunities that would give me more economic independence and make my life better than my mother's. I learned how to hide myself and my thoughts by keeping my mouth shut, by covering my terror with a smile, and by acting as if everything was going to be all right. In order to get through it, I searched for support, for meaning to my life in the Mt. Salvation Baptist Church. Whenever tough times came, rather than argue or fight, I turned inward and prayed very hard. Later, when the church disappointed me, as it surely had to, I began to smoke and drink. Fortunately for me, stronger drugs were not as available to young people as they are now.

Since those days the nonobjective reporting of newspaper journalism has always been of interest to me. To the average person, news photographs represent reality, but I ask "Whose reality?" and "Why?" As I travel from city to city and from country to country, I see how newspapers vary tremendously in their points of view. I see how photographs are used to reinforce the credibility of stories; and how the same picture is often used to reinforce stories written from opposing points of view. Placing one photograph beside another changes the way the viewer reads it. Adding words to a photograph can make it say almost anything.

It is hard for photographers not to base the photographs they make on pictures they already have in their minds. Even so, their specific intent can easily be altered by an editor's intent, which may be controlled, in turn, by the newspaper's publishers. And then, of course, advertisers often influence what publishers "feel comfortable" including in their pages.

I became a photographer partly in response to the continuous omission and misrepresentation of me and my point of view as a black working-class female who grew up poor. I know I can make a photograph say a lot of different things. However, I hope that the way I make images helps the viewer become better aware of how photographs are really abstracted constructions.

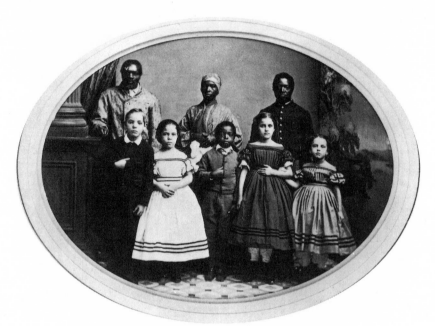

Newly Freed Slaves, 1863
PHOTOGRAPHER: MYRON H. KIMBALL
(COURTESY SCHOMBURG CENTER FOR RESEARCH IN BLACK CULTURE,
NEW YORK PUBLIC LIBRARY)

FINDING A SPACE FOR MYSELF IN MY FILM
ABOUT COLOR CONSCIOUSNESS

Kathe Sandler

I CAME UPON THE PHOTO *Newly Freed Slaves* AS I WAS BEGINNING
research for my documentary film *A Question of Color,* which concerns
attitudes about skin color, hair texture, and facial features in the
African American community. On a personal level, this photo is about
me. It is a visualization of my racial past and present. The little white-
looking slave children are my existential ancestors.

I am a black American woman from an interracial background. I
look white. I identify myself as black. The fact that I choose blackness
has a lot to do with historical and contemporary white racism and racial
classification. I realize that in most of the world, someone who looks
like me, with sandy-blond hair and green eyes—a person who *looks*
white—would not be considered black. And yet because I am an Amer-
ican, raised in a society with a legacy of slavery, apartheid, and the "one
drop" theory of blackness, I was raised as a black person and see myself
as black, even when the world that I live in often resists my identity.

The photo describes the range of complexions in black America, from
the most African-looking to the most European-looking. Certainly in
my own family that very range is there. *Newly Freed Slaves* depicts a
group of individuals about to face a changed world where they would
still be disenfranchised, brutalized, and demeaned under a system of
legal apartheid. More than one hundred years after these newly freed
slaves stood before the camera, African Americans continue to be the
victims of racial oppression and de facto segregation. We live in a soci-
ety that continues to devalue that which is most African about us. It is
no small wonder that that old rhyme about color still haunts us:

> If you're white, you're all right.
> If you're yellow, you're mellow.
> If you're brown, stick around.
> But if you're black, get back!

What role did skin color, hair texture, and facial features play in the
experiences of the newly freed slaves? And what role do those same

qualities play for the thirty-odd million African Americans who have survived to this day in a society that fails to embrace all of us?

Color consciousness has left a lingering imprint on the texture and fabric of black American life. Despite the impact of the "Black Is Beautiful" movement of the late sixties and early seventies and the resurgence of Afrocentrism today, African Americans have been and continue to be influenced by the values of white racism.

During the early days of slavery, a caste system emerged in our community that recognized light skin color, straight hair, and European features as a physical ideal. These values became ingrained in the multihued and ethnically varied African American population and continue to affect many of us today. It is this lingering, internalized racism that I explored for eight years while making my film. The process of attempting to create a vehicle to transcend color consciousness demanded a sustained and conscious struggle on my part.

I had been making *A Question of Color* all my life. Everything that ever happened to me about "color"—in my family, in my community, in white America, and in the world—had prepared me to tell this story. The making of *A Question of Color* was a process in which my own experiences were transformed and retold by the many individuals I filmed. Eventually, though, the film called upon me, the filmmaker, to come out of hiding and participate.

People shared hidden, painful stories with me about tensions between best friends, family members, lovers, spouses, and community leaders over "color." There was the recurring theme of the young woman whose boyfriend wouldn't bring her home to meet his mother because she was "too dark"; and then there was the first black mayor of a southern city, who had to overcome not only *white* segregation but color and class discrimination in the black community as well. There was Wiley, a light-skinned young man who admitted to preferring light-skinned women with long, straight hair and "nice eyes"; and Karen, the woman in her twenties who felt she'd be fifty years old before she could accept the natural texture of her kinky hair. There was Kayin, a young dark-skinned boy of eleven who wanted to lighten his skin "like Michael Jackson" so that girls, and white people in general, would like him better. And there was Pat, a very light-complexioned working-class

woman who felt that she had to project a tough-girl image to keep other black people from messing with her.

Some of the interviews would have been nearly impossible for me to have gotten on my own because of my white-looking appearance. At every turn, I was confronting my own existential pain over color. I later found it necessary to work with others who could help with certain interviews.

I was fortunate enough to work with two terrific associate producers who helped shape the film. One was Wayne Middleton, who became my brother and confidant in the course of making the film. He convinced me to go to Tuskegee, Alabama, to shoot interviews with people he knew there through his family. This shoot became a very important segment of the film. We interviewed Dr. Benjamin Payton, the president of Tuskegee University, who provided us with a historical analysis of the development of color-caste consciousness during slavery. Dr. Payton explained how the "mulatto" children of masters often were relatively privileged vis-à-vis other slaves. Some received education, or freedom, or both, which led to some limited opportunities. As a result, during and following slavery, a light-skinned leadership class emerged in black America comprised primarily of the recent descendants of slave masters and other whites.

The other important associate producer was my sister Eve, who is browner-skinned than I. Eve contributed many things, including an important segment concerning two teenage boys who are best friends, Keith and Keyonn. Keith is light-skinned and Keyonn is relatively dark. The two young men, who were also rap artists, discussed how they were related to in very different ways in the black community—yet they had never discussed these differences before. Tellingly, their experiences were analogous to the different ways in which my sister Eve and I were treated in the black community, something that *we* rarely discussed. Though my sister's skin color is light brown and she has long, wavy hair—a visibly light-skinned black woman—I look white, which made our experiences very different. At one point during the filming, Keyonn asked us directly: "Now, just what were the color issues between yawl two?" Later, when I was completing my film, I found a way to tell this story, something I had been reluctant to do because there were things about myself that I found unacceptable and that I wanted to obscure. It

wasn't until I was willing to expose myself, however, and be existentially honest, that the film truly came together.

Within my own family, there was the issue of color and preference. My light-skinned sister, Eve, had the experience of being, in relation to me, the darker-skinned sibling. (Color is always a relative thing: there are several people in the film who saw themselves as dark even though most African Americans would see them as light, as well as the other way around.) My sister and I had different dispositions as well as looks. My African American aunts and uncles were convinced that Eve was "spoiled." In fact, they called her "Evil Evie" when she was unruly, which was often. I, on the other hand, was considered good, well-behaved, and angelic. Certainly the issue of my color—being blond and green-eyed and looking white—was tangled up in there. Underneath it all, I was prized because I was the white-looking one. My grandmother's family were the Wades of North Carolina, with the Native American (or "Indian") complexions and the dark wavy hair, and Eve had a recognizable Wade look. She was normal and I was special. She was bad and I was good.

Yet my experiences in the black community were schizophrenic. I was routinely favored by family and others who knew me, but shunned by strangers because they took me for white. In school I found I had to physically fight girls to prove myself. I felt a great resentment because I was so often not perceived to be black, though I had been socialized as a black person. I was picked on, set apart in the black community because of the confusion about my identity. At times, I believe, if Eve and I could have, we would have gladly exchanged our appearances.

I came from an interracial background, and I thought my own experiences were too idiosyncratic, too potentially distracting to include in the film. Yet my own experiences were no more idiosyncratic than those of the white-looking black children in the picture who had been slaves, which is no doubt what attracted me to that photo. It represented a kind of historical validation for me. And my voice was as significant as any of the twenty-four other voices in the film.

There was a fine line I had to walk when telling my story, to balance what was and what wasn't essential about my experiences. I had to be completely clear about the role I needed to play in *A Question of Color* before I could forge my path through the many stories being told. I was

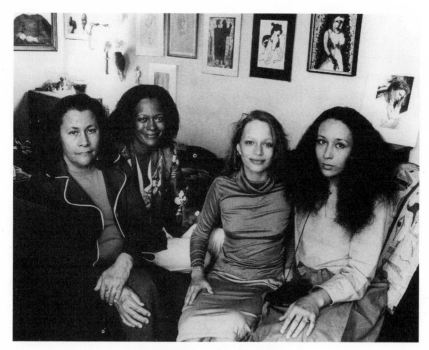

Kathe Sandler with Family, 1977
PHOTOGRAPHER: LOU DRAPER (COURTESY KATHE SANDLER)
(From left, grandmother Mary Alexander, mother Joan Sandler,
Kathe Sandler, and sister Eve Sandler)

the conscience, the perspective of the film, but also a participant in the film: my experience could be no more or less important than anyone else's.

One of my biggest challenges was to convey the ideas of the film clearly. I wanted *A Question of Color* to shed light on a recurring theme in human relations: how oppressed people adopt and internalize the very views that their oppressors have used to oppress them. I wanted the film to remind people that issues of color consciousness are also real for other people of color—in the Caribbean, in Africa, in Latin America, and in Asia—who have experienced similar forms of domination. I also wanted to tackle the intersection of gender and color: the position of men over women that serves to further oppress and divide black women. Our value as women has been determined by how attractive we are to men—mainly black men—who are guided by a color-conscious standard.

My husband and co-writer, Luke Charles Harris, who is a scholar in the field of race relations, helped me to ensure that these themes were clearly integrated into *A Question of Color* despite a steady current of resistance from an assortment of people, including (mainly white) film editors, some funders, and a handful of people of color with whom I worked. There is no way to make a film that challenges how people view themselves and the world without producing some anxiety, even in the best-intentioned of people. I was repeatedly finding myself in the position of having to face down individuals who seemed intent on undermining my vision.

Two months before completing the editing of *A Question of Color*, I was confronted by an irate white man who had been editing the film for several months. He was yelling, being verbally abusive, and waving his hand in my face about some mundane technical decision he had obviously hoped to influence. It was not his decision to make and I let him know it. It took me all of a few minutes to recognize from his body language and fury that this outburst had very little to do with the technical matter at hand. As my vision of the film had come more sharply into focus, it had become increasingly difficult for this man to work for me. I met with him to sort out whether he recognized the seriousness of his conduct. I was not convinced that he did, but for the sake of completing the film in a timely fashion I decided to continue to work with him. Two days later he quit, but not before spewing more insults in my face.

At every critical moment in the production of *A Question of Color* there seems to have been an explosion of some kind. And with each explosion I was forced to regroup, pick up the pieces, and move forward. I was lucky enough to secure two talented editors, women with whom I had worked in the past. This was the best team of editors I had ever assembled. I also promoted the film's assistant editor to associate editor. Working more closely with the new associate editor, who was a woman of color, confirmed something I had suspected all along: that she had far greater insight into my film than the former editor, who had been her supervisor.

In completing *A Question of Color*, I had to locate my individual experiences within a broader *community* experience. While my individual pain around color was and is real, I am cushioned by the privilege of looking like a white woman in a society where images of white women are used to oppress black women, in a society where dark-skinned women are denigrated most.

I was drawn to the photo of the newly freed slaves, with the mysteriously white-looking children and the dark-skinned mother(?), because it triggered a historical recognition in me. Seeing this photo of multi-hued African Americans from more than one hundred years ago helped me to frame my own story in the context of the story of color consciousness in contemporary black America. There are many ways in which color consciousness continues to pervade our community: in the sexist music videos that often exclude dark-skinned women and objectify lighter-skinned black women and others; in the face of Michael Jackson; in the perpetuation of such notions as "good" and "bad" hair. It is a reminder that we are not yet free or fully empowered as a community.

Yet there has always been an alternative sensibility operating in our community. In Tuskegee, Alabama, I met and filmed Mrs. Annie Caldwell, a ninety-six-year-old great-great-grandmother who has since passed away. She had experienced racial segregation most of her life, as well as the color divisions in the black community that were a result of it. Mrs. Caldwell was a black-skinned woman who had one of the most self-affirming conceptions of blackness I have ever experienced. She described herself as a "black African person," and she thought that black was the "beautifullist color you could look at!" Mrs. Caldwell helped me to grasp the presence of an ongoing progressive ideology of positive black consciousness that has helped sustain African Americans, from the time of our arrival on the shores of North America to this day.

In the middle of her interview, Mrs. Caldwell took me by the hand and led me out in front of the camera, exposing me to my cinematographer. She referenced my color in her interview, about me being light and her being dark, and this footage found its way into the film. She helped me to journey from the role of the film's impersonal "omniscient" narrator to that of a first-person "I," a true participant.

When at last I decided to discuss, in my film, the story of color in my own life, and within my family, this 1977 photograph of my grandmother, my mother, myself, and Eve played an important role. (The photo was taken by a family friend, Lou Draper.) There is my grandmother on the left, a transplanted North Carolinian with "Indian" complexion and hair. On the other end is my sister Eve, who looks most like my grandmother, and who grew up light-skinned in black America, but dark compared to her white-looking sister, me. There is my mother,

who grew up "dark but pretty" in the forties, decades before the "Black Is Beautiful" movement rocked the foundations of traditional color consciousness in the African American community. And there I am, sitting between my mother and sister. I am seventeen. I was raised at the height of the Black Consciousness movement and am deeply influenced by it. I look white. I identify myself as black. I want to be darker, to have kinky hair. I am wondering what to do about the many people, especially black people, who can't get over my color, my look, and my identity as an African American.

There is a need for us to look across with empathy at the experiences of our entire community with respect to color consciousness, without privileging any one experience over another. And we need to infuse our African American consciousness with gender consciousness, which will enable us to destroy the devastating burden that color consciousness places on black women. When we actively divest ourselves of Eurocentrism and, to a lesser extent, our tendencies to stigmatize, resent, and delegitimize those of us who look "less black," then we will truly celebrate the rainbow of colors, hair textures, and features that are our community. The range that we see in the photograph of the newly freed slaves is the same range we see in our families, and throughout black America.

As bell hooks writes in *Black Looks: Race and Representation:* "It is only as we collectively change the way we look at ourselves and the world that we can change how we are seen. In this process, we seek to create a world where everyone can look at blackness and black people with new eyes."

AFFIRMATIVE ACTION AND THE WHITE BACKLASH: NOTES FROM A CHILD OF APARTHEID

Luke Charles Harris

My younger brother, Larry, and I came of age in the 1950s and '60s as American-style apartheid, Jim Crow, was disappearing. As my brother and I stood before the camera for this photograph, however, we did not realize that the era of the second great Reconstruction for African Americans was in progress. Like the first Reconstruction, almost a century earlier, it would prove to be a brilliant social movement but would be thwarted when the African American quest for full citizenship was confronted immediately by a vitriolic political backlash emanating from the white community.

The photo of the white demonstrators (see p. 114), some of them carrying placards proclaiming that "Whites Have Rights Too," reflects this backlash. It represents the reality that many whites view people like my brother and me as undeserving interlopers on their terrain, as people who seek to usurp their vested rights. But who do we—my brother and I—truly symbolize in this photograph? I think we represent the children of apartheid. Although even as young boys we had already been touched by racism, we had absolutely no idea how deep the antipathy to our participation in mainstream American society ran. We were part of a whole generation of blacks raised to see America as a land where everyone could compete fairly on a level playing field, even as we lived lives that reflected the experiences of the despised "other," lives cruelly circumscribed because we were black.

Affirmative action programs were supposed to help make the myth of the level playing field a reality. They were defined by one commentator as a range of public and private programs that were "designed to equalize hiring and admissions opportunities for [the members of] historically disadvantaged groups by taking into account those very characteristics which [had] been used to deny them equal treatment."[1] In my case, growing up as a beneficiary of affirmative action programs created an intellectual hunger to explore the meaning of equality and full citizenship—a hunger to examine what it means to count as a full member of our society.

My exploration of these concerns has led me to believe that African

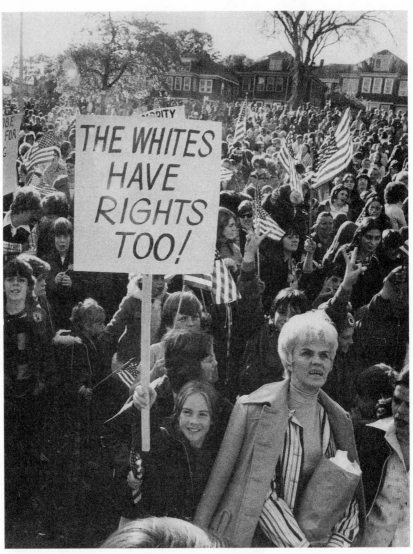

Sign of the Time, c. 1972
(COURTESY UPI/BETTMANN, NEW YORK)

Luke Charles Harris with Brother, c. 1950s
PHOTOGRAPHER: UNKNOWN (COURTESY LUKE CHARLES HARRIS)

Americans must confront the white backlash to affirmative action head-on, with no misgivings whatsoever. There is an urgent need for us to reconceptualize what "equality" and "full citizenship" mean in the latter part of the twentieth century and to wrestle their meaning away from problematic notions of "reverse discrimination" developed by the opponents of affirmative action. To accomplish this goal, we must discern what it means to include blacks within our society after centuries of outright exclusion; and we must ensure that our legal theories as well as our public policies address the pattern of racial exclusion that began with the birth of the United States and which continues today. We speak, after all, of concerns that were a threshold problem at the point of our nation's creation, concerns that relate to the fact that our Constitution at first failed to embrace African Americans as citizens.

Post-apartheid America was an era of great hope, and an era in which many of us refashioned our lives. But its parallels to the first Reconstruction, which occurred after the Civil War, are startling. Our ancestors had hoped that the first Reconstruction would transform their former lives as slaves and marginalized freedmen into lives as full-fledged citizens able to participate in all aspects of American life. Our foremothers and fathers spoke then of "forty acres and a mule" and momentarily basked in the glory of emancipation and the promise of the Thirteenth, Fourteenth, and Fifteenth Amendments to the Constitution, which seemed to reflect a national commitment to full citizenship for all Americans. They had dreams of liberty, dignity, and equality. But they saw their dreams of opportunity transformed into America's homegrown nightmare of apartheid.

The second Reconstruction grew out of the civil rights movement, the Black Power movement, the assassinations of John F. Kennedy, Malcolm X, Robert F. Kennedy, Martin Luther King, Jr., and others, and in the wake of spectacular urban rebellions across the nation. Formal apartheid—imposed by law and sanctioned by custom—had, in fact, begun to crumble in 1954 as a result of Thurgood Marshall's extraordinary victory before the Supreme Court in the *Brown* case, the passing of the great Civil Rights Acts of 1964, 1965, and 1968, and the birth of nationwide affirmative action initiatives in the late 1960s. Once again African Americans felt that they were on the edge of full membership in American society. But again their hopes were dashed by an immediate white backlash to their efforts.

It came, at first, in the form of a deep hostility toward desegregation, as reflected in this 1972 photograph of a rally of about eight thousand people in South Boston who were protesting the busing (for purposes of racial desegregation) of Boston public school students. The resistance to desegregation quickly developed into often disingenuous and deeply hypocritical cries of "reverse discrimination" made by traditional conservatives, confused liberals, and some self-righteous black neoconservatives. Ultimately, this backlash became a dominant theme of American national politics between 1968 and 1992 and a prominent feature of the reactionary Republican regimes of presidents Nixon, Reagan, and Bush, all of whom exploited, in different ways, the racial tensions that resulted from the meaningful efforts to treat blacks and other victims of discrimination as full citizens.

It appeared that no one was quite sure how to promote equality in America. For example, no one had sorted out the ways in which American institutional norms and practices would have to be recast to promote equality for all. Yet hope was in the air, and despite the fact that problems seemed to swirl around my own family with a bewildering persistence, by the time I was a teenager, in the late 1960s, I had come to believe that I could reshape my life and transcend all racial obstacles in the atmosphere of this new era. I thought that American society had at last come to grips with the reality that it must pay special attention to the needs and rights of its most disenfranchised members. Little did I know that for countless millions of white Americans, "reverse discrimination" (that is, "discrimination" against whites) would emerge as the great moral issue of the day at precisely the moment when our society should have been redoubling its efforts to comprehend the meaning of equality and full citizenship for those of us whose lives had been shaped by circumstances that are categorically different from those of our white counterparts.

In his widely acclaimed study of black education in the South, Henry Allen Bullock cogently illuminates the backdrop of injustice that served to separate blacks and whites, and which gave rise to the second era of Reconstruction:

> Jim Crow was a way of life to which [African Americans] were exposed for the purpose of perpetuating their caste condition.... [Blacks] were to be kept socially isolated by means of a

rigid system of residential segregation; they were to be limited
to special occupational pursuits by means of job restrictions;
they were to be tailored in "Negro ways" through a rigid code
of interracial etiquette; and they were to be reinforced in their
obedience to caste rules through formal schooling.[2]

It is a cruel paradox, however, that white Americans, such as the
demonstrators pictured here, seem blind to the injustices perpetrated in
the past and refuse to concede that the barriers placed in the paths of
blacks have seriously undermined our efforts to participate in what is
now considered an open, egalitarian society. Without belaboring the
point, it is essential to note that blacks still have a disproportionately
large number of poor, female-headed families; that blacks still have
fewer years of education than whites; that black income is still a frac-
tion of white income; that black unemployment is still twice the rate of
white unemployment; that blacks are still grossly overrepresented in
low-paying, low-status occupations (and correlatively underrepresented
in responsible jobs in government, business, academia, and the tradi-
tional professions); and, finally, that blacks can still expect fewer years
of life than their white counterparts. Rather than blaming the victims,
we must come to recognize that collectively these problems are inextri-
cably linked to the centuries-old struggle for racial equality in America.
John Hope Franklin, a historian addressing these harsh truths in the
mid-1970s, observed that: "Racial violence continues to stalk the land.
Inequalities of infinite varieties and complexities persist. Racial injus-
tice...pervades the nation...[and its] linkage to the sins of our fathers of
the eighteenth and nineteenth centuries is clear."[3]

Even the so-called middle-class black fails to escape the effects of
race, since American racism also marks the lives of our bourgeoisie. For
instance, in addition to confronting the psychological ramifications
of racism, middle-class blacks in the late 1960s—who were among the
initial beneficiaries of affirmative action policies—were faced with two
serious hurdles: (1) as a general rule, they were materially less well off
than mainstream whites; and (2) for the most part, they had in no way
experienced social, educational, and occupational backgrounds similar
to their white counterparts—backgrounds that would have allowed
them to offer their children advantages directly comparable to those
available to the offspring of privileged whites. Rather, they had grown

up in a Jim Crow America that was absolutely committed, except in a few token cases, to denying them and their children the opportunity to participate on an equal footing with whites in all spheres of life.

Today, middle-class blacks and whites still confront markedly different realities. According to the Bureau of Labor Statistics, as recently as 1979 even the more privileged black families in America found it difficult to achieve an income level sufficient for an urban family of four to maintain a stable existence. This should come as no surprise: black men with four years of college earn only 80 percent of the salaries received by their white counterparts; and only a few dollars more than white male high school graduates. The 1980 census indicated that over the lifetime of their careers, the average white male college graduate will earn approximately $450,00 more than a black male college graduate. Even when black and white middle-class families have comparable incomes, their net worth or wealth (i.e., total assets minus total debts) is drastically different. Thus, in 1984, "black householders had a median net worth of $3,397 and white households $39,135, so for every $1 of wealth in the median white household, the median black household had [nine cents.]"[4]

G. William Domhoff suggests that even the middle-class black graduates of the most prestigious prep schools in the nation face "an elite world permeated by overt and covert...forms of discrimination." He contends that these students confront

> ...the "modern," more subtle racism prevalent at higher levels of elite bureaucracies [that] is now beginning to discourage [them] as well as black executives studied by other investigators. These young men and women have gone more than halfway to meet the demands of white culture, changing in ways that the white power structure in effect demanded of them. But the power structure has changed little to meet them and it continues to exclude them. It remains a structure that institutionalizes the values and practices of upper-class white males.[5]

Thus, although not all blacks are victims of poverty, all blacks may well have suffered the lingering burdens of racial bigotry. In short, even relatively privileged African Americans don't compete with whites on a level playing field. They may be better off than their working-class and

poor black counterparts, but, in general, they do not enjoy the same opportunities as their white peers.

Certainly this was true in the case of my brother Larry and me. The *Brown* decision changed little for us. We grew up on welfare in southern New Jersey, and we confronted northern apartheid at every turn. Our natural mother was a New York City prostitute. Crippled by alcohol and drug addiction, she abandoned all seven of her children, leaving us in different welfare shelters. We never got to really know her or our five other brothers and sisters. Nor were we ever certain of our father's identity. Born in 1950, I was the oldest child. Larry, my brother, was a year younger, and we were the first to be set adrift. But without question, we were the lucky ones, for were were adopted as infants by a great-aunt, Mrs. Eva B. Cox, who became our real mother. Mrs. Cox, who worked as a domestic for over half a century, had migrated to New Jersey from Florida as a young woman. Although her formal education didn't go beyond the fifth grade, she was a deeply religious person with a boundless capacity for nurturing others; and her love and devotion for us throughout her life would serve as a spiritual shield against all the problems that seemed to envelop our extended family. The photograph of Larry and me shows us standing in the front yard of the Cox family home. Immaculate and demure, we followed Mrs. Cox's ground rules, rules that she felt would lead us to success. Propriety, the church, decency, good manners, hard work, selflessness, being seen and not heard, were the values she attempted to instill in us.

We grew up, however, surrounded by people who had seen their dreams of equality die in the midst of Jim Crow in the 1920s, '30s, and '40s. Refugees from poverty and a broken family, we endured the limited resources of our segregated neighborhood in Merchantville, a small town a few miles outside of Camden, New Jersey. We went to an elementary school with severely limited resources while our white counterparts went to schools with resources we could only imagine. By the time we were in junior high school, we had entered the antiquated public school system of Camden, a system that bombarded us with extremely negative messages about our abilities and prospects. For instance, in my case, the ninth-grade counselor told me in no uncertain terms that college was not for me. In his opinion, I was not the kind of person who was ever going to learn how to master subjects like algebra,

chemistry, and physics. At the time, although I had never before heard of algebra, chemistry, and physics, I knew they were important. So his vision of me hurt; it was profoundly unsettling. By the tenth grade I was no longer taking a full load of college-prep courses. I was on my way to nowhere fast. But fate intervened.

Just before my senior year of high school, in 1967, I was training for the upcoming cross-country season in a park near my home when an older white runner, a man I didn't know, jogged up alongside me and struck up a conversation. At first I wondered: "What's up with this white guy? Who is he to be talking to me?" But after he identified himself as a former All-American cross-country runner and the author of a book on distance running, I was suitably impressed and wanted to get to know him. This was Tom Osler, and he gave me a copy of his book. Later I asked him to help me train, which he generously agreed to do. Every Saturday we would go on long runs of fifteen to eighteen miles, during which we would talk about life and about my future. One day he suggested that I go to college. He was a mathematics professor at Saint Joseph's University in Philadelphia, and planted and nurtured in me the idea that I could transcend the expectations of my high school guidance counselors. (Years later, after college and just before I was to head off to Yale Law School, I would find out that my mom, Mrs. Cox, had privately asked him to encourage me in this direction.)

But how was I going to overcome my high school record and my Scholastic Aptitude Test scores which were at best mediocre? These results were "written in stone" and clearly suggested that, all things being equal, I did not "merit" the opportunity to go to a decent college. Luckily, I had the good fortune to reach college age at the dawning of the creation of affirmative action programs. It was 1968, a year of tremendous social and political upheaval across America. One direct result of this turmoil was that affirmative action initiatives were put in place in colleges and universities throughout the country in an attempt to address, among other things, the old problem of black exclusion. Still, I had too few college-prep credits to be accepted at a liberal arts college directly from high school. But after a year at a New Jersey teacher's college, I was able to transfer, with Tom Osler's recommendation, to Saint Joseph's, under its affirmative action program.

Affirmative action, to me, represented hope, encouragement, and an

opportunity to discover, develop, and exercise my potential. It created an opportunity for me to engage in an extremely difficult and yet liberating process of personal growth and transformation. In so doing, it offset an array of "standardized" admissions criteria at institutions of higher education that had obscured the human promise of people of color (myself included) for generations. The traditional criteria, after all, had been developed without a view toward ferreting out promise among the children of apartheid. They had simply not been designed to focus with precision upon the intellectual gifts and the professional promise of the dispossessed.

In this respect, affirmative action was, and is, much more than a "remedy for the racism of the past" or a tool to diversify certain environments. Rather, affirmative action has the effect of leveling the playing field, context by context, institution by institution—at least for some of us. For it seeks, above all else, to redress discriminatory hiring, promotion, and admissions practices that are still alive today. President Kennedy signed Executive Order 10925 and Lyndon Johnson signed Executive Order 11246 not to combat slavery, but to combat institutionalized forms of discrimination that had been, and continue to be, deeply woven into the texture and fabric of late-twentieth-century American life.

The idea of institutional racism was first articulated by Stokely Carmichael and Charles Hamilton. They argued that the norms and practices of some institutions were based on Eurocentric attitudes and assumptions that served, unintentionally yet systematically, to exclude blacks. Ann Dummett, an astute observer of race relations, concludes that

> Racism as a social reality is a characteristic of a whole society.
> A racist society has institutions which effectively maintain
> inequality between the members of different groups in such a
> way that the open expression of racist doctrine is unnecessary
> or where it occurs, superfluous.... Racist institutions, even if
> operated partly by individuals who are not themselves racist
> in their beliefs, still have the effect of making and perpetuat-
> ing inequalities....
>
> Institutionalized racism warps and breaks self-confidence,
> the sense of identity, the self-respect and independence of

black people while simultaneously distorting the nature of white people, stimulating their aggressions, feeding their resentments and fears, warping their judgements, and encouraging them in self-deception.... But institutional racism works quietly: its effects might shout loud to black people, but they are obscure whispers in the ear of the white population.[6]

The self-deception of whites described by Ann Dummett helps explain the raw anger on the face of the middle-aged white woman in the foreground of the photograph of the white demonstrators. Lacking a framework for understanding the implications of racism (and the white privilege that goes along with it) she can only view herself as a casualty when confronted with programs that seek to dismantle apartheid. But she is not alone. Many traditional white liberals and progressives also harbor antipathy toward affirmative action, not unlike their neoconservative and conservative counterparts. And there is an alarming ambivalence, even a growing hostility, toward it on the part of black intellectuals, policy makers, and professionals who lack a cogent alternative vision.[7]

To my mind, however, affirmative action represents a daring set of programs that center on the identifiable, ugly, and ever-present problems of institutional racism in modern America—problems which, although they are invisible to most whites, continue to reflect a major obstacle to black mobility. Thus, while many whites felt that their rights were shrinking in the late 1960s and early '70s, I felt that my rights were being fully realized for the first time through an array of programs that focused upon the relevant distinctions between my experiences and those of white Americans.

In other words, to avoid discriminating against blacks, and other people of color, American institutions had to be prodded and encouraged to pay attention to certain group experiences. For example, admission officials in academia had to be persuaded to create special programs to account for the distinct background experiences, training, and culture that are in varying degrees an element in the lives of all blacks. And this was good for America. For such officials were called upon to reconceptualize their admissions criteria so that academic excellence was not defined in a way that masked the capabilities of our citizens of color.

Indeed, we must all transcend a false concept of discrimination that confuses nondifferentiation with nondiscrimination, while implicitly assuming that whites and blacks are somehow, as if by magic, similarly situated for the purposes of public policy decisions; and that, as a result, they can now be evaluated in exactly the same fashion. In short, we must learn to distinguish between "rational differentiations" and the confused notion of "reverse discrimination." Rational differentiations (that is, those made between people who are in demonstrably different situations) offer no award of personal privilege to blacks; nor do they discriminate against whites. For such distinctions, in theory, allow for no more special assistance to blacks than is required to offset a range of supposedly neutral institutional procedures that, in fact, unfairly privilege whites and arbitrarily exclude blacks for reasons unrelated to a genuine conception of meritocracy.

So we must ask ourselves anew: How do we redefine our collective identity and recreate our political community so that it embraces the formerly excluded as full citizens? What group differences must we recognize? What group differences should we foster, celebrate, and protect? What group differences should we seek to diminish or eradicate? To resolve such questions, we must, as Duncan Kennedy suggests, develop a method

> ...to talk about the political and the cultural relations of the various groups that compose our society without falling into racialism [or] essentialism.... We need to conceptualize groups in a "post-modern" way, recognizing their reality in our lives without losing sight of the partial, unstable, contradictory character of group existence.[8]

Thus, affirmative action programs represent public policies sculpted to the contours of our national experience. They are, in fact, "the only policy initiative since the abolition of slavery that constitutes a frontal assault on [a] system of occupational apartheid that had its origin in slavery itself."[9] Despite the heated public debate that surrounds such programs, they are really nothing more than social experiments designed to play a role in transforming patterns of human oppression that have undermined and masked the capabilities of people of color in this society for generations. Yet affirmative action programs are in no sense a panacea for the plight of the poor and those victimized by racial and other forms of bigotry; nor

were they ever supposed to be. Such programs must be linked to meaningful economic reform and new patterns of social organization or else their impact will be limited. Nonetheless, affirmative action initiatives still represent a huge step in the right direction.

In my case, affirmative action made it possible for me to grow and to reshape myself in a hostile world. I got the chance to go to college, where I did quite well. Later I studied law at Yale, became a Fulbright Scholar, a law clerk to a prominent judge, a litigator at a top New York City law firm, and a professor at a major liberal arts college. But, much more importantly, my personal success is part of a larger legacy. Affirmative action has made it possible for an entire generation of African Americans, poor and working class as well as middle-class (the children of domestic workers, educators, laborers, prostitutes, and doctors), to begin to break through the unwarranted institutional roadblocks to our participation in all segments of the American workplace for the first time in our nation's history.

Another story unfolds from my childhood photograph. My brother Larry fared much differently than I. Though Larry had been a better student than I in high school, he was also more consumed by the difficult circumstances of our younger lives. He lacked the confidence to pursue the path of education which, through unique circumstances, I had been encouraged to follow. My brother became a mail-room clerk in a Philadelphia bank and dreamed of continuing his education until his life was cut short at age thirty by congenital heart failure.

Although my brother and I fared quite differently in our lives, in the realization of our potentials, we both received opportunities that protected us from some of the more disastrous circumstances facing young people growing up in and around Camden, New Jersey, and other inner-cities today. The erosion of a base of working-class manufacturing jobs in the post-Civil Rights era combined with the proliferation of deadly drugs in our neighborhoods has turned many urban communities into war zones. The need for special programs designed to offset the social inequities faced by blacks is therefore needed now even more urgently than ever before.

Yet bewildered by and insensitive to the subtleties of contemporary American racism, we seem as a nation unable to confront the monstrous

consequences of our collective past where African Americans are concerned. Indeed, paradoxically some whites now use the tactics of the civil rights movement of the 1950s and '60s, publicly demonstrating against affirmative action initiatives to symbolize their belief that they are the principal victims of racial discrimination in post-apartheid America, whereas nothing could be further from the truth. We must, therefore, transcend the paralysis of a superficial analysis that suggests that blacks and whites are similarly situated in modern America, and learn to distinguish rational differentiation from reverse discrimination. Perhaps then white Americans now blind to the circumstances of the children of apartheid can be made to recognize that we are a nation haunted by our history of slavery, apartheid, and contemporary de facto segregation. And perhaps then we can envision a future free of the white backlash to affirmative action.

NOTES

1. Myrl L. Duncan, "The Future of Affirmative Action: A Jurisprudential/Legal Critique," *Harvard Civil Rights–Civil Liberties Law Review* 17 (1982), p. 503.

2. Henry Allen Bullock, *A History of Negro Education in the South: From 1619 to the Present* (Cambridge: Harvard University Press, 1966), pp. 147–48.

3. John Hope Franklin, *Racial Equality in America* (Chicago: University of Chicago Press, 1976), p. 74.

4. Gerald David Jaynes and Robin M. Williams, Jr., eds., *A Common Destiny* (Washington, D.C.: National Academy Press, 1989), pp. 291–92.

5. G. William Domhoff, *Blacks in the White Establishment: A Study of Race and Class in America* (New Haven: Yale University Press, 1991).

6. Ann Dummett, *A Portrait of English Racism* (Middlesex, Eng.: Penguin, 1973), pp. 131, 151–52.

7. For a perspective that attempts to exorcise the specter of rejection and ambivalence that haunts the contemporary discourse on affirmative action, see Luke Charles Harris and Uma Narayan, "Affirmative Action and the Myth of Preferential Treatment: A Transformative Critique of the Affirmative Action Debate," *Harvard BlackLetter Law Journal* 11 (1994), p. 1.

8. Duncan Kennedy, "A Cultural Pluralist Case for Affirmative Action in Legal Academia," *Duke Law Journal* (1990), p. 732.

9. Steven Steinberg, "Et tu Brutus," *Reconstruction* 2, no. 2 (1992), pp. 32–33.

PART IV:

PERSONAL AND CULTURAL IMAGES
IN A CRITICAL CONTEXT

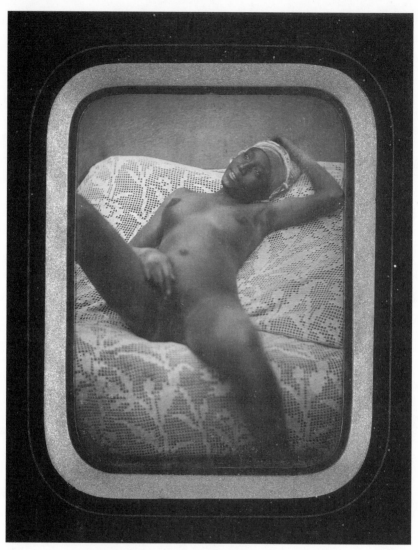

Daguerreotype of a Nude Woman, c. 1850s
PHOTOGRAPHER: UNKNOWN
(COURTESY COLLECTION OF J. PAUL GETTY MUSEUM)

THE EROTIC IMAGE IS NAKED AND DARK

Carla Williams

I DO NOT RECALL THE CIRCUMSTANCES UNDER WHICH I DISCOVERED her image, but I knew instantly that it was rare and important. It was stored in a box all by itself, and I would probably never have found it had I not worked in the museum that owned it. She was extraordinary—a young black woman in France almost 140 years ago, naked and displayed and open and touching herself and reclining and smiling. The lace coverlet on which she is posed reminds me fondly, sweetly of my own grandmother's linens, while her frankness and sexuality remind me of everything that my grandmother is not. Through all of my research I have never seen another piece of nineteenth-century photo erotica quite like this. The daguerreotype plate is of an impressive size and I wonder what was so extraordinary about this model to merit such special treatment, since by the mid 1850s, when this was made, the popularity of daguerreotypes in France was waning in favor of simpler positive-negative processes. Moreover, I am intrigued by what could possibly be the connection between this photographer's model—perhaps a prostitute, removed by a continent, a culture, and a century and a half—and me.

She is completely bare except for her head, which is wrapped in the fashion of West Indian women. Interestingly, this small cultural marker is the only positive clue as to who she might have been. She is positioned awkwardly, expressly for the act of being viewed, and we seem to see every inch of her, except for her lower legs and feet. The focal point of the photograph, her open crotch, is coyly out of focus, yet with the explicit placement of her fingers she invites us to look, yet simultaneously avoids the viewer with her gaze.

French artists of the mid-to-late nineteenth century often used prostitutes as models, and frequently made nude photographic studies of them. Whether or not this woman was actually a prostitute, her compliantly amiable expression implies her active participation in the making of this image. As a frankly, publicly, sexually explicit black woman, however, she exemplifies deviance, libidinous and otherwise, as defined

by nineteenth-century medical and social sciences, and her image is inevitably allied with the business of pleasure.[1] Because there are so few photographic images that survive of black women from the 1850s or before, this daguerreotype is significant in its representative role. By virtue of the size and explicitness of the image, if nothing else, this daguerreotype is not just a "dirty," pornographic secret, but rather it signifies a crucial development in the visual depiction of African women.

According to Sander Gilman, medical scientists in the first decade of the nineteenth century (in particular J. J. Virey and George Cuvier in France) were reaching "scientific" conclusions relating the physical appearance of the black woman's genitalia to her so-called deviant sexual practices and proclivities. Also highly popular during this period were character evaluations based upon the "disciplines" of phrenology and physiognomy, which are valuable to us now insofar as they are a source of images of black people, regardless of how their collectors used them in an attempt to determine character from the evidence of physical features. The basic principle behind both phrenology and physiognomy is that the character of a person can be determined by the configuration of his or her facial features or the shape of his or her head, an idea that dates back to the writings of Aristotle. The study of physiognomy, which focuses on the facial features, was first given visual realization in the drawings of Giovanni Battista della Porta in his *De Humana Physiognomia* in 1586, and the first racial anatomical studies were made in 1784. All of these pseudo-scientific investigations informed the development of the anthropological "mug shot" aesthetic as employed in photography as a means of categorizing racial types. Behavioral classifications, sexual and otherwise, based upon physical difference are still with us, and they continue to define how we evaluate character through every aspect of appearance. Of course, they also determine how Africans are viewed within the larger society and, more importantly, how they perceive themselves.

As further example of the proliferation of the representations of black bodies and the popular attention they captured, at least two different South African women, both referred to as the "Hottentot Venus," were widely exhibited throughout Europe as sexual curiosities in the first decades of the nineteenth century. They were stripped naked and dis-

played in cages, ostensibly as representatives of what their own culture prized as physical beauty. Europeans, while regarding them as freaks, nevertheless mimicked the exaggerated shape of their buttocks with the invention of the bustle which simulated their highly desirable silhouette. By the time this daguerreotype was made, in the 1850s, the dissected genitalia and buttocks of the most famous of them, Saartjie Baartman, had been on exhibit in the Musée de l'Homme in Paris for nearly forty years, where they remain on view to this day.[2] In fact, because of the extremely grotesque exploitation and mockery of her sexual difference, Baartman has become a contemporary martyr, a turning point of reference in the representation of African women.

Visual representations of blacks can be found throughout Western art, especially during periods of colonial expansion into Africa and the Orient, when the local color became the exotic subject of many a painter's brush. In the mid-nineteenth century, the popularity of erotica and the invention of photography coincided with just such a period, and this convergence developed broadly to include in the various media all imaginable permutations alien to the notion of personal intimacy.

Someone recently described the model in this daguerreotype to me as "the black woman making sex with herself," which seemed to me at the time to be pretty accurate, if a bit pathetic. I had spent months thinking about the picture and regarding her only as a nude; until I heard that comment, I never though of her as masturbating. Yet the act of masturbation, simulated or real, suggests a power to please one's self that is not unlike the act of self-portraiture, which is similarly self-sufficient, highly personal, and exploratory. When either of these activities is engaged in by a black woman for an audience, it becomes an empowering act for her because we are unaccustomed to black women defining their own sexual pleasure or their own images; the viewer relinquishes control.

The woman in this picture, as the object of our sexual delectation, represents a curious dichotomy; that is, her physical difference is denounced in the scientific and intellectual circles of the day as repellent and disgusting while the visual image of her clearly seeks to provoke a sensual and sexual reaction from its viewer. The now-you-see-it, now-you-don't peep show–like quality of the daguerreotype process

adds another element to the forbidden enjoyment. Although I doubt that her image was ever displayed or exhibited publicly, the daguerreotype is to large too be cradled in one's palm or slipped into the pocket of an overcoat. Like most erotica, she was probably made for an individual's private pleasure (maybe there was even mutual pleasure in the studio). Erotic pictures, as stimulants or icons of pleasure, tended to celebrate the participants and revel in mutually pleasurable activity. But this picture is unlike most nineteenth-century erotica involving blacks because she is completing a sex act with herself; she does not engage with any partner other than the anonymous photographer and the viewer. Her aloneness may have been a result of the perceived "reality" of the photographic image; it is one thing to draw or paint a sex act, quite another to put two real persons together, in any sexual or racial combination, to make a photograph of it. Thus, the viewer can find her and the idea of her sexuality safely desirable without actually having to imagine touching her or what her response might be.

A woman photographer I know recently pointed out to me that women of color do not usually incorporate nudity in their self-portraiture, a fact that I had not realized. In a recent issue of the journal *Afterimage*, Lorraine O'Grady addresses this same issue, making the observation that, in her experience, women of color are not inclined to bare their bodies in public places, so that, for example, after swimming in a public pool, the black women would be the only ones in the shower afterward who didn't take off their swimsuits.[3] This sort of reserve was true of my own experience, yet it was so implicit in my upbringing that I never thought about it extending beyond the puritanism of my family. O'Grady surmises, I think rightly, that this unspoken habit among black women suggests that, over the years (since emancipation), black women have been taught by mothers and grandmothers to protect the display of their bodies, a display that for so long had been completely out of their control. Automatically, perhaps unconsciously, many of us still observe that lesson.

As the subject of an erotic photograph, the woman in the daguerreotype does not embarrass or titillate me in the personal way that an old photograph of an unidentified nude man that I once found in my mother's drawer did. At the same time, however, at the museum where I discovered this image, I only felt comfortable talking about her as a

subject of my interest in her ethnicity. Just once I opened one of the other boxes of nineteenth-century erotica in that collection. The objects were stacked two layers deep, and to sort through them casually would have revealed my true interest. An extraordinary thing about erotica is that virtually every serious amateur or professional photographer has created a piece of it—nearly every snapshot collection and many museum collections contain some—but, at least in the United States, it is illicit, forbidden, and few people admit to looking at, let alone studying it. Moreover, unlike a photograph of a "nude," which is thought to be classic and formal and idealized, the specifically erotic image is naked and dark, animalistic and fleshly.

Yet I frequently take off my clothes for my photographs, and it was this simple affinity that compelled me to this daguerreotype. But when I do disrobe I am the photographer as well as the subject, and I determine what is comfortable and what I want shown and what part of my body will communicate what part of my message. I cannot recall specifically, but it seems to me that it was not very difficult to make my first nude photograph of myself. I knew that I would be the one to develop the film and make the prints, and if I were uncomfortable I would tuck it away and not show it. At the same time, I felt terribly mature and far removed from what I had always been taught about such exposure. I believed that there was an artistic precedent for it; I was seventeen or eighteen years old and experimenting with the camera. It never occurred to me then that there was anything extraordinary about the fact that I was black and making such images. Yet when I think back on it, I realize that I had never seen a nude of another black woman when I began to photograph myself.

The woman in the daguerreotype does not look much older than I was then. Unlike her, I have never posed for another photographer— how uncomfortable it seemed to me, how false. I feared that I would feel manipulated and grotesque on a purely cosmetic level. Besides, and most importantly, I was suspicious of what anyone else might endeavor to say with my image. The interplay between the historical and the contemporary, between imposed representation and self-presentation, is fundamental to the difference between me and the anonymous woman in the daguerreotype. The discovery of this image provides me with a little more of my particular visual history, a base from which I can begin

to define my likeness, as well as my sexuality, in the context of my humanity. In this way, I take control of my own representation, I revel in my own skin.

NOTES

1. Sander Gilman, "Black Bodies, White Bodies: Toward an Iconography of Female Sexuality in Late Nineteenth-Century Art, Medicine, and Literature," in Gates, Henry Louis, Jr., ed., *"Race," Writing, and Difference* (Chicago: University of Chicago Press, 1985), pp. 223–261. This essay is a provocative discussion of the relationship between visual art and scientific theory in the nineteenth century, and elaborates on several of the issues that I discuss here.

2. Hugh Honour, *The Image of the Black in Western Art*, vol. 4 (Houston: Menil Foundation, 1989), pp. 54–55.

3. Lorraine O'Grady, "Olympia's Maid: Reclaiming Black Female Subjectivity," *Afterimage* (summer 1992), pp. 14–15.

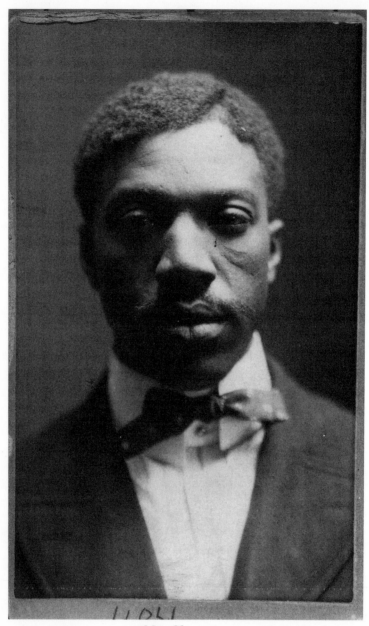

Mug Shot, 1901
PHOTOGRAPHER: UNKNOWN (COURTESY DERRICK JOSHUA BEARD)

MUG SHOT: SUSPICIOUS PERSON

Claudine K. Brown

My first encounter with a mug shot occurred when I was an undergraduate at Pratt Institute. I'd taken the train to Baltimore to visit my family, and discovered a bulletin board with police mug shots outside the ladies' room at the train station. The image that caught my attention was that of H. Rap Brown, an activist and spokesperson for the Student Nonviolent Coordinating Committee. These close-up frontal and profile shots made the wiry young black man look larger than life and extremely threatening.

I had just recently heard H. Rap Brown speak at Long Island University. The audience was enthralled by his passion for the civil rights movements and his straightforward, no-nonsense delivery. He had the long graceful fingers of a basketball player and the irreverent wit of many of the young men in my neighborhood. His mug shot made him an anonymous stranger. He was no one's son, no one's lover, and a danger to all who might encounter him.

More recently mug shots have become commonplace in the media thanks to the programs that feature dramatizations of the crimes of *America's Most Wanted,* or those that allow the public to observe actual arrests on programs like *Cops.* The theme song from *Cops* poses the question: "Bad boys, bad boys, what'cha gonna do?" to a reggae beat. The bad boys who are shown are overwhelmingly young and black. These television programs, not unlike mug shots, depict black men as untrustworthy, dangerous, and not very intelligent.

The mug shot of Benjamin Rutledge, reproduced here, initially caught my attention because of the stately demeanor of its subject. Rutledge is a neatly attired black man with a stylish haircut and a proud forward gaze. At first blush, one might take it for a portrait that Rutledge would have sent to a loved one or friend.

Only upon turning the photograph over do we realize that this is, indeed, a mug shot. On November 5, 1901, Mr. Rutledge was arrested for "being a suspicious person." While to my eye he appears to be

404 418

Name Benjamin Rutledge

Alias

Crime Susp. Person

Age 29 **Comp.** Colored

Height 5.7½ **Weight** 174

Hair Blk **Eyes** Brown

Nose **Face**

Marks Scar above left eyebrow

Born Tenn.

Married No

Trade Waiter

Date of Arrest Nov. 5/01.

Officer Barry Conway

Remarks D.C.I.

well-dressed and responsible-looking, clearly the police and some of his contemporaries perceived him to be "suspicious."

Though Africans were brought to this country against their will, the fact that we are here seems to be a continuing cause for consternation. We raise the suspicions of others when we walk through their neighborhoods, enter their business establishments, and show up at places where we were not previously welcomed. Our grooming is not always an issue, nor is our ability to pay for admission. Our presence alone is often quite disconcerting.

As a black woman living in Brooklyn during the seventies and eighties, raising two male children alone, I learned from my own experiences as well as from the experiences of others to fear for the lives of my sons. The death of Yusef Hawkins, a sixteen-year-old black child who happened to be in an environment where his presence aroused suspicion and placed him in mortal danger, served as a wake-up call for an entire community.

In August of 1989, Yusef Hawkins and three friends were in the predominantly white neighborhood of Bensonhurst trying to buy a used car. Hawkins was fatally shot and his friends were attacked by a group of white youths who mistook them for young men who they believed had been invited to the birthday party of a former girlfriend of one of the white youths.

At the time of Hawkins' death, Brooklyn's black community was still bearing the pain of a racially motivated attack on another young black man, in Howard Beach. In 1986, Michael Griffith was hit by a car while fleeing a gang of white teenagers.

The senseless loss of life leaves a lasting impression; and many African American parents empathized strongly with the parents of these victims, for the circumstances of their tragedies are a familiar reality for us all. Every black man in my family has a tale to tell of a personal indignity that has threatened his physical and/or emotional well-being.

My eldest son was born on November 22, 1970. His father and I brought him home from the hospital on Thanksgiving Day, and he received a warm welcome from his father's clan, which included a great-grandmother, grandfather, grandmother, aunts, uncles, and numerous cousins. My own grandmother was eagerly awaiting our

Christmas visit so that my son could be blessed by my grandfather and received by my family. As an added enticement she promised to cook apple dumplings for breakfast. Though we needed no enticement, her offer served to hasten our departure for Baltimore.

When we arrived on Christmas Morning, I called old friends to tell them about my first child and to alert them that Grandma was seriously throwing down in the kitchen. Friends and family began to gather for a meal that continued and blended into the next as new visitors arrived.

One of my oldest friends couldn't make it, but she called to share her anxiety with me. Her husband, who delivered oil, had not come home. This was very uncharacteristic behavior. He was a very loving family man whom I had known since grade school. While I actively took part in our festive family homecoming, my friend's worries stayed with me.

By the end of the day, when all of the gifts had been unwrapped and most of the turkey had been ravished, the phone rang. My friend called to tell me that her husband was dead. He had been killed by plain-clothes police officers. They alleged that they'd told him to move his oil truck and that, in response, he appeared to be reaching for a weapon. So they shot him until he was no longer a threat.

This man lost his life long before civilian review boards were a matter of on-going public concern; and this was not the first innocent black man that one of these officers had murdered. A few years earlier, while answering a call to a home to stop a domestic quarrel, one of them had ended the quarrel by taking the life of the husband. In neither case did citizen groups take to the street shouting "No justice, no peace!"

Black parents across America entreat their sons to dress neatly so that they won't be followed in department stores, or stopped for looking sus-picious. Just as early civil rights freedom riders were encouraged to wear clean white shirts and ties so that they would be respected, we often encourage our sons to adopt attire that will make them socially accept-able. And just as the freedom riders were met with jeers and derisive behavior, our children today are followed, challenged, and insulted.

One Christmas, my eldest son and I were shopping at B. Altmann's together and we separated so that he could buy my gift. We agreed to meet near the Thirty-fourth Street entrance. When I arrived at the des-ignated time, he was being grilled by black security guards. When he explained that he was waiting for his mother, they told him that they

sincerely doubted that his mother even knew where B. Altmann's was. Even black men, doing their jobs, will insult, demean, and demoralize our sons.

More recently, I sent my youngest son to a museum opening that I could not attend. I RSVP'd in his name, and when he arrived he was given a name tag. Nonetheless, he was followed by museum guards, who were curious about what he was doing at the opening. He was astute enough to ask these guards whether or not their children or families ever came to museum openings. When they replied no, he suggested that maybe it was because they had come once and been treated with the same disrespect that he was experiencing.

Not only are young black males harassed in certain business establishments and cultural institutions, they are also not safe as pedestrians. If they ask the elderly for the time, they are often accused of assault. If they run to work because they are late, the assumption is that they are fleeing the scene of a crime. If they have the misfortune of being near the scene of a crime, they are stopped, questioned, and sometimes arrested because they are perceived to be interchangeable.

My children, my brothers, and men that I love have all been stopped by police and frisked on at least one occasion. Many have been questioned as to why they were walking through what turned out to be the neighborhood they lived in. A tall, dark, and striking young man who I love like a son was detained for snatching a young white woman's purse even though he didn't remotely fit the description of the assailant. He was walking at a leisurely pace with a friend, he wasn't in possession of any property belonging to the victim, and he was not carrying, nor has he ever carried, a purse.

Though black Americans are incredibly diverse in appearance, others believe that we all look alike. Though our skin tones range from milk-white, pecan-tan, mahogany, and burnt umber to blue-black, we are still described simply as light- or dark-skinned. Though our hair texture can be straight, wavy, curly, or kinky, we are often mistaken for people we don't in the least resemble.

Thus, a young black college student will be positively identified as a rapist because of his flat-top hair cut; and a corporate executive will be taken for a potential mugger because of his dark, brooding countenance.

Very recently my eldest said to me, "You have taught us a great deal,

but you will never know what it is like to walk the streets of this country as a black man. You will never be treated as we are treated—feared for no reason, hated by the ignorant, and stalked by our own. You don't have the experience to teach us how to survive in this world."

My youngest talks about young black men who have no compunction about killing because they have no fear of imprisonment. "You can't hurt me, I'm already dead" is their manifesto.

We live in a time when young black men take each other out because of the color of a baseball hat or a look of disrespect. Young black men are feared and suspect in our own communities.

While early slave and Jim Crow laws were very clear about where we could and could not go, the belief that there are places that we simply should not be remains. Whether it is the Cotton Club or an exclusive country club, Scarsdale or Bensonhurst, there are places and communities where our very presence makes us suspect. And while black women may appear to be simply out of place in such circumstances, black men are perceived as persons positively intent on criminal mischief when they cross the line.

As a parent, I made a critical decision to maintain an open house. I didn't want my children in the street unsupervised; therefore I opened my home to their friends. We had boys over for dinner every night. When we went to the movies or the circus, we always took others with us. I checked homework, visited teachers, and purchased school supplies for all the boys in our lives. I took some on their first vacations out of New York City and helped others prepare financial-aid forms and applications for college.

These young men are all bright, witty, and wonderful. Some have finished college and are pursuing the careers of their dreams. Others are working and going to school. Some have gone into the military, and we have held our collective breaths during the invasion of Panama and the Persian Gulf War. One is in prison, and some are walking very precariously on the wild side.

Some probably have a great deal in common with those children whose faces end up in mug shots. Perhaps I have been blessed, for I have not had a single young black man come through my doors who didn't impress me as a person of worth. I visit my old neighborhood in Brooklyn often. I have a ritual breakfast at Mike's or Junior's with the young

men whom I know and love. They are rapidly becoming the men of their community. I look forward to watching them play with their children in the park at Washington and Lafayette. I believe that they will treat their women with the same respect that they have accorded me. I hope that younger men will watch them with pride, and admire their style, their work ethic, and their generosity of spirit.

I hope that they, as well as their fathers, brothers, and friends will begin to forge a nation of tolerance, where brothers acknowledge and celebrate their differences as well as their similarities. I look forward to the day when our collective and singular presence ceases to be a cause for suspicion and our pursuit of life, liberty, and justice need not be supported by legal intervention.

I am my brother's keeper. I am his sister, his mother, his child, his lover, and his friend. His survival is my survival. May he live long and prosper.

Melvin Van Peebles, 1971
MOVIE STILL FROM *Sweet Sweetback's Baadasssss Song*
(COURTESY CINEMATON INDUSTRIES)

THE CONTINUING DRAMA
OF AFRICAN AMERICAN IMAGES
IN AMERICAN CINEMA

St. Clair Bourne

There's no Santa Claus and everybody's sitting around the tree with their stockings.

— MELVIN VAN PEEBLES

JAMES BALDWIN'S WRITINGS ABOUT THE AFRICAN AMERICAN QUEST for freedom and justice always questioned the wisdom of integrating into a "burning house," his metaphor for this country. To me, a survey of past and present African American activity in both the independent and the mainstream Hollywood film scenes in America raises the same issue. What is the nature of "African American progress" in the movies and in American life in general?

One thing is obvious: film and television images in America are greatly influenced by the political conditions of the times, and these images tend to serve the psychological needs of the people who create them. For example, the purpose of the Africans brought here by white male Europeans was to provide service labor and nothing more. Therefore, European Americans economically, socially, and cinematically positioned the Africans and their descendants in a society as the European Americans conceived it. This process continues in media; sometimes with the assistance of African American filmmakers themselves.

When I reflect on the politics of media, I always think back to my own start in filmmaking. Becoming one of the original staff producers for *Black Journal*, the first national public-affairs documentary series in American television, was due as much to the social conditions of the times as my own energy. During the days of the black cultural revolution, there was general unrest among the African American population due to racial discrimination and treatment as second-class citizens. A specific complaint concerned our chronic exclusion from the media and the negative distortions that took place when we were represented. The tactics of the civil rights movement, nonviolence and petitioning white

society for justice, were beginning to be discredited as the marchers and activists were thwarted by violent resistance and government complicity. Thus, planned and spontaneous rebellions erupted in the cities where there were large black populations.

The government's response was twofold: repression and concession. Some examples of the government's first (repressive) response are: The FBI's COINTELPRO operation, the murder by the Chicago police of Black Panther Fred Hampton, the frame-up of L.A. Panther Geronimo Pratt for murder, and many other such incidents. Concessions came in the form of programs and positions that were made available to provide African Americans access to broadcast media. It should be noted that these measures were taken not out of benevolence or goodwill but, rather, were the result of pressure placed on them by black protest for a share of the American pie as we perceived it.

One of these earned concessions was the creation of the PBS *Black Journal* series, under the leadership of veteran filmmaker William Greaves, who served as its executive producer. The *Black Journal* series provided an African American "from-the-inside" advocacy voice in its documentaries, and as a result helped change the editorial treatment of African Americans in mainstream television, where, before, a black point of view was rarely presented.

Political and social change was in the air. As African Americans began to establish a base of power, other disenfranchised groups (Latinos, women, gays, and so on) began using the techniques of black activists, and they too slowly began to gain media access. Other factors were also at work. In the theatrical film industry, skyrocketing production costs and dwindling attendance figures were creating a crisis for several of the major Hollywood studios. The co-optation process, encouraged by market forces, kicked into high gear as a wave of profitable movies oriented toward African Americans became the economic lifesaver for Hollywood in those years.

Outside of Hollywood, an African American independent cinema has existed since the early 1900s in direct response to the racist caricatures to be found in America's pioneer white movies. Approximately 150 companies produced hundreds of films that ranged from black "imitation Hollywood" images to images that showed the diversity and the depth of our community. However, it was Melvin Van Peebles—the Charlie

Parker of American cinema—who played the key historical role in reestablishing African American films as a cultural force with his film *Sweet Sweetback's Baadasssss Song*.

Melvin Van Peebles was born in Chicago and graduated from Ohio Wesleyan University before serving as an officer in the U.S. Air Force's Strategic Air Command, flying as a navigator-bombardier. After his return to civilian life, he trained as a painter in Mexico and subsequently worked as a cable-car gripman in San Francisco. On the basis of several short films he made while living in San Francisco, Van Peebles was invited to France by the Cinémathèque in Paris.

After having written five novels in French and thereby qualifying for a French director's card, he made his first feature film, *La Permission (Story of A Three-Day Pass)*, a bittersweet romance between an American soldier and a French girl. That film brought him back to America as a "French" delegate to the 1967 San Francisco Film Festival, where it was acclaimed the critics' choice. Shortly thereafter, he was hired by Columbia Pictures to direct *Watermelon Man*, a comedy about a white bigot who one day wakes up and discovers he's black.

In 1970, instead of accepting a three-picture contract with Columbia Pictures, Van Peebles struck out on his own. His 1970 film *Sweet Sweetback's Baadasssss Song* was a celebration of resistance, that told the story of a "black underclass" brother's growth in consciousness, fighting and beating the police and escaping.

When Melvin Van Peebles started production on *Sweetback*, he had no idea that his pioneering efforts would produce not only a new film but a new attitude. That attitude, based on Van Peebles' desire to see images of African American life as he perceived it, was reflective of (and, in turn, energized by) the civil rights and Black Power movements. Melvin Van Peebles, in creating "new" images that tapped into the black rage of the times, encouraged a generation of others to create their own visions of life on film as well.

Even the photographs used to publicize the film were in themselves icons of resistance and certainly challenged the role in which white American culture tries to imprison us. The head shot of Van Peebles, for example, looks directly and defiantly at the viewer—a symbol of black positioning to white America during those times. There is no hint of eyes diverted in fear or shame; rather, this iconic black face projected

an attitude that challenged racism and at the same time reinforced the then new "Black Is Beautiful" ethos. The second photo, that of Sweetback strangling a policeman, is infinitely more aggressive and is, even today, years later, still white America's nightmare. Witness the turmoil surrounding the protests by police organizations all over the country against the lyrics of rap artist Ice-T's "Cop Killer."

Sweetback was commercially successful and demonstrated to Hollywood the box-office power of the African American audience. In its wake, Hollywood proceeded to do what it does best—absorb elements from a new innovative cultural expression and co-opt them to create a bland version of the original. These "blaxploitation" films, as they came to be known, fulfilled specific economic and psychological purposes at the service of an ideology of white superiority, not an unusual pattern for the managers of European American culture.

Blaxploitation films were full of contradictions. Most of the stories in these films took place in a black community and featured a largely black cast. Yet the crews, writers, and directors were usually white. The villains were always white males, but white males whom the white world was comfortable with as "bad guys" (crude Mafia thugs, drug dealers, or "crazies"). Because the black movement of the times overemphasized the rhetoric of "regaining lost manhood" (which today would be considered extreme male chauvinism), the black male image in these films ultimately became a new stereotype. African American women were, accordingly, ill-treated, usually assigned a role in which they lounged around in scanty clothes between beatings at the hands of the bad guys or while waiting to be rescued by the good guys. Later, black women would be treated to their own gun-toting, miniskirted, stereotyped roles such as "Foxy Brown" or "Coffee." (Today they would be called "gangsta bitches.") After roughly two dozen films in which the formula story line was recycled over and over, audiences quit going and this genre died.

Still, the question remains: Why did so many black people pack the theaters to see these films? A key element in African American cultural expression is the resistance to racist treatment and the assertion of collective and individual strength to overcome those barriers. The African Americans portrayed in the blaxploitation films were depicted as fighting the system in one of its manifestations and winning—although in this

Cop Gets It, 1971
MOVIE STILL FROM *Sweet Sweetback's Baadasssss Song*
(COURTESY CINEMATON INDUSTRIES)

case, "winning" usually consisted of little more than beating up the scum of the white community, exploiting and mistreating women, and even selling dope. But to people who had seen only "coon" roles in a steady stream of Hollywood films, these new films were "progress" of a sort.

There were also African American independent filmmakers who attempted to counter the blaxploitation films. *The Spook Who Sat by the Door, Ganja and Hess, The Long Night*, and *Top of the Heap* are some of the efforts that come to mind. In addition, film journalist Clyde Taylor has written extensively about the burst of creativity that occurred at UCLA's film department in the mid-1970s. Energized by the momentum of the Black Power, Pan-Africanist, and cultural nationalist movements, a group of young film students—Haile Gerima, Julie Dash, Larry Clark, Charles Burnett, Pamela Jones, Ben Caldwell, Billy Woodberry, and others—shared in the production of each other's films, works that went well beyond the category of student films and

aiming toward the development of a new wave of black dramatic films, alternatives to the black exploitation films that Hollywood was then producing. Taylor has also commented that what was remarkable about this movement was the portrayal, for nearly the first time, of black women with a legitimate, positive existence of their own. Although varied in approach, the films of Julie Dash, Alile Sharon Larkin, Pamela Jones, and Barbara McCullough began exploring the interior complexity of the black woman persona.

There were several spin-offs from independent African American film activity. Film groups like the African Film Society in Atlanta and San Francisco and the Blacklight Film Festival in Chicago sponsored screenings and invited filmmakers to appear with their work. At the same time, films by African filmmakers like Ousmane Sembene, Med Hondo, and Ola Balagun began to be shown here and, even though they were not seen by a large African American audience, they did influence black critical taste by providing a point of comparison with Hollywood's black films. Where white Hollywood films featured perhaps one stereotypical black character and black Hollywood films featured updated "coon"roles, most of the African films that made it to these shores presented a wide range of black characters.

Looking forward, there are both hopeful and frustrating signs. Although this current generation of black working filmmakers are the benefactors of the cultural nationalism and Black Power movements of the late sixties and early seventies, the latest group of filmmakers seems to march to a different ideological drumbeat distinct from African American independent filmmakers. For starters, their films do not invoke themes of resistance and in some instances actually avoid an up-front sense of politics, a traditional characteristic of independent black films. They eschew the very political sensibilities that brought black filmmaking to where it is today.

Secondly, most of the Hollywood African American filmmakers are stuck with the same old—albeit updated—narrow choice of character types. Whereas before the stereotypes demanded "cool cats" and "fine mammas," now the scripts that the studios are willing to underwrite call almost exclusively for "hip-hop B-boys" and "gangsta bitches," thus restricting contemporary directors to the formulaic "black life is oppressive in the ghetto" message. In the process, these films limit the

responses to this oppression to dancing your way out (à la *House Party*), losing your soul to middle-class corporate life (à la *Strictly Business*), or dying in a blaze of gunfire (à la *Menace II Society*). These concepts are a reinvention of the same old artistic wheel, though perhaps with bigger budgets.

On the other hand, a black independent film such as Norman Loftus's *Small Time* shows that you can examine the world of the black underclass with intelligence and insight. Another independent film, Wendell Harris's *Chameleon Street*, explores the complexities of black middle-class life in a creative way rather than reduce the lifestyle to a shallow imitation of white corporate life. Of course, Spike Lee's commitment to political themes is well known and Julie Dash's *Daughters of the Dust* combines Afrocentric cultural politics and cinematic lyricism in a style and scale unprecedented in the history of American cinema. Charles Burnett's films (*Killer of Sheep, My Brother's Wedding,* and *To Sleep With Anger*) explore with sensitivity the pressures that come to bear on working-class African American life. Bill Duke's *Deep Cover* has shown that even within the confines of the standard Hollywood "cop" genre, he has the ability to create a filmic "outside renegade" vision, an artistic element central to the depiction of African American life in America.

Everyone wants to see their lives dealt with honestly and in their full variety. Hollywood has proven itself unwilling to do that with American life in general and African American life in particular. To their credit, Melvin Van Peebles and other independent filmmakers have endeavored to fill that vacuum, and continue to do so. Perhaps by their efforts Baldwin's "burning house" will someday seem a beacon of enlightenment.

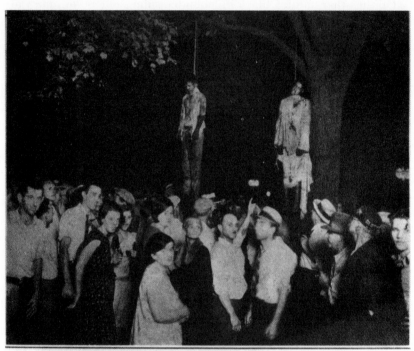

CIVILIZATION IN THE UNITED STATES, 1930
The lynching of Tom Shipp and Abe Smith at Marion, Indiana, August 7, "by party or parties unknown." Page 353

The Lynching of Tom Shipp and Abe Smith at
Marion, Indiana, August 7, "By Party or Parties Unknown," 1930
PHOTOGRAPHER: UNKNOWN
(COURTESY SCHOMBURG CENTER FOR RESEARCH IN BLACK CULTURE)

HOW COME NOBODY TOLD ME
ABOUT THE LYNCHING?

Jacquie Jones

I CAN'T SAY THAT I REMEMBER EXACTLY THE DAY I SAW THE photograph, or even the book I saw it in. All I remember precisely is the image, a man strung to a tree, limp and yet not dead-looking, dressed in the clothes Christ wore in his last earthly moments. And then, below, the white men who surrounded the spectacle in the spectacle: a child on the shoulders of one, a blur beneath the hat of another, still another with a Hitler mustache, pointing ambiguously.

I remember, too, the shudder that went through me, that changed the way I looked at everything from that moment on. I remember how long, how intently I looked at that photograph, reproduced carelessly in the tome, added as an afterthought to whatever the text was, no doubt. I was in high school at the time, eleventh grade, to be exact. It was the same year I was introduced to Gwendolyn Brooks and Ossie Davis, the year I read *The Autobiography of Malcolm X* and *Native Son* and all I could of Mao's Red Book. And still, it shocked me.

Something about it was so matter-of-fact.

Now, my upbringing was not a particularly sheltered one. By the time I saw that photograph, my parents had been separated for ten years. The same year as the Watergate break-in, my mother, a former Washington debutante, grew an Angela Davis afro and struck out on her own, with me and my brother in tow. We ended up in Memphis, Tennessee, and that is where I grew up: in the aftershock of Martin Luther King's assassination, the white response to Black Power, and in the mire of forced desegregation of public schools.

My mother relocated from Brooklyn to assume the post of educational director for the Urban League in Memphis at a time when that city was going through intense social changes. Although those changes are still all but invisible to the uninitiated, the times were indeed turbulent. For the first time, eyes were trained on the inequities and the misery suffered by most black Memphians, who constituted a sizable chunk of Memphis's population. Everybody was angry and battle-worn.

As the 1970s reached middle age, token integration reached its height, and I was one of its conspicuous beneficiaries. I was the only black girl in my Girl Scout troop; and for a year, I was the only black student at a private junior high school. At the time, all this meant to me was that, by the time I was sixteen, I had been called "nigger" more times than I had probably been called anything else, except maybe "Jacqueline Michelle Jones," which I heard anytime I got on my mother's nerves.

I had known intense, personal racism. I had known the ubiquitous, institutional kind as well. I knew that everybody in the projects was black. I assumed that was not a coincidence. I knew about slavery. I knew about the debacle of Reconstruction. I knew about the half-truths and out-and-out lies of the history books. I knew that white racism was cowardly and self-defeating, indicative of moral inferiority. I knew that it was a disease, one begotten of ignorance perhaps, but one that was also ultimately and inevitably punishable. At least, I thought it was.

But then I stared at that photograph again, I checked the styles of the hats and suits, and I thought, "These people aren't dead yet. The man with the blur could have issued my driver's license. That little boy could be my history teacher." I realized that it was a moment that was not quite spent, not quite gone. And I realized that racism and race hatred were phenomena not easily stereotyped or ghettoized, not easily dismissed, as they customarily were at school and at home .

So, in the moments that I studied this man long dead, his shoulders and hands and shins, his lolling head, his bloody clothes, I realized the fundamental contradiction of the world in which my brother and I had grown up, the insular world of after-hours de facto segregation that still encompasses the majority of African American children, though these days not so benevolently. On the one hand, we had not been kept from much of the hostility of racists, but, on the other, we had been kept ignorant of some of the far-reaching consequences of racism. We had not been told of the true danger. In fact, we had been led to believe that precious rewards lay ahead, compensations for the indignities we suffered in our pioneering forays: the Ebony Fashion Fair, *Soul Train*, and, when we were older, Boonesfarm.

Our knowledge of slavery was circumspect and philosophical. We knew nothing of shipping slaves stacked four deep, one on top of the

other, of the customary rape of black women, of the metal ring worn around the neck to keep slaves from eating crops, of the slow death that came from harvesting the poisonous indigo. We knew nothing about lynching.

And, above all, we had been led to believe that there was always a safe place, a place we could come back to at the end of our day, a place we could not be touched, spiritually or physically, by the contempt that so defined our public existence as black children in the post–civil rights South. But here was proof, that no matter our diligence, our futures could never be guaranteed. Now, in retrospect, I realize how fragile our world was, how tentatively situated between fire hoses and riots and crack cocaine and Uzis.

African Americans had clamored for integration, and they had gotten it, cosmetic though it may have been. No teacher would ever again tell a young black child that it was unrealistic to dream of being a lawyer, as Malcolm X had been told. Instead, they would tell that child, "Study hard and you can get a minority scholarship." And they might even add, "Don't worry—you don't even have to do as well as the white students. We don't expect that much from you." The brightest black students would be discouraged from going to historically black colleges and universities now that the doors to "good" schools had been opened so courageously by the generation before. "Why waste your talents?" they would say.

Instead of locking black children out of opportunity with outdated textbooks and inferior facilities, there was the more modern method, the more direct assault. They would measure us with a yardstick that said we were always, always, second-rate and then they would place this photograph in our history book as an aside. They didn't bother to explain who took the photograph, when it was taken, who this black man was, or even why he was lynched. It was there just to say that lynchings happen, that when hateful crimes are committed against black people, no explanations are warranted. It was there to say that racism is casual and normal.

By the time the eighties arrived, the filter of integration had removed this ordinariness from our consciousness. The very concept of racism had changed. Without the obvious and concrete barriers of compulsory segregation and the conspicuous denial of basic human rights, the idea

of racism was reduced to individual grievances. Success or failure, we were taught, depended on personal industry and relative competence. But still, there was that black man swinging below that sprawling tree as white men looked on and chatted, as unaffected as if they were at a picnic. These white men did not look like the evil overseer in *Roots*, or the crazed Bull Connor. They didn't even look like the redneck Confederate wannabees in southern public schools.

Eventually, I turned the page and left Memphis to attend Howard University—despite the objection of my guidance counselor, who thought Harvard would have been a better choice. At Howard, two years later, I saw the photograph again. This time in Abdul Alkalimat's primer *Introduction to Afro-American Studies*. This time, the framing was different, pulled back to show two lynching victims. I felt sick this time. Not amazed, ill. This time I could see smiles, sense the personal jokes at play. "Look at the size of that one," I could hear them quipping. "Ha, ha, ha. The hair on that last youngin' of yours is kind of kinky."

It was like a social event. Were white men asking each other, I wondered, "How come nobody told me about the lynching?" Was it like the Kappa Alpha Psi Black and White Ball or Homecoming at Howard? Did they drink liquor and go home like John Wayne? Wake their women and attempt to implant them with fledgling racists? How did this night, these nights, end? Where were these fellows now? Had they all, like George Wallace, found God?

Even walking down the hall of an all-white junior high school, I had never considered the pervasiveness of the threat this photograph signified for me. I was no longer in Memphis. I was in Washington, D.C., the nation's capital, the seat of government, the refuge of the legitimacy of my rights. Shouldn't I be safe here, at least? But there it was again on PBS, and again on PBS, and again in print. And there it was again and again and again. What did it mean? Was the image, the recurrence of the image, the proliferation of the image, an inside warning or an outside threat?

In each context, the message seemed to be different, the faces in the crowd changed: at times, they were laughing; at others, they took on demonic proportions. At a reluctantly desegregated high school, the photograph was inflicted on us by a white teacher, like a subliminal lashing. At a black college, it was trotted out, like a Nazi war crime. In

William Greaves' documentary on the life of the African American journalist and activist Ida B. Wells, *Passion for Justice*, it was an illustration of the immediacy and hazard of Wells's antilynching crusade. But in each case, it devastated, because it made concrete in one moment the brutal history, the living legacy of human bondage and racial tyranny that Americans, both black and white, would prefer to forget.

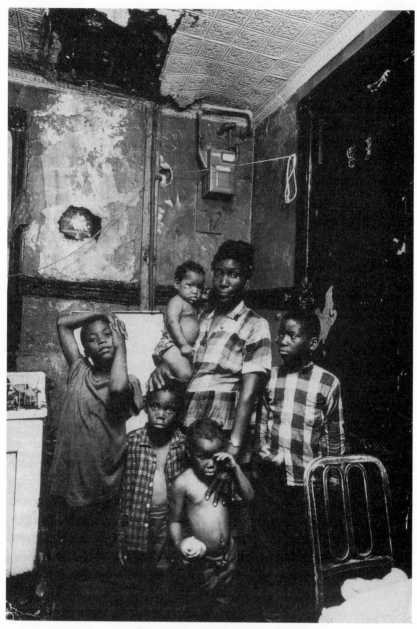

Hard Core Poverty, 1966

PHOTOGRAPHER: JOHN LAUNOIS (COURTESY BLACK STAR PHOTOS)

HARD CORE POVERTY

Paul A. Rogers

From the moment of its equation in the modern era as a sign of slave status, black subjectivity has remained an irreducible, biological phenomenon despite the attempts to verify its existence in cultural terms. Since the late nineteenth century, and especially during the twentieth, various efforts have been made to displace the discourse on black subjectivity to the realm of culture—to describe particular cultural and artistic forms or behaviors as products of an African historical and cultural matrix. While in the strictest formalist terms, such descriptions may be true, I believe they sidestep the more persistent reality: namely, that black people in the Americas are seen as differing social subjects not because their ancestors came from another place (in this case, Africa) but because of the color of their skin. In other words, the status of black racial difference is predicated upon the recognition of corporeal difference, not different language or religious or cultural practices. Elvis Presley may sing in a style that ultimately traces back to modes of vocal production found in West Africa, but he is not a black man. In turn, Leontyne Price may finesse the pyrotechnics of operatic singing as well as any European diva, but she is still a black woman. In both instances, it is their physical bodies—Hortense Spillers calls it the "flesh"—that prohibits their occupation of the racial category commonly associated with their practices.

When I began to study the topic of racial representation in American art at the commencement of my graduate study, I knew I was studying a highly rarefied group of cultural objects—paintings and sculpture, not spy novels or Hollywood films, like some of my American Studies peers. Nonetheless, I was shocked and, frankly, disappointed, at the total absence of images of resistance and subterfuge. Where were the images of the strength and cunning of the Nat Turner rebellion, the enraged and disgusted black man surmounting, at his peril, the evil and wicked overseer, or the calculating, sex-abused black woman in the kitchen blending a poisonous root into her captor's meal—the sort of personages populating the novels of Toni Morrison. As her novels imply, we

know these figures existed. However, if visual images play the crucial role in the construction of history that all of my readings were telling me, what was made of these historical personages and their struggles that continuously took place? Driven by the same interrogative predilection that, I believe, consumed the early-twentieth-century art historian Freeman Murray, I wanted to confirm, through my studies, my long-held conviction that the very sight of black people in American society operated functionally like talismans, magical, fetishistic objects capable of causing some of the most sordid behavior to be directed toward them, everything from pogroms in broad daylight to the twisted and contorted desire of rape.

Recently, I was challenged by the idea of zeroing in on how it is that black artists have transformed and subverted the logics constructed in visual images that define "blackness." If a particular body of images were/are "arguing" that blacks are like this or like that, how have these arguments been overturned, challenged? I began to ask myself these questions in relation to the collages of Romare Bearden from the sixties, which include photo-fragments of black (and white) people torn from magazines. Categorizing the photographs from which these photo-fragments were torn as generically photo-documentary—images representing the social realities of particular subjects—I wanted to explore how Bearden's work performed an operation upon this visual discourse that, more often than not, presents the existential circumstances of the scene represented as occurring naturally, without the intervention of social or cultural forces.

John Launois's photograph *Hard Core Poverty* (1966) depicts a single-parent family of six posed bleakly in the corner of a ramshackle room. In the center of the grouping, staring frankly at the viewer with a wry brand of exasperation, stands the mother with a young infant nestled in her bent right arm, with the hand of that arm resting upon the head of one son and her left hand holding onto the upper torso of another—holding him back, or perhaps comforting him. He is rubbing his eyes, as if crying, and his lower lip juts forward in a pouting gesture. To her right stands a dreamy-eyed boy with his fingers entwined and palms wrapped around the side of his head in a gesture of youthful ennui. To her left, another boy, a little older, glares across at his carefree brother.

All of the signs of poverty are here. Paint is peeling from every wall and, in the upper-left corner of the room, a large hole pierces the wall. The

sense of crowding is overwhelming. All of American life's daily household chores and functions are confined to this one room: above the mother's head a rope (for laundry?) stretches from one wall to another; behind a portion of it, attached to the wall, is a gas or electric meter; on the left side of the photograph stands what appears to be a sink. Squished up against the wall, huddling in the corner, how can this family manage in such a miserably overcrowded space? How can this mother, over-whelmed as she must be with her five children, function in such an envi-ronment—indeed her paunch suggests the impending arrival of yet another mouth. More broadly considered, how do race, gender, and poverty intermingle here so convincingly, causing a naturalizing effect to occur: in the space of this photograph, and so many like it, why must the black body, the black family matrix, become the sole explanation of its social, political, and economic circumstance? What concerns me here is the way this static image of dystopia, with its supplementary but reveal-ing title, *Hard Core Poverty*, suggesting a fixed and essential quality, sig-nifies "blackness" as an irreducible condition upon whose body poverty is mapped, organized, and finally, firmly (hard *core*) situated as natural.

The generalized and dispersed impression of dilapidation the image produces is anything but innocent, as it speaks to the relationship of the group to its environment, and does so in a manner that produces moral and ethical considerations. As noted, the paint is peeling from the walls, and where attempts to repaint have been made, for example, the swath of dark paint defining a faux-wainscot, the application is sloppy, the evident grain of the brush suggesting a harried job. (One imagines some housing authority workers slapping the paint on in the crudest perfunc-tory manner, robot-like.) Similarly, the quality of the patchy, scraped area around the hole in the wall evinces slapdash labor, at best. It is not hard to imagine the dampness of the room, its unpleasant odor. Yet it is the black bodies of this family, particularly that of the mother, which activate the environment with any significance, defining the meaning of the scene represented. In noting that this is a black-and-white photo-graph, I, nonetheless, cannot help but notice the similarities between the drabness of the family's skin color and that of the surrounding walls, and the plaid-like play of light and shadow on their faces, piti-fully mimicking the walls, and, almost comically, repeated in the pat-tern of the mother and son's shirts. Moreover, all wear clothing evincing

various states of pauperization: as indicated, the mother and the son to her left wear shirts of the same cloth, the young crying boy wears no shirt, and his brother next to him stands with an open shirt that is missing buttons. Intestinal disorder is evinced in the protruding stomach of the young boy closest to the viewer.

The sense of abandonment and sheer out-of-controllness are barely contained by the family-portrait pose. In fact, I'm disturbed by the evident distance from the family portrait's implied purpose—generational edification, group proclamation of love and togetherness, declaration of progenic well-being. The mother seems to have only temporary control over her children. The hand pressing upon the chest of the child in front of her is tense, as she no doubt only moments before succeeded in restraining him; and her other hand, atop the head of another boy, is pivoted as if she has turned his head toward the camera and remains holding it there. And it would seem that the angry brother stares at his sibling because of his playful gesture, his willingness to resist the protocols and seriousness of the situation. Any minute they may explode. This corporeal/architectural equation would seem precious were it not for the metaphoric resonances that determine its meaning according to the ethical and moral discourse of North America. Very briefly, poverty and its effects are the spawn of personal moral lassitude; lack of industry is the cause of poverty; to be unclean is to be immoral, and so on. These are staples of the American moral diet.

What *Hard Core Poverty* succeeds in representing is a vision of blackness that is the result of a dysfunctional matriarchy, ostensibly thematized as a cultural—not natural—phenomenon, but visually buttressed, nevertheless, by a series of metaphors that ground meaning, explanation, blame, in the body of the mother. I can't help but note the absence of a father; yet she is curiously productive. Is she both man and woman? Her chest is flat, "masculine," yet, as noted, she appears to be pregnant. Is she some unknown sort of self-sustaining organism, capable of self-impregnation? All the children appear male, does she also bear the responsibility of transmitting masculinity and their role in society as men to them? Most significantly, what am I to make of the strange absence of history in this image.

Often in the family portrait produced at home, some attempt is made through the use of props or staging to add further significance to the

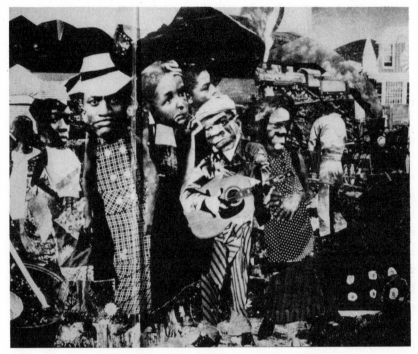

Watching the Good Trains Go By, 1964
COLLAGE BY ROMARE BEARDEN (COURTESY PAUL ROGERS)

scene—posing near the fireplace or the family trophy chest, with paint-
ings or photographs in the background, or clutching memorabilia in
one's hand. But other than the clothes on their backs, this family
appears to have no possessions. And these absences do more than pre-
sent to us the "reality" of hard-core poverty, or, for our sociological
appetites, place on display a concrete example of a dysfunctional family
structure appallingly outside the realm of the bourgeois norm. In the
context of bourgeois ideology, such material accoutrements serve not
only as benign descriptives of a given family's social standing or accom-
plishments, but serve more importantly as markers inscribing the fam-
ily and its individual members in some meaningful way in the grand
narratives of History, Culture, and Society. This family, significantly,
bears no such relations, and it is race that structures their negation.

This racialization as the natural effects a type of dehistoricized sub-
jectivity, a form of trans-historical lumpenization. In *Hard Core Poverty*

what I'm presented with is any old dirty kitchen, any old place. Some-one might successfully place it in the twentieth century, but is this the fifties, the twenties, or the nineties? Fossilized, the surrounding envi-ronment appears to have resisted its possible transformation in time through design overhaul: this mother has been standing in this same room for centuries.

I believe the rhetoric of racial representation transforms considerably in the context of Bearden's collage. In *Watching the Good Trains Go By* (1964), photo-fragments, torn and cut strips of colored paper, and cut shapes from photostatically reproduced images form a densely com-pacted space in which several figures stand gazing outward in several directions. The figures are formed by a dazzling array of textures, play of light and dark, planar shifts, and, because of the preponderance of photo-fragments, temporal and spatial shifts in "reality." Each photo-fragment carries in minute form the sanction of modern society's consent to the "truth" of the photograph. It is a commonplace in our culture that the photograph possesses physically an indication of an irrevocably "objective" presence, what John Tag refers to as the "corresponding pre-photographic existent."[1] I know that the photo-fragments are culled from photographs of "real" people, that they are records of actual events. The photo-fragments are sufficiently sparse and physically large enough to inspire an effort to reconstruct an image of their respective "prior exis-tents." For example, the central figure playing the guitar "wears" frag-ments of clothing culled from photographs of different people. His fore-head, nose, and upper lip are one man's, his ears are another's, while his chin and lower lip are yet someone else's. Nonetheless, at the very least I can begin to imagine what these people looked like; cognitively, each fragment retains a degree of autonomy, a "memory" of its prior unfrag-mented "being." The point here is that the presence of these multiple others coheres precisely in the creation of a distinct individual figure. Indeed, it is through the complex interplay of media and technique that the resultant formal configuration of each "subject" analogizes, or, more specifically, allegorizes the relationship of the individual to community. An underlying message of images such as *Watching the Good Trains Go By* seems to be the impossibility of individual existence without the reci-procal exchange with community, and vice versa.

In *Watching the Good Trains Go By*, the evidences of poverty are rep-

resented as the reality of daily life, persistent circumstances through and around which the subjects work, play, and, crucially, muse. However, the transformation of these spaces—as I see it, their reenchantment—hinges upon the foregrounding of the subjects in all of their modal variety; the markers of poverty function limitedly in a stipulative manner, identifying the locale, the scene, but not the meaning of the subjects represented. For example, to my eyes, the figures in *Watching the Good Trains Go By* bear the markers of poverty: the two figures on the left side of the collage and the figure just to the right of the center of the collage wear patchwork clothing that have the appearance of being thrown together—polka dots with knitted sweater, floral patterning with appliqué work. Two of the figures are barefooted and we cannot help but notice the pail of porridge in the bottom-left of the image. The tawdry quality of this clothing is reminiscent of the shabbiness epitomized in *Hard Core Poverty*. Upon further examination, however, the focus here is less illustrative, less documentative, than it is poetic. What the image enacts is an attempt to reveal formally a playful aesthetic at work, one transforming the vestiary flotsam of American society into local fashion. Bearden is clearly pointing one in the direction of African American quiltmaking, a tradition that applied a rhythmic, West African–derived principle of (to Western eyes) dissonant pattern combination/organization to the socioeconomic realities of disfranchisement that resulted in, amongst other things, an imposed scavenger-junkman relationship to vestiary goods (and we know the same to have taken place with food). It was the woman-created tradition of quiltmaking that transformed this obscene state of affairs to one of aesthetic transcendence, an instance of the concrete transformative capacity of art within the sphere of lived experience. Throughout Bearden's collage we witness this instance of the very type of work/play that remains concealed in images such as *Hard Core Poverty*. Because this vestiary transformation is situated across the bodies of his figures, Bearden seems to suggest that all of his figures are quilters, and, by synecdochic implication, suggests that African American culture functions as—that is, *is*—one inherently transformative.

The pensiveness of Bearden's figures is particularly noteworthy. When we read these eyes as indices to a larger scope of mediatory possibilities, we can begin to understand the value of the sort of temporal transformations Ellison cogently identified in Bearden's work ("sharp

breaks, leaps in consciousness, distortions, paradoxes, reversals, telescoping of time"). I can only imagine that they are thinking about their past, present, and future, their pains, joys, triumphs, and defeats. Embedded in a series of disjunctive planar shifts, suggesting a random and immediate movement from one spatial circumstance to another, these gazing figures suggest a reworking of time that overturns the dehistoricizing logic that essentializes blackness as a subjectivity outside of history, one arriving at the shores of contemporary societal experience thoroughly and completely worlded.

Recall the muddied surfaces, dark corners, and looming shadows of *Hard Core Poverty*. It is these environmental factors, I have argued, that provide the meaningful spaces across which the black body defines itself and its meaning within the image. As they frame and reflect this pathetic family portrait, their threatening emptiness functions provisionally as an indexical barrier rerouting explanation of the tragedy envisioned back onto the bodies themselves; in other words, for me there is no explanation, indeed there is no need; the meaning *is* its revelation—seeing is not only believing but knowing. Accordingly, the subjects represented are anything but inscrutable; the transgression of social values embodied in the compromised relation with the surrounding environment—now clearly a person(al) problem—is immanent (biologically derived) *and* transparent (inscribed across their bodies). Bearden's collage functions radically differently. If *Hard Core Poverty* denies the possibility of external explanation, Bearden invests these same bodies and spaces with a descriptive depth and quality that overturns the logic of their constitutive divestiture. To be sure, one never finds in Bearden's work an attempt to represent concretely the systemic explanations of the black experience: we see no images of the tragedies of the welfare office, the violence of the police state, nor the ravages of urban transiency. Rather, Bearden's project involves a fundamental conceit, that is, while his images necessarily sustain the rhetoric of an implied will possessed by the subjects represented, the difference lies in the construction of a vision of "blacks," or a vision of a "black" world (some might say a "black" vision) that is not, in turn, thwarted by the limits of biological destiny, which imputes blame back to them. Thus what I call reenchantment involves the displacement of black subjectivity from the realm of biology, remapping it through the visual discourse of culture.

In conclusion, I have focused on the transformation of a form of visual representation that, through a series of spatio-temporal metaphors, establishes black subjectivity as one of *biological* difference, into one of *cultural* difference, and I want to end with some broader speculations on the implications of this process for contemporary cultural theory. Recently much has been said about the surreptitious rearticulation of biologized racialism as a form of cultural difference.[2] According to these critiques, culturalist discourses that speak of lineages, heritages, traditions, roots, gifts, and so forth, ultimately dip into the pot of essentialism, which is to say, they succumb to the biological assumption of irremediable difference, engendering a degree of epistemological concern that frankly, I find unwarranted and impractical. What is too often left to the side of such considerations is politics, the affairs and conduct of everyday social life, and how discourses participate in and are the result of the construction of that social life. Social categories are inherently mystifying, concealing their origins as social constructions. But upon revelation of their constructedness they do not disappear, nor do they simultaneously reveal the possibilities for alternative constructions. The latter occur through process, and this is what I mean when I say politics. Bearden's trans-historicizing construction of black subjectivity might, at first glance, be adequately explained as essentialist in its implicit insistence upon an enduring culturalized blackness, one resisting diachronic transformation or reconstitution. And in its explicit, if fragmentary, reliance upon the racial (corporeal, biological) "proof" of the photo-fragment—in the collage space, undoubtedly the most intractable recognizable code of blackness—the collages could be said to attempt, semantically at least, maintenance of the idea that there is an essential quality that sustains itself across time, one that is immanent. However, what is important is the transformation of this thematic—the question of historicity—from one of an articulated emptiness (the collapse into biology) to one of cultural and social fullness, a visual argument of ontological and experiential repletion.

NOTES

1. John Tag, *The Burden of Representation* (Amherst, 1988). Tag's comments on the use of the photographic image in the legal sphere are useful for a discussion of consent with respect to not

only photographic, but all images: "...an image produced according to certain institutionalised formal rules and technical procedures which define legitimate manipulations and permissible distortions in such a way that, in certain contexts, more or less skilled and suitable trained and validated interpreters may draw inferences from them, on the basis of historically established conventions. It is only in this institutional framework that otherwise disputable meanings carry weight and can be enforced (p. 95)."

2. For example, after an explicit examination of the way race is constituted in a variety of literary, cultural, and academic discourses, Walter Benn Michaels argues: "If...our culture can only function as a justification of our values insofar as it is transformed into something more than a description of them, then the question of which culture we belong to is relevant only if culture is anchored to race. Our sense of culture is characteristically meant to displace race but...culture has turned out to be a way of continuing rather than repudiating racial thought. It is only the appeal to race that makes culture an object of affect and that gives notions like losing our culture, preserving it, stealing someone else's culture, restoring people's culture to them, and so on, their pathos. Our race identifies the culture to which we have a right, a right that may be violated or defended, repudiated or recovered. Race transforms people who learn to do what they do into the destroyers of our culture; it makes assimilation into a kind of betrayal and the refusal to assimilate into a form of heroism." Walter Benn Michaels, "Race into Culture: A Critical Genealogy of Multiple Identity," *Critical Inquiry* (summer, 1992), pp. 684–85.

WANTED BY THE FBI

INTERSTATE FLIGHT - MURDER, KIDNAPING
ANGELA YVONNE DAVIS

FBI No. 867,615 G

Photograph taken 1969 Photograph taken 1970

Alias: "Tamu"

DESCRIPTION

Age:	26, born January 26, 1944, Birmingham, Alabama		
Height:	5'8"	Eyes:	Brown
Weight:	145 pounds	Complexion:	Light brown
Build:	Slender	Race:	Negro
Hair:	Black	Nationality:	American
Occupation:	Teacher		
Scars and Marks:	Small scars on both knees		

Fingerprint Classification: 4 M 5 Ua 6

1 17 U

CAUTION

ANGELA DAVIS IS WANTED ON KIDNAPING AND MURDER CHARGES GROWING OUT OF AN ABDUCTION AND SHOOTING IN MARIN COUNTY, CALIFORNIA, ON AUGUST 7, 1970. SHE ALLEGEDLY HAS PURCHASED SEVERAL GUNS IN THE PAST. CONSIDER POSSIBLY ARMED AND DANGEROUS.

A Federal warrant was issued on August 15, 1970, at San Francisco, California, charging Davis with unlawful interstate flight to avoid prosecution for murder and kidnaping (Title 18, U. S. Code, Section 1073).

IF YOU HAVE ANY INFORMATION CONCERNING THIS PERSON, PLEASE NOTIFY ME OR CONTACT YOUR LOCAL FBI OFFICE. TELEPHONE NUMBERS AND ADDRESSES OF ALL FBI OFFICES LISTED ON BACK.

J. Edgar Hoover

DIRECTOR
FEDERAL BUREAU OF INVESTIGATION
UNITED STATES DEPARTMENT OF JUSTICE
WASHINGTON, D. C. 20535
TELEPHONE, NATIONAL 8-7117

Entered NCIC
Wanted Flyer 457
August 18, 1970

AFRO IMAGES:
POLITICS, FASHION, AND NOSTALGIA

Angela Y. Davis

NOT LONG AGO, I ATTENDED A PERFORMANCE IN SAN FRANCISCO BY women presently or formerly incarcerated in the County Jail in collaboration with Bay Area women performance artists. After the show, I went backstage to the "green room," where the women inmates, guarded by deputy sheriffs stationed outside the door, were celebrating with their families and friends. Having worked with some of the women at the jail, I wanted to congratulate them on the show. One woman introduced me to her brother, who at first responded to my name with a blank stare. The woman admonished him: "You don't know who Angela Davis is?! You should be ashamed." Suddenly a flicker of recognition flashed across his face. "Oh," he said, "Angela Davis—the Afro."

Such responses, I find, are hardly exceptional, and it is both humiliating and humbling to discover that a single generation after the events that constructed me as a public personality, I am remembered as a hairdo. It is humiliating because it reduces a politics of liberation to a politics of fashion; it is humbling because such encounters with the younger generation demonstrate the fragility and mutability of historical images, particularly those associated with African American history. This encounter with the young man who identified me as "the Afro" reminded me of a recent article in the *New York Times Magazine* that listed me as one of the fifty most influential fashion (read: hairstyle) trendsetters over the last century.[1] I continue to find it ironic that the popularity of the "Afro" is attributed to me, when, in actuality, I was emulating a whole host of women—both public figures and women I encountered in my daily life—when I began to wear my hair natural in the late sixties.

But it is not merely the reduction of historical politics to contemporary fashion that infuriates me. Especially disconcerting is the fact that the distinction of being known as "the Afro" is largely a result of a particular economy of journalistic images in which mine is one of the relatively few that has survived the last two decades. Or perhaps the very

WANTED BY THE FBI

INTERSTATE FLIGHT - MURDER, KIDNAPING
ANGELA YVONNE DAVIS

FBI No. 867,615 G

Photograph taken 1969

Photograph taken 1970

Alias: "Tamu"

DESCRIPTION

Age:	26, born January 26, 1944, Birmingham, Alabama		
Height:	5'8"	Eyes:	Brown
Weight:	145 pounds	Complexion:	Light brown
Build:	Slender	Race:	Negro
Hair:	Black	Nationality:	American
Occupation:	Teacher		
Scars and Marks:	Small scars on both knees		

Fingerprint Classification: 4 M 5 Ua 6
1 17 U

CAUTION

ANGELA DAVIS IS WANTED ON KIDNAPING AND MURDER CHARGES GROWING OUT OF AN ABDUCTION AND SHOOTING IN MARIN COUNTY, CALIFORNIA ON AUGUST 7, 1970. SHE ALLEGEDLY HAS PURCHASED SEVERAL GUNS IN THE PAST. CONSIDER POSSIBLY ARMED AND DANGEROUS.

A Federal warrant was issued on August 15, 1970, at San Francisco, California, charging Davis with unlawful interstate flight to avoid prosecution for murder and kidnaping (Title 18, U. S. Code, Section 1073).

IF YOU HAVE ANY INFORMATION CONCERNING THIS PERSON, PLEASE NOTIFY ME OR CONTACT YOUR LOCAL FBI OFFICE. TELEPHONE NUMBERS AND ADDRESSES OF ALL FBI OFFICES LISTED ON BACK.

DIRECTOR
FEDERAL BUREAU OF INVESTIGATION
UNITED STATES DEPARTMENT OF JUSTICE
WASHINGTON, D. C. 20535
TELEPHONE, NATIONAL 8-7117

Entered NCIC
Wanted Flyer 457
August 18, 1970

FREE ANGELA

1994. PHOTOGRAPHER: ALBERT WATSON (COURTESY ALBERT WATSON)

segregation of those photographic images caused mine to enter into the then dominant journalistic culture precisely by virtue of my presumed "criminality." In any case, it has survived, disconnected from the historical context in which it arose, as fashion. Most young African Americans who are familiar with my name and twenty-five-year-old image have encountered photographs and film/video clips largely in music videos, and in black history montages in popular books and magazines. Within the interpretive context in which they learn to situate these photographs, the most salient element of the image is the hairstyle, understood less as a political statement than as fashion.

The unprecedented contemporary circulation of photographic and filmic images of African Americans has multiple and contradictory implications. On the one hand, it holds the promise of visual memory of older and departed generations, of both well-known figures and people who may not have achieved public prominence. However, there is also the danger that this historical memory may become ahistorical and apolitical. "Photographs are relics of the past," John Berger has written. They are "traces of what has happened. If the living take that past upon themselves, if the past becomes an integral part of the process of people making their own history, then all photographs would acquire a living context, they would continue to exist in time, instead of being arrested moments."[2]

In the past, I have been rather reluctant to reflect in more than a casual way on the power of the visual images by which I was represented during the period of my trial. Perhaps this is due to my unwillingness to confront those images as having to some extent structured my experiences during that era. The recent recycling of some of these images in contexts that privilege the "Afro" as fashion—revolutionary glamour—has led me to reconsider them both in the historical context in which they were first produced (and in which I first experienced them) and within the "historical" context in which they often are presented today as "arrested moments."

In September 1969, the University of California Regents fired me from my post in the philosophy department at UCLA because of my membership in the Communist Party. The following summer, charges of murder, kidnapping, and conspiracy were brought against me in

connection with my activities on behalf of George Jackson and the
Soledad Brothers. The circulation of various photographic images of
me—taken by journalists, undercover policemen, and movement
activists—played a major role in both the mobilization of public opin-
ion against me *and* the development of the campaign that was ulti-
mately responsible for my acquittal.

Twenty-five years later, many of these photographs are being recycled
and recontextualized in ways that are at once exciting and disturbing.
With the first public circulation of my photographs, I was intensely
aware of the invasive and transformative power of the camera and of
the ideological contextualization of my images, which left me with little
or no agency. On the one hand I was portrayed as a conspiratorial and
monstrous Communist (i.e., anti-American) whose unruly natural
hairdo symbolized black militancy (i.e., anti-whiteness). Some of the
first hate mail I received tended to collapse "Russia" and "Africa." I
was told to "go back to Russia" and often in the same sentence (in con-
nection with a reference to my hair) to "go back to Africa." On the
other hand, sympathetic portrayals tended to interpret the image—
almost inevitably one with my mouth wide open—as that of a charis-
matic and raucous revolutionary ready to lead the masses into battle.
Since I considered myself neither monstrous nor charismatic, I felt fun-
damentally betrayed on both accounts: violated on the first account,
and deficient on the second.

When I was fired by the UC Regents in 1969, an assortment of pho-
tographs appeared throughout that year in various newspapers and
magazines and on television. However, it was not until felony charges
were brought against me in connection with the Marin County shootout
that the photographs became what Susan Sontag has called a part of
"the general furniture of the environment."[3] As such, they truly began
to frighten me. A cycle of terror was initiated by the decision of the FBI
to declare me one of the country's ten most-wanted criminals. Although
I had been underground for over a month before I actually saw the pho-
tographs the FBI had decided to use on the poster, I had to picture how
they might portray me as I attempted to create for myself an appear-
ance that would be markedly different from the one defined as armed
and dangerous. The props I used consisted of a wig with straight black
hair, long false lashes, and more eyeshadow, liner, and blush than I had

ever before imagined wearing in public. Never having seriously attempted to present myself as glamorous, it seemed to me that glamour was the only look that might annul the likelihood of being perceived as a revolutionary. It never could have occurred to me that the same "revolutionary" image I then sought to camouflage with glamour would be turned, a generation later, into glamour and nostalgia.

After the FBI poster was put on display in post offices, other government buildings, and on the television program, *The FBI*, *Life* magazine came out with a provocative issue featuring a cover story on me. Illustrated by photographs from my childhood years through the UCLA firing, the article probed the reasons for my supposedly abandoning a sure trajectory toward fulfillment of the middle-class American dream in order to lead the unpredictable life of a "black revolutionary." Considering the vast circulation of this pictorial magazine,[4] I experienced something akin to what Barthes was referring to when he wrote, "I feel that the Photograph creates my body or mortifies it, according to its caprice (apology of this mortiferous power: certain Communards paid with their lives for their willingness or even their eagerness to pose on the barricades: defeated, they were recognized by Thiers's police and shot, almost every one)."[5] The life-size headshot on the cover of the magazine would be seen by as many people, if not more, than the much smaller portraits on the FBI poster. Having confronted my own image in the store where I purchased the magazine, I was convinced that FBI chief J. Edgar Hoover had conspired in the appearance of that cover story. More than anything else, it seemed to me to be a magnification and elaboration of the WANTED poster. Moreover, the text of the story gave a rather convincing explanation as to why the pictures should be associated with arms and danger.

The photograph on the cover of my autobiography,[6] published in 1974, was taken by the renowned photographer Phillipe Halsman. When I entered his studio with Toni Morrison, who was my editor, the first question he asked us was whether we had brought the black leather jacket. He assumed, it turned out, that he was to recreate with his camera a symbolic visual representation of black militancy: leather jacket (uniform of the Black Panther Party), Afro hairdo, and raised fist. We had to persuade him to photograph me in a less predictable posture. As recently as 1993, the persisting persuasiveness of these visual stereotypes was made

clear to me when I had to insist that Anna Deavere Smith rethink her representation of me in her theater piece *Fires in the Mirror,* which initially relied upon a black leather jacket as her main prop.

So far, I have concentrated primarily on my own responses to those photographic images, which may not be the most interesting or productive way to approach them. While the most obvious evidence of their power was the part they played in structuring people's opinions about me as a "fugitive" and a political prisoner, their broader and more subtle effect was the way they served as generic images of black women who wore their hair "natural." From the constant stream of stories I have heard over the last twenty-four years (and continue to hear), I infer that hundreds, perhaps even thousands, of Afro-wearing black women were accosted, harassed, and arrested by police, FBI and immigration agents during the two months I spent underground. One woman who told me that she hoped she could serve as a "decoy" because of her light skin and big natural, was obviously conscious of the way the photographs—circulating within a highly charged racialized context—constructed generic representations of young black women. Consequently, the photographs identified vast numbers of my black female contemporaries who wore naturals (whether light- or dark-skinned) as targets of repression. This is the hidden historical content that lurks behind the continued association of my name with the Afro.

A young woman who is a former student of mine has been wearing an Afro during the last few months. Rarely a day passes, she has told me, when she is not greeted with cries of "Angela Davis" from total strangers. Moreover, during the months preceding the writing of this article, I have received an astounding number of requests for interviews from journalists doing stories on "the resurgence of the Afro." A number of the most recent requests were occasioned by a layout in the fashion section of the March 1994 issue of *Vibe* magazine entitled "Free Angela: Actress Cynda Williams as Angela Davis, a Fashion Revolutionary." The spread consists of eight full-page photos of Cynda Williams (known for her role as the singer in Spike Lee's *Mo' Better Blues*) in poses that parody photographs taken of me during the early 1970s. The work of stylist Patty Wilson, the layout is described as "'docufashion' because it uses modern clothing to mimic Angela Davis's look from the '70s." [7]

Some of the pictures are rather straightforward attempts to recreate press photos taken at my arrest, during the trial, and after my release. Others can be characterized as pastiche,[8] drawing elements, like leather-jacketed black men, from contemporary stereotypes of the sixties-seventies era of black militancy. They include an arrest scene, with the model situated between two uniformed policemen and wearing an advertised black satin blouse (reminiscent of the top I was wearing on the date of my arrest). As with her hair, the advertised eyewear are amazingly similar to the glasses I wore. There are two courtroom scenes in which Williams wears an enormous Afro wig and advertised see-through minidresses and, in one of them, handcuffs. Yet another revolves around a cigar-smoking, bearded man dressed in fatigues with a gun holster around his waist, obviously meant to evoke Che Guevara. (Even the fatigues can be purchased—from Cheap Jack's!) There is no such thing as subtlety in these photos. Because the point of this fashion spread is to represent the clothing associated with revolutionary movements of the early seventies as revolutionary fashion in the nineties, the sixtieth-anniversary logo of the Communist Party has been altered in one of the photos to read "1919–1971" (instead of 1979). And the advertised dress in the photo for which this logo is a backdrop is adorned with pin-on buttons reading "Free All Political Prisoners."

The photographs I find most unsettling, however, are the two small headshots of Williams wearing a huge Afro wig on a reproduction of the FBI wanted poster that is otherwise unaltered except for the words "FREE ANGELA" in bold red print across the bottom of the document. Despite the fact that the inordinately small photos do not really permit much of a view of the clothing Williams wears, the tops and glasses (again quite similar to the ones I wore in the two imitated photographs) are listed as purchasable items. This is the most blatant example of the way the particular history of my legal case is emptied of all content so that it can serve as a commodified backdrop for advertising. The way in which this document provided a historical pretext for something akin to a reign of terror for countless young black women is effectively erased by its use as a prop for selling clothes and promoting a seventies fashion nostalgia. What is also lost in this nostalgic surrogate for historical memory—in these "arrested moments," to use John Berger's word—is the activist involvement of vast numbers of black

women in movements that are now represented with even greater masculinist contours than they actually exhibited at the time.

Without engaging the numerous debates occasioned by Frederic Jameson's paper "Postmodernism and Consumer Society,"9 I would like to suggest that his analysis of "nostalgia films" and their literary counterparts, which are "historical novels in appearance only," might provide a useful point of departure for an interpretation of this advertising genre called "docufashion" as "[W]e seem condemned to seek the historical past," Jameson writes, "through our own pop images and stereotypes about that past, which itself remains forever out of reach."10 Perhaps by also taking up John Berger's call for an "alternative photography" we might develop strategies for engaging photographic images like the ones I have evoked, by actively seeking to transform their interpretive contexts in education, popular culture, the media, community organizing, and so on. Particularly in relation to African American historical images, we need to find ways of incorporating them into "social and political memory, instead of using [them] as a substitute which encourages the atrophy of such memory."11

NOTES

1. *New York Times Magazine*, date unknown.

2. John Berger, *About Looking* (New York: Pantheon Books, 1980), p. 57.

3. Susan Sontag, *On Photography* (New York: Farrar, Straus and Giroux, 1978), p. 27.

4. During the 1960s *Life* magazine had a circulation of approximately forty million people. (Gisele Freund, *Photography and Society* [Boston: David R. Godine, 1980], p. 143.)

5. Roland Barthes, *Camera Lucida* (New York: Hill and Wang, 1981), p.11.

6. *Angela Y. Davis: An Autobiography* (New York: Random House, 1974).

7. *Vibe* 2, no. 2 (March 1994), p. 16.

8. I use the term *pastiche* both in the usual sense of a potpourri of disparate ingredients and in the sense in which Frederic Jameson uses it. "Pastiche is, like parody, the imitation of a peculiar or unique style, the wearing of a stylistic mask, speech in a dead

language: but it is a neutral practice of such mimicry, without parody's ulterior motive, without the satirical impulse, without laughter.... Pastiche is black parody, parody that has lost its sense of humor." (Frederic Jameson, "Postmodernism and Consumer Society" in Hal Foster, ed., *The Anti-Aesthetic: Essays on Postmodern Culture* [Port Townsend, Washington: Bay Press, 1983], p. 114.)

9. Jameson's essay has appeared in several versions. The one I have consulted is referenced in note 8. I thank Victoria Smith for suggesting that I reread this essay in connection with the *Vibe* story.

10. Jameson, p. 118.

11. Berger, p. 58.

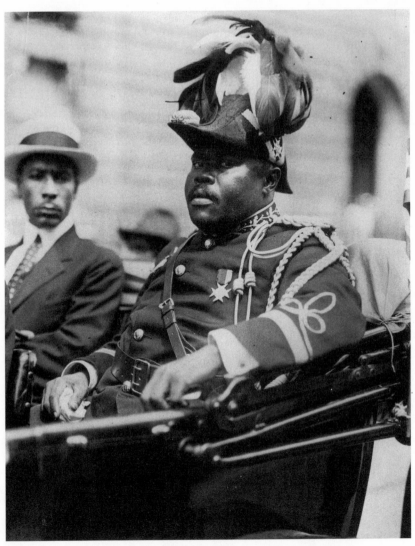

Rev. J. C. Austin (left) with Marcus Garvey, 1922

MAKING NOISE:
MARCUS GARVEY *Dada*, AUGUST 1922

Robert A. Hill

No man knows what is in my mind and they shall not know until the time comes.

— MARCUS GARVEY

*Riddle me riddle,
guess me this riddle,
an' p'raps not.*

— TRADITIONAL

IF MARCUS GARVEY WAS A RIDDLE TO HIS CONTEMPORARIES, HE was also, symbolically, a larger-than-life figure. The sphinxlike quality of his posture in the famous photograph of him taken riding in procession in August 1922 is emblematic of the man whom William H. Ferris called "the Master propagandist...the greatest we have seen in our day."[1] The image projected in the photograph is that of a man with a colossal determination. Clad in a field marshal's uniform of World War I vintage, plumed and gold-braided, Garvey dresses the part of commander-in-chief of his visionary African empire. Although he appears impassive, he is not silent. The communication from the photograph is visual *and* vocal, encompassing several layers of meaning that have a special resonance in black culture.

Recumbent and regal, Garvey is photographed as he rides in his high-powered touring car, the symbolic vehicle of the new black affluence after World War I. At the same time, as a means of glorifying his movement and its program of African restoration, Garvey hit upon the idea of presenting his movement as heir to ancient Egypt as the symbol of Africa's sovereignty. Emblematic of his political and racial philosophy, the great sphinx and pyramid at Giza are represented on the masthead of Garvey's influential *Negro World* newspaper. The emblem of the sphinx was also worn on the caps of Garvey's uniformed African Legions, the paramilitary auxiliary component of his organization. The

fusion of ancient Africa and modern America, symbolic nexus of Egyptology and speed and power (as represented by the automobile), parallels Garvey's twin program of African restoration and regeneration.

And like the winged figure of classical mythology—except that he is seated in an automobile along "The Avenue," as Seventh Avenue in Harlem was called, rather than on a rock outside Thebes—Garvey has continued to be a riddle to inquirers. His visage in the photograph is well-nigh inscrutable: colossal, puzzling, mysterious, impersonal. "No man knows what is in my mind," Garvey was happy to advise his listeners in Jamaica, in February 1928, "and they shall not know until the time comes."[2]

"As never before, the Hon. Marcus Garvey was the cynosure of the eyes of the entire Harlem public today," was how the *Negro World* reported the impression created by the leader of the Universal Negro Improvement Association (UNIA).[3] The August 1922 parade inaugurated the Third International Convention of the Negro Peoples of the World. The dazzling pomp of the procession, starting at noon from the offices of the UNIA at 56 West 135th Street and winding through the streets of Harlem, was the curtain-raiser to the annual UNIA convention before it resolved itself into a month-long parliamentary body—a black legislature calling itself the "House of Deputies of the Negro Peoples of the World."

Mimicking the annual royal procession that preceded the formal opening of the British House of Commons, the UNIA procession discloses something important about the conception of the movement and its architect. It reflects the fact that Garvey's bravura rested on something more substantial than mere fascination with gaudy pageantry. His histrionics and constant role-playing possessed a definite coherence, resulting from a keen appreciation of the exigencies of statecraft. Convinced that the solution to the problem of black inferiority lay in establishing a powerful black government, Garvey declared: "This thing of governments is a big idea, very, very big, is the biggest thing of the age, is the thing men are seeking everywhere."[4] Speaking in the course of the August 1922 UNIA convention, Garvey went on to explain that "the question of the age is that of political freedom, political liberty and political emancipation for all people."[5]

In August 1922, Garvey sartorially underscored his adherence to this

vision of statecraft, as is illustrated by comparing the costumes worn at the 1921 and 1922 convention processions. The principal change was to be the *military attire* that Garvey and his retinue of UNIA officials donned; according to the official *Negro World* report, everyone "wore the same brilliant variegated color uniforms, indicative of their respective offices, with gold trimmings and gold sashes, and with swords, helmets and plumed hats, as worn by them at the divine service held in the morning at Liberty Hall, thus giving them a striking military appearance." Alvin J. Moses observed that "His Supreme Highness [Potentate Gabriel Johnson] had changed his livery from the crimson robe trimmed with green that he wore on past occasions, to a black naval uniform, finished off smartly with gold braid."[6]

In Garvey's two previous convention appearances, in 1920 and 1921, he dressed "in a flowing robe of crimson slashed with green" topped off with Oxford cap.[7] Garvey's robes, patterned upon the scarlet and blue robes worn by an English honorary Doctor of Civil Law, a degree that he conferred upon himself in 1920, was also the ceremonial dress of his titular office as Provisional President of Africa. The frontispiece photograph in the second volume of *Philosophy and Opinions of Marcus Garvey* (1925) shows him clad in these same Doctor of Civil Law robes. A full-height version appeared earlier in *The Universal Negro Almanac* for 1921, and the same portrait also illustrated the sheet music for the marching song *Our Leader* by William Isles.

The first indication of a change in Garvey's attire occurred during the August 1921 court reception, the social high point of the UNIA convention. "It was a ceremonial that may correctly be regarded as a revival of the ancient glory, pomp and splendor of Ethiopia in the days of the Queen of Sheba, centuries long ago, of her greatness and world supremacy, comparable to similar state functions held in the ceremonial courts of England, Germany, Italy, France and the United States," the *Negro World* declared. The report went on to record the following:

> His Highness the Potentate [Gabriel Johnson] wore the same uniform he wore on the morning of the opening of the convention, consisting of a military hat with ostrich feather plume, black broadcloth trousers with gold stripe down the side, gold sword, gold sash over the shoulder and around the

waist, white gloves and gold military cape. *The Provisional President of Africa wore a military hat, very pointed, tipped with white feathers, broadcloth trousers with gold stripe down the side, a Sam Browne belt crossing the shoulder and around the waist, gold epaulets, gold and red trimmings on the sleeves, gold sword and white gloves. He looked the image of Marshal Joffre, though he seemed a trifle uncomfortable in his new, unaccustomed attire.*[8] (Emphasis added.)

Speaking in Jamaica in late March 1921, Garvey was reported to have said that "he wanted to see Negro statesmen, Negro magnates, Negro admirals and Negro Field-marshalls. And that hope would eventually be achieved when they set up the great republic in Africa (cheers)."[9] Garvey proceeded to implement his wish, as evidenced by the designation "Commander-in-Chief of the African Legion" in the caption to the photograph published of him in military uniform. The picture first appeared in the supplement featuring photographs of UNIA leaders carried as part of the Christmas 1921 special issue of the *Negro World*.[10] Taken by Touissant Studios of Harlem, the portrait was full-length; it showed Garvey attired in a brilliantly hued military uniform. Standing in a relaxed pose and facing left, Garvey wears headgear bedecked with white feathers; in his left hand he clutches a gleaming sabre with a large gold tassel hanging from the handle.

A man given to enigmatic twists, dazzling histrionics mixed with constant role-playing, Garvey was a master manipulator of the visual image. He was certainly one of the pioneers in the political use of the visual arts to communicate his political message. The black poster tradition was in no small measure stimulated by the propaganda produced by the Garvey phenomenon.

The photograph of Garvey parading in August 1922 has come to define more than any other portrait of this much-photographed figure the iconography of the man and the movement. Emblematic of Garvey's espousal of black supremacy, the photograph has long since achieved visual status as emblematic in the pantheon of black nationalism. First published in the *New York Daily News* of August 2, 1922, the original shows Garvey accompanied by a driver and two companions. A cropped version of this original photograph was published a short time

afterward in the *Literary Digest* of August 19, 1922, under the title *The "Negro Moses" Rides in State.* It is this cropped version that has since supplied the image of Garvey reproduced in wall murals, posters, post-cards, book jackets, paintings, lithographs, etchings, and so forth.

By contrast with this popular iconographic portraiture, the official iconography of Garvey in Jamaica eschews this martial image in favor of "a careful, rather subdued realism," in the words of Veerle Poupeye-Rammelaere. This subdued quality is reflected in several instances: the portrait of Garvey used on the fifty-cent bank note issued in 1969 by the Bank of Jamaica, the 1970 ten-cent stamp forming part of the series hon-oring Jamaica's five national heroes, and in the two twenty-five-cent postage stamps issued in 1987 to mark Garvey's centenary. The same applies to the portrait used on the hundred-dollar gold coin and ten-dollar silver coin issued also by the Bank of Jamaica, to commemorate Garvey's centenary. "The image strictly adheres to the established [Jamaican] Gar-vey iconography," observes Poupeye-Rammelaere, who notes that Garvey is always "represented in a civilian suit rather than in regalia."[11]

At the heart of Garvey's visual legacy, therefore, is a malleability of image. Whereas his photograph in military attire supplies the source of his mythic representation within the realm of popular consciousness, his stereotypic image as consummate showman is softened to accom-modate official and respectable opinion with the use of images of Gar-vey in civilian clothes. The August 1922 image of the martial Garvey thus possesses a complicated and ambiguous history, in the way that it has been both used and avoided.

The identity of the original photographer is not known, but most probably he was a white male. He would have positioned his camera advantageously before the line of march. Far from blending into the scene, the white photographer's presence would have been experienced as intrusive among the throng of black spectators lining the parade route. The photographer in this context is an extension of the dominion of white superiority against which the march itself is a symbolic protest.

The camera scrutinizes the marchers; in return, the marchers resist the camera's scrutiny with a range of silent but far from passive responses. The camera not only scrutinizes; it also polarizes through its depiction of what it sees and how *it* in turn is seen by those whom it scrutinizes.

The photograph reflects a similar tension. On the surface representa-
tional level, it shows us the photographer's attempt to control how
marchers and officials are seen. At a deeper level, the marchers also
struggle to assert autonomy in the face of the camera. The photogra-
pher achieves his goal by deliberately understating and flattening out
the cultural complexity of the parade phenomenon. The marchers'
independence is achieved only when the performative aspect of the
parade is perceived behind the camera's attempt to objectify them. At
this intersection of the pictorial and the cultural, there is convergence as
well as conflict of ideological and symbolic fields.

Viewed from within this perspective of spatial and ideological contes-
tation, Garvey's expression in the photograph seems to encompass a
wide mixture of emotions: defiance, hostility, hatred, fascination,
uneasiness, fear, puzzlement, surprise. It denotes also a look of dread at
being "discovered." If the white photographic presence was, on one
level, flattering to Garvey, it was also, on another level, menacing. This
might explain why in this photograph Garvey seems to have the look of
a man whose bluff has been called. At the same time, Garvey rewards
the camera with the allure of his defiant otherness—the motive for the
camera's excursion to Harlem in the first place—even as he becomes
implicated in its seductive mission.

If Garvey's face appears relentlessly immobile, it is its very immobil-
ity that serves to throw into relief the agility and emotional expressive-
ness of his piercing eyes. This was the feature of his appearance that
commentators found most noteworthy about him. It was Garvey's
"merry alert eyes that are alive with the ready intelligence of the man of
the world" that caught the attention of Michael Gold in his interview
with Garvey published in *New York World* magazine.[12] Lucian H. White
also emphasized the effect of Garvey's "small, rather close-set eyes
[that] sparkle as he chats, but become grim and icy where he is not
pleased."[13] The French writer Maurice Dekobra, after his meeting with
Garvey in Liberty Hall in November 1920, noted that "Garvey is a big
man, with a pointed head, fuzzy hair, huge lips, and a remarkably pen-
etrating gaze."[14] The same expressiveness of the eyes was the quality
that stood out for W. E. B. Du Bois. In an otherwise unflattering account
of Garvey's leadership, Du Bois described him as "A little, fat black
man, ugly, but with intelligent eyes and big head...."[15]

In the present photograph Garvey's expression reflects an emotional depth and intensity that belies the immobility of his features while confirming the impression received by his contemporaries. As soon as Garvey's eyes made contact with the camera amid the monotony of black faces along the parade route, his expression automatically changed. At that moment, the parade and the presence of spectators recede into the background. Garvey's eyes and the eye of the camera focus upon each other, the camera's probing eye searching the quizzical gaze of the . Black Moses, causing his defenses automatically to go up. The visual terrain now becomes contested political space. The camera is not neutral. It sets in motion a contest of racial and political wills. Determined to capture the image of the leading black dissident of the era, to acquire it for the visual archive of white superiority, the camera attempts to objectify and come away with an exhibit of Garvey. The photograph is neither neutral nor innocent in relation to Garvey's underlying message. What it does, with all the clarity of any great photograph, is to register the tension between the subjectivity of the photograph and the objective need that causes it to be recorded in the first instance.

Although the original image seems to have been photographed by a *Daily News* staff photographer, when it was reproduced in the *Literary Digest*, the official credit is given as Pacific & Atlantic Photos, a stock photo agency. When P&A Photos was bought out by the Associated Press, however, ownership of the image passed to Wide World Photos, AP's photo service. At some point afterward (though just when is not altogether clear), the photograph became the property of United Press International's photo library, now owned by the Bettmann Archive/Bettmann Newsphotos of New York. Economic ownership, however, does not determine the cultural transmission and meaning of the image. That follows the needs of popular culture, which is subject to an entirely different logic of appropriation, one based on the assertion of autonomy as opposed to control.

The story of the evolution of Garvey's relationship with the instruments of American opinion-formation is a complex one that still remains to be investigated. Garvey was not simply a source of graphic amusement for white readers, a sort of visual satire of blacks. This was the view of one of Garvey's opponents who declared that "The public press wants news, and it is ready and willing to herald anyone who is a

joke, fool, clown, or crook sufficiently to attract attention, to cause talk."[16]

In fact, Garvey demonstrated an exceptional skill in manipulating his public image and therefore his relationship to the media. This was done not only through the use of costumes, but also through the selective release of photographs to various publications and newspapers. For example, Garvey attempted to sustain favorable white media coverage through the publication of *Philosophy and Opinions of Marcus Garvey,* the first volume of which his wife, Amy Jacques Garvey, compiled and published in 1922. It is significant that they declined to use the photograph of Garvey attired in his field marshal's outfit for the frontispiece of the book. They preferred to use, instead, the subdued image of Garvey attired in a three-piece tweed suit, clasping a silver-tipped walking stick. The intention was obviously to communicate the image of Garvey as statesman. When a second and expanded volume of the *Philosophy and Opinions of Marcus Garvey* was subsequently published in 1925, the photograph chosen for the frontispiece shows Garvey seated in a high-backed chair and attired in his flowing scarlet robes and academic cap with golden tassel that were the insignia of his UNIA president-general's office. Neither photograph betrays even a hint of the martial.

An official photograph of Garvey and other UNIA hierarchs clad in their military uniforms was published in the *Negro World* on August 12, 1992. The picture shows "Hon. Marcus Garvey and staff at reviewing stand, 7th Avenue and 135th Street, New York, August 1, 1922." Although no photographic credit is given, the handwriting etched on the negative reproduced in the *Negro World* suggests that the photograph was taken by James VanDerZee. This was two years before the young aspiring studio photographer was hired as UNIA's official photographer for the August 1924 convention, an event he would record with his characteristic honest, down-home style that captured for posterity the luster of the movement shortly before its breakup.

Garvey would make only one other ceremonial appearance attired in his commander-in-chief outfit. This was in the August 1924 parade that was to be his last in America. A few months later, speaking in New York on November 16, 1924, Garvey explained that his approach was necessitated "because to organize Negroes we have got to demonstrate; you cannot tell them anything; you have got to show them; and that is why

we have got to spend seven years making noise; we had to beat the drum; we had to do all we did; otherwise there would have been no organization." [17] Although his image as commander-in-chief was a conscious creation, when he had the opportunity to choose, he opted not for the militaristic persona of the parade; instead he portrayed himself, as reflected in the frontispieces selected to adorn each of the *Philosophy and Opinions* volumes, in far more somber, less bellicose tones. The respectable image of the philosopher-statesman that Garvey strove to cultivate clashed, however, with the demands of "making noise." The result was, inevitably, a constant dissonance at the center of Garvey's message—or, rather, multiple messages.

Let us turn now from examining Garvey's relationship to the photograph to an examination of the photograph as a record of the Garvey movement. Viewed in this broader context, the image communicates a number of significant meanings. Perhaps the most obvious symbolism is the recreation of the street parade as a celebration of ethnicity in American popular culture. "This particular type of celebratory performance seems to have been an American invention," observes Mary Ryan. [18] The *Negro World*, in describing the event, employs the rhetorical equivalent of civic pageantry: *"Harlem Turns Out en Masse to Witness Pageant/Scene of Extraordinary Splendor Thrills and Enthuses Spectators/Parade a Mile and Three-Quarters Long."*

The Garvey parade, with its organization into ranks—with legions and various uniformed auxiliaries, such as the Black Cross Nurses, Ladies' Motor Corps, Boys' and Girls' Juvenile Corps, Black Star Band, and so on—represents a further ethnic adaptation of what Ryan calls "the characteristic genre of American ceremony." Thus Garvey's annual UNIA procession parallels the American patriotic rite of Fourth of July celebrations as well as the system of ethnic parades and holidays in America.

Wallace Thurman has described the extraordinary spectacle of UNIA parades in the early twenties in Harlem. "Garvey added much to the gaiety and life of Harlem with his parades," Thurman notes. Following Garvey's removal from the scene by imprisonment, Thurman went on to evoke a sense of nostalgia for the glory days of Harlem and the Garvey movement:

Garmented in a royal purple robe with crimson trimmings and an elaborate headdress, [Garvey] would ride in state down Seventh Avenue in an open limousine, surrounded and followed by his personal cabinet of high chieftains, ladies in waiting and protective legion. Since his incarceration in Atlanta Federal prison on a charge of having used the mails to defraud, Harlem knows no more such spectacles. The great parades held now are uninteresting and pallid when compared to the Garvey turnouts, brilliantly primitive as they were.[19]

Truman Hughes Talley, in his January 1921 article "Garvey's 'Empire of Ethiopia'" was awestruck by the fabulous mis-en-scène of the opening of UNIA's August 1920 parade. "The most glittering and fame-studded of parades of the black ages in which virtually every Negro of any standing in any part of the world appeared," Talley wrote, "wended its triumphal way between endless lines of flag-waving enthusiasts in the streets of New York's colored colony." Talley continued:

On the opening day there was held the great parade, which resulted in much more than a spectacular display of pageantry. It was a panorama of patriotism. Fifty thousand Negroes of all ranks and stations in life and from every part of the globe—there were princes, high officials of various governments, and even a Haitian admiral—were in the line of march. There were twelve bands that were almost smothered in the enthusiastic tumult of the tens of thousands of participants and onlookers. Their colors—"black for our race, red for our blood, and green for our promise"—were everywhere to be seen intertwined with the Stars and Stripes.[20]

G. Rupert Christian, UNIA convention delegate from Columbus, Ohio, wrote with obvious racial pride in describing the effect that the August 1922 parade had upon him. It was, he wrote, "a parade that will go down in history as a brilliant, imposing and elaborate event." It was "a spectacle which truly reveals the ancient glory of Ethiopia."[21]

Beyond this similarity with the American parade phenomenon, the composition of the UNIA parade also mirrors the shifting class and ethnic dimensions of the dominant American model, which, according to

Ryan, was indicative of the fact that "emblems suggestive of class lost their privileged ceremonial position around 1850." She explains the effect of this displacement of class: "For the next few decades the line of march was swollen with new contingents whose variety and hetero-geneity defied categorization. Throughout this robust yet transitional and anomalous period groups of workers were far outnumbered by con-tingents composed of the members of voluntary societies."[22]

Like American Fourth of July processions, which, from 1850 onward, were dominated by the presence of fraternal orders, militia companies, and ethnic benefit societies, the UNIA parade was comprised almost wholly of ethnic and fraternal groups. If, as Ryan demonstrates in her essay, the American parade from the middle of the nineteenth century reflected the erosion and unraveling of social hierarchy through the countervailing force of ethnicity, the UNIA parade was a prime example of the enduring strength of this change well into the 1920s.

Another distinctive social category of the American parade was that of gender. According to Ryan, gender "operated largely to define parad-ing as a male prerogative, offering women only a shadowy position in the line of march," with the result that "the parades of the nineteenth century were almost exclusively male affairs."[23] From the visual evi-dence offered by the photograph of Garvey in the August 1922 parade, it appears that gender dichotomies were equally present in the public ceremonial of the UNIA parade as well. In this sense, the picture reflects gender differences within the larger UNIA.

In the original, uncropped *Daily News* version, Garvey is seen seated in the rear of the official car, in the company of Reverend J. C. Austin, D.D. (billed as "America's Greatest Pulpit Orator") and Major Gelp and Lieutenant Yearwood, both of the Universal African Legion.[24] In the cropped version of the original photograph, the one usually published, Reverend Austin is the only one of those three men to remain visible, if slightly out of focus. The selectivity that transforms what was originally a group shot into the photo of a pair of men, finally extracting from it a portrait-like image of Garvey solo, represents an interesting case of visual and historical involution.

Noticeably absent from the parade was Amy Jacques Garvey, whom Garvey married in Baltimore in late July 1922, a matter of a few days before the start of the UNIA convention. Garvey's wife was also absent

from the reviewing stand of the parade. Indeed, there are no women present in the reviewing stand. But two years later, Amy Jacques Garvey would emerge from the organization's shadows. Thus, a photograph of the August 1924 parade published in the *New York World* of August 2, 1924 ("Leaders Who Reviewed Negro Parade") shows her in a place of prominence, immediately behind Garvey, who is flanked by his male UNIA hierarchs. To her right on the platform stands a second, unidentified, woman.

Amy Jacques Garvey's prominence on the reviewing stand of the August 1924 parade serves as graphic confirmation of the novel position that she had assumed within the UNIA hierarchy. She passed from Garvey's personal secretary to becoming Garvey's de facto chief of staff and principal political confidante, at a time when Garvey grew increasingly distrustful of his own colleagues after he was indicted for mail fraud. Her ascendancy caused great resentment and dissension among the male leadership of the UNIA organizational hierarchy. In a typically feisty letter written to the *Negro World*, she declared that she knew "how, when and where to treat with some men," and warned that her "four and a half years of active service in the Universal Negro Improvement Association under the personal direction of Marcus Garvey has given me a fair knowledge of men and the methods they employ in the organization and out of it." [25]

And yet, despite the undoubted influence she wielded within the uppermost counsels of the UNIA, she was still not permitted to ride alongside Garvey in the 1924 parade. On this occasion, seated beside Garvey was Reverend R. Van Richards, chaplain of the Liberian Senate. A place on the reviewing stand *behind* Garvey was all that she could hope to achieve as far as the UNIA's procession was concerned. Powerful as she had become, she was restricted from appearing to share in the public business of politics, which was still seen to be the province of men only.

By going beyond the surface appearance of these photographs, refusing to take them at their face value, we are able to discern the implicit connection between power and gender inside the UNIA hierarchy. Thus, although female contingents marched in the UNIA parade (the ladies of the Universal African Motor Corps and the Black Cross Nurses), it is now apparent that the procession was, fundamentally, a

celebration of black manhood—a depiction of New Negro Manhood. The female auxiliaries of the UNIA were designed to serve the Universal African Legions (the male paramilitary auxiliary) on future African battlefields. The Black Cross Nurses, modeled on the International Red Cross, symbolized the female humanitarian role in aiding black men. The ideal of male dominance thus acquired legitimacy from women and was expressed in the sphere of public ritual. At the head of a contingent of nurses marching in the August 1922 parade was the banner, "The Black Cross Prepared for Any Calamity That May Befall the Negro Race."[26] Their presence, along with that of the female Motor Corps, not only served to enliven the UNIA procession; symbolically, it communicated the primacy of black manhood as the dominant ideal of the UNIA.

The UNIA's use of female symbolism in its ceremonies was further evidenced when, as Worth Tuttle reports in his description of the organization's evening convention meeting in 1921, there suddenly appeared a black Goddess of Liberty. "There is the living symbol of a national life," Tuttle observed, clearly moved by the sight of this "black Liberty, draped in red and green, carrying a new scepter, crowned with a black *pileus*," while noting the rapture of the audience that "thrilled with all the joys of a nationality, without, as yet, any of its responsibilities."[27] Note that the black Goddess of Liberty, symbolizing national unity and harmony, was paraded *inside* Liberty Hall and not in the street procession. It seems that when it came to the UNIA's indoor ceremonial, women were always prominent.

This ritual distinction was most clearly manifested in the context of the "Royal Court of Ethiopia," the annual UNIA reception, which was the high point of its social calendar. Officially presided over by the Potentate of the UNIA, it was the social occasion when convention delegates were presented together with their consorts. It was also the occasion for conferring honors and titles. The *Negro World* report of the August 1922 court reception, which was held inside a lavishly decorated Liberty Hall, describes in detail "the gowns worn by the distinguished ladies" and speaks of the "charming appearance" made by Mrs. Garvey "who, as a young bride of but a few weeks, was with her distinguished husband the centre of attention."[28]

The females of the "Royal Court of Ethiopia" appear to have served

more than a social role. In keeping with the ritual of statecraft that provided the model for Garvey and the UNIA, they served as allegories of domestic and social harmony and thus contributed legitimacy to the fragile claims of their male consorts to racial power and mastery. These gender differences, however, ought not obscure differences of class, which also functioned among the women of the UNIA. In terms of social-class status, female members of the Black Cross Nurses ranked well below the social elite of black women who occupied pride of place inside the UNIA court reception.

If the photograph is indicative of specific gender as well as class differences that were present within the UNIA, it also reflects the cultural production of the UNIA in New York and its foundation in the West Indian immigrant community. Inscribed within the photograph's cultural representation is evidence of the West Indian ethos of the movement. The UNIA parade, viewed as an instance of cultural performance, was also a species of the West Indian parade complex. This is the value of the photograph as a cultural statement of the West Indian ethos of the New York Garvey movement. On this reckoning, the photograph, in addition to recording the UNIA's adaptation of the American parade, describes a parallel cultural tradition with its own language of performance and aesthetic representation. Ultimately, it was by this means of cultural reworking and adaptation that the UNIA was able to achieve such a high level of allegiance among the large West Indian community in North America. The UNIA parade is evidence of what one recent commentator describes as "the dynamic relationship of the Caribbean community in New York with the people they left behind."[29]

Owing in part to the continuity and durability of West Indian cultural life, in the first couple of years of the UNIA's existence in America, West Indians formed the backbone of the association. "When the movement was started," recalls the UNIA's William Sherrill, "West Indians resident in New York were the first to follow."[30] In 1925 William Ferris, former editor of the *Negro World* and a high-ranking UNIA official, underscored the evolution of the movement from its initial West Indian character. "For the first two years," he noted, "West Indians loyally carried the association forward, now the greater majority of the membership consist of native [i.e., native-born] Americans."[31]

Indeed, the critical factor in the ascendancy of Garvey, and what

accounted for the rapid success of the UNIA in America, and in Harlem in particular, was the influx of West Indian immigrants, who arrived in large numbers during and immediately after World War I. With the West Indian population of Harlem serving as the political nucleus of the UNIA, Garvey was able, by the early twenties, to enlist the support of thousands of African Americans who rallied behind his program of militant racial nationalism. Their support principally took the form of purchases of stock in Black Star Line, with the hope of establishing a profitable trade route controlled by blacks between America and Africa.

A small number of West Indians had been arriving in the United States since before the Spanish-American War, settling along the eastern seaboard with other foreign-born blacks from Cuba, the Virgin Islands, and the Portuguese Atlantic islands of Cape Verde and the Azores. In 1900, a total of only 3,552 foreign-born blacks resided in New York city, with West Indians accounting for the majority. (At that time, the African American population of the city stood at 57,114.)[32]

Then came the great slump in West Indian sugar prices as a result of competition from American and German beet-sugar. The foreign-born black population in New York City jumped to 12,851 in 1910,[33] the overall total number of black immigrants reaching 40,339, as "the impoverished islands began to descend upon the mainland their working population, laborers, mechanics, peasants, ambitious enough to be discontented with conditions at home and eager to improve their lot by seeking success in the land of Uncle Sam."[34]

With the outbreak of World War I, there was an ever more dramatic increase. Arriving at a rate of 5,000 per year, by 1920 the total number of foreign-born blacks in the United States, with West Indians representing at least two-thirds of their number, shot up to more than 100,000. After passage of the notoriously racist Immigration Act of 1924, followed by the Great Depression of the thirties and the outbreak of World War II, the flow of black immigrants from the West Indies dwindled to a trickle. Between 1900 and 1932, however, the number of foreign-born black immigrants giving the West Indies as their country of last residence reached a total of 107,075. The great majority of these West Indian immigrants settled in New York City, with most living in Harlem.

West Indian immigrants represented a mixture of skilled and

unskilled workers. Both groups were represented within the UNIA, with the majority of recruits made up of skilled artisans and tradespeople, unskilled workers, and a smattering of clerks and professionals. In terms of literacy, they stood above the level of the general American population.[35] In the words of Dr. Charles Petioni, these West Indians were "men and women of education, of social standing and of enterprise...trained to meet members of other groups on terms of equality."[36] It was from out of this West Indian cultural milieu that there emerged, in 1916–17, the well-known phenomenon of the Harlem street orators ("soap-boxers," as they were called), the majority of speakers, as well as the crowds of listeners that surrounded them, being West Indian.[37]

Street-corner oratory reproduced on American soil the cultural practice of the West Indian "man-of-words" tradition.[38] Adapted to meet the exigencies of racial and ideological protest under conditions of American racism and political upheaval attendant upon World War I, it was expanded and redirected by a remarkable range of self-educated West Indian immigrants, principal among them Hubert H. Harrison, W. A. Domingo, Marcus Garvey, Richard B. Moore, Frank Crosswaith, and Grace Campbell. Garvey served his apprenticeship as a radical spokesman of black self-determination from his stepladder at 135th Street and Lenox Avenue in Harlem.

The West Indian immigrants thus imparted to the fledgling New York UNIA a distinctive Caribbean ethos. It was reflected further in Garvey's choice of August 1 as the official date of the UNIA's annual parade, as well as the month of August for its convention. August 1 was especially important for West Indians; it marked the anniversary of West Indian slave emancipation. The anniversary was commemorated in Jamaica with traditional "bruckin'" parties—the name deriving from a stately dance characterized by a thrust and recovery motion of the hip and leg. The ceremonial king and queen of the "bruckin'" party also carried wooden swords, which served to accentuate the dancing motion of their bodies.

The panoply of ceremonial events staged during August, thus marking the high-point of the UNIA's official calendar, resonates with the distinctive West Indian character of the New York membership of the organizations. The same principle of local culture influenced the character of the Jamaican branch of the movement. According to Beverly Hamilton, the phenomenon of Garveyism became inextricably bound

up with local folk belief in the supernatural. Thus Garvey became associated inside Jamaica with "a belief system which saw [Garvey] as a prophet imbued with almost divine qualities who could foretell events, sometimes change the course of nature, and who could put a curse on his enemies."[39]

In the Caribbean, all popular, public entertainments entail a strong element of masquerade and burlesque of aristocratic and monarchical forms that hark back to the folk celebrations during slavery. Appointment of a monarchical figure, usually a queen, was customary for all such popular folk celebrations. In Jamaica, costumed queens and others used to "brag"—a processional dance in which a queen and train-bearers, princes, and so on, paraded, accompanied by drum-and-fife music and the sounds of sticks being hit over the head of the queen by members of her entourage.[40]

Popular folk entertainments—such as tea meetings, quadrilles, Jamaican bruckin' parties, plantation Jonkonnu, and Set Girls' parades with competing red and blue sets led by their respective king and queen—reflected the existence of a vibrant masquerade folk culture, out of which evolved an indigenous tradition of ritual and ceremonial parading. African and European influences were clearly represented in the Creole articulation of masquerade forms.[41] A distinct echo of this cultural tradition, particularly as it came to be employed in the West Indies for communal fund-raising purposes, could be discerned in the UNIA's "Coronation of the Seven Queens of Africa." Attended by a military escort honor guard in the form of the Universal African Royal Guards, the event was organized by the ladies of the "Provisional Court of Ethiopia" as part of a UNIA building-fund benefit.[42]

Writing in the early part of 1920, a West Indian in Panama made the same connection between Caribbean culture and the impending election of an African "Potentate," proclaimed by Garvey as one of the principal justifications for the UNIA's 1920 convention. "Pardon me," the gentleman disdainfully declared, "but this sounds like the story of 'The Count of Monte Christo' or the 'dream of Labaudy' [sic], or worse still, 'Carnival,' as obtains in the city of Panama, where annually they elect 'Her Gracious Majesty, Queen of the Carnival,' and other high officials."[43] "Is the ghost of Lebaudy keeping Mr. Marcus Garvey from sleeping?" asked the French journalist P. Valudel, who also saw a con-

nection with Jacques Lebaudy (1874–1919), the eccentric French millionaire who, in 1903, had tried to storm Spain's Rio de Oro colony (in what is today Spanish Sahara), proclaiming himself "Emperor of the Sahara."[44] A Nigerian observer, in a letter published in the *Nigerian Pioneer* in December 1920, declared that he found Garvey's "pipedream" of an African empire to be "a splendid theme for a musical comic opera" along the lines of a Gilbert and Sullivan production.[45] Garvey's fellow Jamaican, Claude McKay, writing in 1922, was of the view that "Garvey's arrest by the Federal authorities after five years of stupendous vaudeville is a fitting climax."[46] The editorial writer for the *Kansas City Call* declared that "His high-sounding titles and his gaudy uniforms were the patter of the magician—just so much nothingness."[47] What all of these comments share is a common perception of Garvey and the UNIA as fantastic, theatrical, and not a little absurd—a sort of farcical *opéra bouffe*, even if, as the *Kansas City Call* admitted, "behind them, solid as the rock of Gibraltar, was the determination of the Negro to get up in the world."

The UNIA's parades embodied a powerful element of burlesque, although it has proved difficult for commentators alien to the folk culture of the Caribbean to appreciate them. Participants within the movement were not so handicapped. In the *Negro World*'s description of the opening of the 1921 convention, for example, the writer asserts that he saw "the Potentate riding in his auto looking like an emperor, the Chaplain General looking like a Pope, the President General like a king, the American leader like a cardinal and the International Organizer like a queen."[48] He could have been describing the ensemble of monarchical elements that go to make up West Indian masquerade, except that here the parade was occurring in the United States and in the service of a social movement.

The Caribbean folk tradition was never innocent or naive in its enactments, however. During slavery, blacks in the Caribbean islands prevented from publicly imitating whites in an organized manner. When it was permitted, as in the case of popular recreations, the effect was dissimulative. Anthropologist Peter J. Wilson speculates that the social effect "may well have been mockery of European ways.... Mockery and satire could well have been the name of the game."[49] Under the pretense of innocent mimicry, ceremonial performance concealed

deeper motives and thoughts. Beneath the appearance of cultural aping and assimilation, plantation control over the aesthetic and normative realms was contested through revelry and ritual. Social satire seems not to have been beyond Garvey. Indeed, the incongruity of a field marshal's costume worn with a plumed hat and gold braid was, quite frankly, Dadaist in its flouting of conventional values.

Like the rebellious Dada movement of the twenties, Garvey's caricature shows the Janus face of the movement as well as his aspirations. The carnivalesque aspect of Garvey and the UNIA's rituals contained an element of dissimulation. "Sometimes you have to use camouflage, you know," Garvey readily acknowledged.[50] The fact is that satire supplied an essential weapon in the otherwise impoverished arsenal at Garvey's disposal. What might at first appear to be simply naive mimicry actually disguised a more settled purpose. "They laugh and say that I am spectacular," Garvey declared in responding to his critics.

> Who is more spectacular than the Pope? The critic asks why Garvey wears a red robe. Marcus Garvey flings back the retort, "Why does the Pope wear a red robe?" "Why does the King of England wear purple robes?"[51]

Garvey obviously took delight in his burlesque of power. His enjoyment comes across in the extravagant, Rabelaisian humor he evoked in his continuing caricature:

> They say Mr. Garvey is spectacular. Now what does that mean, anyway? There is no such word in the African dictionary as spectacular. Therefore, if Mr. Garvey is spectacular he has copied it from them. Then why should they be offended at Mr. Garvey's being spectacular? That will show you how unreasonable and unjust some men are. Some white people in Europe and America say Mr. Garvey likes colors and robes and titles. Can you tell me where you can find more titles and robes than in Europe? If you would just take up the "Pictorial Review" you will find that the English people when they are about to open their Houses of Parliament you will see the King and Queen with more robes of more colors than you have seen in the rainbow. (Laughter.) They talk about wear-

ing robes. If you watch the picture from Buckingham Palace to the House of Commons in Westminster you will see hundreds of men with all kinds of uniform, all kinds of turbans, all kinds of breeches (laughter), all kinds of uniform—the whole thing looking like one big human show and everybody going to the circus to see. (Laughter.)

As far as their society is concerned, if you want to hear about titles, just cross the channel. White folks like titles so much that they pile up millions of dollars for a lifetime so that they can buy a title on the other side of the channel. They send their daughters abroad in order that they may marry a lord or a duke or some other person of nobility. Yet they say Mr. Garvey likes titles. So much for the political and aristocratic aspect of being spectacular. Turn now to the religious phase of it. You will find it in the Catholic Church. If you want to see something spectacular just wait until they are coronating a pope or burying a pope, or just wait until they are enthroning a cardinal or an archbishop, and then you will see something spectacular. Why, therefore, should some folks want to be spectacular and do not want Negroes to be spectacular? We say, therefore, that since they have found some virtue in being spectacular we will try out the virtues there are in being spectacular.[52]

Garvey's statement reveals his penchant for satire, particularly to be seen in his heaping upon the sacred symbols of white spiritual power the invective of irony and sarcasm. Garvey was clearly not being naive, even if at times his mimicry seems a bit ingenuous, smacking less of criticism than emulation. But in Garvey's mimicry of monarchical and aristocratic symbols ("frankly in the manner of the governments which have gone out of style in Europe," observed Herbert J. Seligman), one can also detect a powerful element of social striving. For Garvey was just as determined in his quest for social recognition as any of the educated West Indian elite. In a kind of social comedy of manners, Garvey combined derisive laughter with the earnest desire to rise into the higher ranks of society, where the hazard was always the aspirant's exposure to the snub. To those who would follow his example Garvey gave this counsel:

"If others laugh at you," he urged, "return the laughter to them; if they mimic you, return the compliment with equal force. They have no more right to dishonor, disrespect and disregard your feeling and manhood than you have in dealing with them. Honor them when they honor you; disrespect and disregard them when they vilely treat you."[53]

Operating side by side within the Garvey movement was a twin set of competing imperatives: a plebeian attachment to performance and reputation, counterbalanced by the colonial middle-class ideal of piety and respectability. Garvey shifted back and forth between these two poles as readily as he changed costumes. In his January 1922 speech in Brooklyn, Garvey affirms the plebian, Rabelaisian side of himself when he says: "From the time I got sense and was able to read, my first duty was to find out what I was best fitted for. And I found out that I am to make trouble in the world."[54]

Although he would never accept nor practice the standard of priggishness that the rules of etiquette required, the domestic ideal of middle-class culture—in which, in fact, the photograph functioned as an important artifact of respectability—exercised a certain sway over him. Garvey's pursuit of the trappings of respectability was clearly observable, even if it was idiosyncratic. Thus, visitors to his sixth-floor apartment at 133 West 129th Street were frequently moved to comment upon the quality of the furnishings. It was, reported William Pickens, "furnished in the bizarre South-Sea fashion."[55] "Certainly it was not the usual Harlem 'parlor'," a reporter for the *Negro World* noted in 1923:

> Instead of a huge three-piece parlor suite and player piano, I saw tall Egyptian vases, pots with palms, jardinieres of flowers, curious looking African baskets and ornaments. The mellow sunlight streaming through an open window on a sheet of music, "Cavalleria Rusticana," resting on an open piano. Did I hear the "swash" of the oars of a gondola?[56]

Hubert H. Harrison was struck by the fact that in Garvey's apartment "there are splendid couches swinging by chains from the ceiling."[57] "The small apartment in which he sat," also noted Dusé Mohamed Ali, in a satirical portrait of Garvey, "was so greatly overcrowded with a miscellaneous collection of spurious antiques that it was difficult to find a pathway to a seat without knocking over the

cheap and gaudy bric-a-brac that seemed to find a malicious pleasure in resting perilously on the brink of destruction."[58]

Ultimately, it was this divided cultural loyalty that explains Garvey's penchant for concealment. "No man knows what is in my mind and they shall not know until the time comes," Garvey delighted in assuring the world. What the public was treated to was a dazzling series of conjuring acts, as Garvey moved back and forth between the vernacular of the folk and the idiom of striving. It was the source of that "artistic juggling" that caused one commentator to declare: "Marcus Garvey is something of a poet and much of an artistic juggler."[59]

"It is as a caricaturist of the great White Race that Garvey is in his most distinguished role," noted Robert Morss Lovett.[60] This might explain Garvey's continuing significance for the disaffected, among whom his name occupies still a sort of canonical status in the realms of reggae and rap today. Here, in the realm of black popular culture, the figure of the Black Moses finds deliverance.

The moral of this iconographic tale shows the permeability of racial and ethnic identities. It also reveals the close relationship or coexistence that connects the black tradition of satire and signifying with the quest for respectability. It helps to explain how for African Americans the photograph is much more than a complacent mirror of past achievement. The photographic image for African Americans is constantly examined for evidence of the submerged self that speaks and performs. The martial image of Garvey is the perfect metaphor of this subversive visual language in which the visual doubles as a voice.

"i gotta thing bout niggahs," Ntozake Shange declares. The reason, she explains, is that "we are so correct for the photograph / we profile all the time / styling / giving angle & pattern / shadows & still-life." She responds to the peculiar challenge of this visual expressiveness by searching for "the line in niggahs / the texture of our lives." Apprehending the voice inside our still-life image, she hears the picture "beginning to startle / to mesmerize & reverse the reality of all who can see."[61]

It is this combination of visual and vocal qualities that defines the aesthetics of African American visual language. What is alive in Garvey's portrait from the August 1922 procession is, ultimately, not so much the vision as it is the performance of that vision.

NOTES

1. "Watchman What of the Night?" editorial, *Spokesman* (March 1925), p. 4. Ferris had been the former editor of Garvey's *Negro World* newspaper from mid-1920 through 1923.

2. Jamaica Archives, Spanish Town, Colonial Secretariat Files, 1B/5/79, Confidential N23/28.

3. *Negro World*, Aug. 5, 1922.

4. U.S. Department of Justice, Federal Bureau of Investigation, Washington, D.C., File 61-50-124, Address of Marcus Garvey, Trinity Auditorium, Los Angeles, California, June 5, 1922, in Robert A. Hill, ed., *The Marcus Garvey & Universal Negro Improvement Association Papers* (hereafter: *MGP*), vol. 4 (Los Angeles and Berkeley: University of California Press, 1985), p.655.

5. *Negro World*, August 19, 1922, reprinted in *MGP*, vol. 4, pp. 843–50.

6. "Marcus Garvey Heads Notable Gathering in Harlem Parade," *Hotel Tattler*, August 6, 1922.

7. *Daily Mail*, September 2, 1920.

8. *Negro World*, September 3, 1921.

9. *Daily Gleaner* (Kingston, Jamaica), March 29, 1921.

10. "Guiding the Destiny of 400,000,000 Negroes through the Universal Negro Improvement Association," *Negro World*, December 17, 1921.

11. Veerle Poupeye-Rammelaere, "Garveyism and Garvey Iconography in the Visual Arts of Jamaica," *Jamaica Journal* 24 (June 1991), p. 18.

12. "When Africa Awakes," *New York World*, August 22, 1920.

13. *New York Age*, October 21, 1922.

14. *L'Illustration*, March 26, 1921.

15. "Back to Africa," *Century* 105 (February 1923), p. 539.

16. M. Mokete Manoedi, *Garvey and Africa by a Native African* (New York: New York Age Press, 1922), p. 16.

17. *Negro World*, November 22, 1924.

18. Mary Ryan, "The American Parade: Representations of the Nineteenth-Century Social Order," in Lynn Hunt, ed., *The New Cultural History* (Los Angeles and Berkeley: University of California Press, 1989), p. 132.

19. Wallace Thurman, *Negro Life in New York's Harlem*, Little Blue Book no. 494 (Girard, Kan.: Haldeman-Julius Publications, n.d.), p. 21.

20. Truman Hughes Talley, "Garvey's 'Empire of Africa'," *World's Work* 41 (January 1921), p. 264.

21. *Negro World*, August 19, 1922.

22. Ryan, "The American Parade," p. 142.

23. Ibid., p. 147.

24. *Negro World*, July 22, 1922.

25. Ibid., July 21, 1923.

26. *New York Herald*, August 2, 1922. In addition to providing an important ceremonial function, the Black Cross Nurses also performed an educational role within the UNIA, training mothers in hygiene, nutrition, and child care.

27. Worth Tuttle, "A New Nation in Harlem," *World Tomorrow* (September 1921), p. 279.

28. *Negro World*, April 19, 1922.

29. Joyce Toney, "The Perpetuation of a Culture of Migration: West Indian American Ties with Home, 1900–1979," *Afro-Americans in New York Life and History* 13 (January 1989), p. 39.

30. *Negro World*, August 23, 1924.

31. "Watchman What of the Night?" p.5.

32. Calvin B. Holder, "The Causes and Composition of West Indian Immigration to New York City, 1900–1952," *Afro-Americans in New York Life and History* 11 (January 1987), p. 8.

33. Ibid., p. 9.

34. Hubert H. Harrison, *Pittsburgh Courier*, January 29, 1927.

35. *New York Age*, July 19, 1924.

36. *New York Amsterdam News*, December 22, 1934.

37. See Sadie Hall, "Stepladder Speakers," WPA Research Paper, Schomburg Center for Research in Black Culture, New York Public Library.

38. See Roger D. Abrahams, *The Man-of-Words in the West Indies: Performance and the Emergence of Creole Culture* (Baltimore: Johns Hopkins University Press, 1983).

39. Beverly Hamilton, "The Legendary Marcus Garvey," *Jamaica Journal* 24 (June 1991), p. 54.

40. Cheryl Ryman, "Dance as the Major Source and Stimulus for Communicating Africanisms in Order to Effect the Process of Self-Actualization," M.A. thesis, Antioch International University, 1983, appendix 2, p. 134.

41. Cheryl Ryman, "Jonkonnu: A Neo-African Form," part I, *Jamaica Journal* 17 (February 1984), pp. 13–23.

42. *Daily Negro Times*, February 21, 1923.

43. *Crusader* II (April 1920), pp. 27–28.

44. "The Pretensions of Marcus Garvey," *Annales Coloniales*, January 13, 1921.

45. *Nigerian Pioneer*, December 17, 1920.

46. Claude McKay, "Marcus Garvey," *Liberator*, 1922, excerpted in *Crisis*, vol. 24, no. 2 (June 1922), pp. 81–82.

47. *Kansas City Call*, June 29, 1923.

48. *Negro World*, August 13, 1921.

49. Peter J. Wilson, *Crab Antics: The Social Anthropology of English-speaking Negro Societies of the Caribbean* (New Haven: Yale University Press, 1973), p. 192.

50. *Negro World*, September 17, 1921.

51. *Negro World*, February 4, 1922; June 21, 1924.

52. *Negro World*, February 4, 1922.

53. Quoted in Herbert J. Seligman, "African Fundamentalism," in *Marcus Garvey: Life and Lessons*, edited by Robert A. Hill and Barbara Bair (Los Angeles and Berkeley: University of California Press, 1987), p. 4.

54. *Negro World*, February 4, 1922.

55. William Pickens, "The Emperor of Africa: The Psychology of Garveyism," *Forum* (August 1923), p. 1790.

56. J. A. G., "Ten Minutes with Mrs. Marcus Garvey," *Negro World*, March 17, 1923.

57. *Kansas City Call*, July 5, 1923.

58. Dusé Mohamed Ali, "Ere Roosevelt Came: A Record of the Adventures of The Man in the Cloak," *Comet* (Lagos, Nigeria; March 3, 1934), p. 10.

59. Herbert J. Seligman, "Negro Conquest," *World Magazine* (December 4, 1921), p. 4.

60. "An Emperor Jones of Finance," *New Republic*, July 11, 1923, p. 179.

61. Ntozake Shange, "A Photograph: Lovers in Motion," *Three Pieces* (New York: St. Martin's Press, 1981), p. 92, quoted in Gerald L. Davis, "'So Correct for the Photograph': Fixing the Ineffable, Ineluctable African American," *Public Folklore*, edited by Robert Baron and Nicholas R. Spitzer (Washington, D.C.: Smithsonian Institution Press, 1992), p. 106.

About the Contributors

DEBORAH WILLIS (WASHINGTON, D.C.)
Deborah Willis received her M.F.A. in photography from the Pratt Institute and an M.A. in art history and museum studies from the City University of New York. From 1980 to 1992 she was curator of photographs and prints and exhibition coordinator at the Schomburg Center for Research in Black Culture. Currently, Ms. Willis is serving as collections coordinator/museum specialist for the Smithsonian Institution's National African Museum Project in Washington, D.C. Widely published, Ms. Willis is the author of, among other publications, *J. P. Ball, Daguerreotypist and Studio Photographer; Black Photographers 1940–1988: An Illustrated Bio-Bibliography;* and *The Portraits of James Van-DerZee.* A well-respected photographer herself, she has participated in numerous exhibitions and has served as exhibition curator for dozens of shows, including "Fourteen Photographers," "Constructed Images: New Photography," and "Black Photographers Bear Witness: One Hundred Years of Social Protest." Included among her many awards and fellowships are a grant from the National Endowment for the Humanities and the Manhattan Borough President's Award for Excellence in the Arts.

VERTAMAE SMART-GROSVENOR (WASHINGTON, D.C.)
Vertamae Smart-Grosvenor is a writer, poet, culinarian, and anthropologist. In addition, she is a commentator for National Public Radio's *All Things Considered,* and a host for their documentary series *Horizons.* She is the author of *Vibration Cooking: The Travel Notes of a Geechee Girl.*

EDWARD P. JONES (ARLINGTON, VIRGINIA)
Born and raised in Washington, D.C., Edward P. Jones attended Holy Cross College and the University of Virginia. His collection of stories, *Lost in the City,* was nominated for the National Book Award in 1992.

bell hooks (NEW YORK, NEW YORK)
Professor at Oberlin College and City University of New York, bell hooks received her Ph.D. at the University of California, Santa Cruz. She is the author of *Ain't I a Woman: Black Women and Feminism; Feminist Theory: From Margin to Center; A Woman's Mourning Song;* and *Black Looks: Race and Representation.*

E. ETHELBERT MILLER (WASHINGTON, D.C.)
E. Ethelbert Miller is the director of the Howard University Afro-American Resource Center, a poet, and the host of a weekly radio program, *Maiden Voyage.*

CONTRIBUTORS

CHRISTIAN WALKER (ATLANTA, GEORGIA)
Christian Walker, an artist and critic, has had works published in *Aperture*, *Camera Works*, and *Art Papers*.

ADELE LOGAN ALEXANDER (WASHINGTON, D.C.)
Adele Logan Alexander teaches African American and women's history at George Washington University. She is the author of *Ambiguous Lives: Free Women of Color in Rural Georgia*. Since 1981, she and her husband, Clifford, have been partners in Alexander & Associates, a corporate consulting firm.

LISÉ HAMILTON (CORONA DEL MAR, CALIFORNIA)
Lisé Hamilton is a recent graduate of the Yale Law School. After receiving her master's degree in philosophy from Columbia University she pursued a brief career in New York City as a singer/songwriter. She has just moved to California, where she will begin work as an attorney.

CLARISSA T. SLIGH (NEW YORK, NEW YORK)
Clarissa T. Sligh is cofounder and director of Coast to Coast, Women of Color National Artists Projects. An artist who works with photographs, she has exhibited in galleries and museums internationally.

KATHE SANDLER (NEW YORK, NEW YORK)
Kathe Sandler is an independent filmmaker whose one-hour documentary film *A Question of Color* was be aired nationally on PBS in 1994. Her previous documentary film, *Remembering Thelma*, about the late dancer Thelma Hill, won the best Biography of a Dance Artist award at the New York Dance Film and Video Festival.

LUKE CHARLES HARRIS (POUGHKEEPSIE, NEW YORK)
Luke Charles Harris is a professor of political science at Vassar College and director of the college's Office of Affirmative Action. A Yale Law School graduate and Fulbright Scholar, Harris has served as a law clerk to A. Leon Higgenbotham, Jr., former chief judge of the U.S. Court of Appeals. He is completing his doctorate in the Department of Politics at Princeton University.

CARLA WILLIAMS (LOS ANGELES, CALIFORNIA)
Carla Williams is an artist who lives in Los Angeles.

CLAUDINE K. BROWN (WASHINGTON, D.C.)
Claudine K. Brown is the director of the National African American Museum Project at the Smithsonian Institution and the deputy assistant secretary for the arts and humanities. Prior to coming to the Smithsonian, Ms. Brown worked at the Brooklyn Museum for thirteen years as a museum educator and assistant director of government and community relations.

CONTRIBUTORS

ST. CLAIR BOURNE (NEW YORK, NEW YORK)
St.Clair Bourne, a producer, director, and writer, began his career in public television. As an independent filmmaker and head of his own production company, The Chamba Organization, Inc., St.Clair Bourne has more than thirty-three productions to his credit, including documentaries for public television and educational and industrial films.

JACQUIE JONES (STANFORD, CALIFORNIA)
Jacquie Jones was formerly an editor of *Black Film Review* and assistant director of the Black Film Institute at the University of the District of Columbia. She has programmed film festivals for the D.C. filmfest and the Smithsonian Institution.

PAUL A. ROGERS (CHICAGO, ILLINOIS)
Paul A. Rogers is an assistant professor of art history at the University of Chicago. He received his Ph.D. from Yale University, specializing in twentieth-century arts of the Americas.

ANGELA Y. DAVIS (SANTA CRUZ, CALIFORNIA)
Angela Davis was born and raised in Birmingham, Alabama. She graduated magna cum laude from Brandeis University and pursued graduate studies at the Goethe Institute in Frankfurt and the University of California, San Diego. She lives in California and is a professor of history of consciousness at the University of California, Santa Cruz. Her previous books include *Angela Davis: An Autobiography; Women, Race, and Class;* and *Class, Gender, and Politics.*

ROBERT A. HILL (LOS ANGELES, CALIFORNIA)
Robert A. Hill is an associate professor in the department of history at the University of California. He is also the director of the Marcus Garvey Papers Project. His previous publications include *The Marcus Garvey and UNIA Papers* (vols. 1–7) and *Walter Rodney Speaks: The Making of an African Intellectual.*

BOOK DESIGN AND PREPARATION BY CHARLES NIX